The Barbarian Invasions

OCTOBER Books

George Baker, Yve-Alain Bois, Benjamin H. D. Buchloh, Leah Dickerman, Devin Fore, Hal Foster, Denis Hollier, David Joselit, Rosalind E. Krauss, Carrie Lambert-Beatty, Mignon Nixon, and Malcolm Turvey, editors

Broodthaers: Writings, Interviews, Photographs, edited by Benjamin H. D. Buchloh

AIDS: Cultural Analysis / Cultural Activism, edited by Douglas Crimp

Aberrations: An Essay on the Legend of Forms, by Jurgis Baltrušaitis

Against Architecture: The Writings of Georges Bataille, by Denis Hollier

Painting as Model, by Yve-Alain Bois

The Destruction of Tilted Arc: Documents, edited by Clara Weyergraf-Serra and Martha Buskirk

The Woman in Question, edited by Parveen Adams and Elizabeth Cowie

Techniques of the Observer: On Vision and Modernity in the Nineteenth Century, by Jonathan Crary

The Subjectivity Effect in Western Literary Tradition: Essays toward the Release of Shakespeare's Will, by Joel Fineman

Looking Awry: An Introduction to Jacques Lacan through Popular Culture, by Slavoj Žižek

Cinema, Censorship, and the State: The Writings of Nagisa Oshima, by Nagisa Oshima

The Optical Unconscious, by Rosalind E. Krauss

Gesture and Speech, by André Leroi-Gourhan

Compulsive Beauty, by Hal Foster

Continuous Project Altered Daily: The Writings of Robert Morris, by Robert Morris

Read My Desire: Lacan against the Historicists, by Joan Copjec

Fast Cars, Clean Bodies: Decolonization and the Reordering of French Culture, by Kristin Ross

Kant after Duchamp, by Thierry de Duve

The Duchamp Effect, edited by Martha Buskirk and Mignon Nixon

The Return of the Real: The Avant-Garde at the End of the Century, by Hal Foster

October: The Second Decade, 1986–1996, edited by Rosalind Krauss, Annette Michelson, Yve-Alain Bois, Benjamin H. D. Buchloh, Hal Foster, Denis Hollier, and Silvia Kolbowski

Infinite Regress: Marcel Duchamp 1910–1941, by David Joselit

Caravaggio's Secrets, by Leo Bersani and Ulysse Dutoit

Scenes in a Library: Reading the Photograph in the Book, 1843–1875, by Carol Armstrong

Bachelors, by Rosalind Krauss

Neo-Avantgarde and Culture Industry: Essays on European and American Art from 1955 to 1975, by Benjamin H. D. Buchloh

Suspensions of Perception: Attention, Spectacle, and Modern Culture, by Jonathan Crary

Leave Any Information at the Signal: Writings, Interviews, Bits, Pages, by Ed Ruscha

Guy Debord and the Situationist International: Texts and Documents, edited by Tom McDonough

Random Order: Robert Rauschenberg and the Neo-Avant-Garde, by Branden W. Joseph

Decoys and Disruptions: Selected Writings, 1975–2001, by Martha Rosler

Prosthetic Gods, by Hal Foster

Fantastic Reality: Louise Bourgeois and a Story of Modern Art, by Mignon Nixon

Women Artists at the Millennium, edited by Carol Armstrong and Catherine de Zegher

"The Beautiful Language of My Century": Reinventing the Language of Contestation in Postwar France, 1945–1968, by Tom McDonough

The Artwork Caught by the Tail: Francis Picabia and Dada in Paris, by George Baker

Being Watched: Yvonne Rainer and the 1960s, by Carrie Lambert-Beatty

Robert Ryman: Used Paint, by Suzanne P. Hudson

Hall of Mirrors: Roy Lichtenstein and the Face of Painting in the 1960s, by Graham Bader

Perpetual Inventory, by Rosalind E. Krauss

The Absence of Work: Marcel Broodthaers, 1964–1976, by Rachel Haidu

The Filming of Modern Life: European Avant-Garde Film of the 1920s, by Malcolm Turvey

Lucio Fontana: Between Utopia and Kitsch, by Anthony White

Looking for Bruce Conner, by Kevin Hatch

Realism after Modernism: The Rehumanization of Art and Literature, by Devin Fore

Critical Laboratory: The Writings of Thomas Hirschhorn, by Thomas Hirschhorn

Formalism and Historicity: Models and Methods in Twentieth-Century Art, by Benjamin H. D. Buchloh

On the Eve of the Future: Selected Writings on Film, by Annette Michelson

Toward Fewer Images: The Work of Alexander Kluge, by Philipp Ekardt

The Barbarian Invasions: A Genealogy of the History of Art, by Éric Michaud

THE BARBARIAN INVASIONS

A GENEALOGY OF THE HISTORY OF ART

ÉRIC MICHAUD

TRANSLATED BY NICHOLAS HUCKLE

THE MIT PRESS
CAMBRIDGE, MASSACHUSETTS
LONDON, ENGLAND

This book was set in Bembo Book MT Pro by Toppan Best-set Premedia Limited. Printed and bound in the United States of America.

Library of Congress Cataloging-in-Publication Data
Names: Michaud, Eric, author.
Title: The barbarian invasions : a genealogy of the history of art / Éric Michaud.
Other titles: Invasions barbares. English
Description: Cambridge, MA : The MIT Press, 2019. | Series: October books | Includes
 bibliographical references and index.
Identifiers: LCCN 2019005635 | ISBN 9780262043151 (hardcover : alk. paper)
Subjects: LCSH: Art, European. | Art and race. | Art--Historiography--History.
Classification: LCC N6750 .M5313 2019 | DDC 709.4--dc23 LC record available at
 https://lccn.loc.gov/2019005635

10 9 8 7 6 5 4 3 2 1

Contents

Acknowledgments

I would like to thank everyone who, through their sympathetic attention and helpful advice, has encouraged the writing of this book. In particular, I wish to thank Monia Abdallah, Jean-Loup Amselle, Laurent Baridon, Yve-Alain Bois, Hal Foster, Catherine Fraixe, Michael Fried, Patrick Geary, Jennifer Gonzalez, Simon Griffee, Martial Guédron, Joan Hart, François Hartog, Maurice Kriegel, Anne Lafont, Johanne Lamoureux, Jean-Claude Lebensztejn, Meredith J. Levin, Sabina Loriga, Mary Nyquist, Jean-Frédéric Schaub, Silvia Sebastiani, Didier Semin, Jean-Philippe Uzel, and Christopher Wood. I am grateful to the translator, Nicholas Huckle, and to Gillian Beaumont for her wonderful copy-editing of this edition. Finally, this book would not be what it is without the uniquely capable reading of Éric Vigne.

This work is the result of research begun in the spring of 2010 at the Institute for Advanced Study in Princeton with the support of the Florence Gould Foundation Fund.

THE MODERN INVENTION OF BARBARIANS: DELUSIONS OF DESCENT
AND THE TRANSMISSION OF FORMS

The writing of history has always been one of the major tools of power. It shares with art not only the capacity to depict something that never existed, but also the capacity to bring about the new simply by describing it. Just as there was no London smog before Turner painted it, the "barbarian invasions" began to take up a significant place in the European imaginary only after the eighteenth century, when a few historians decided to use the idea to political effect in order to influence the course of history.[1] As Hannah Arendt has noted, "the deliberate denial of factual truth—the ability to lie—and the capacity to change facts—the ability to act—are interconnected; they owe their existence to the same source: imagination."[2] Thus the myth of the barbarian invasions, based as it was on the hypothesis of "alternative facts" situated in a distant past, became a political construct powerful enough to change the history of Europe. At the same time, it was the instrument that made possible the entire rewriting of the history of European culture, a culture from which, up to that point, the barbarians had, by definition, been excluded.

For this reason, we can say that the history of art began with the barbarian invasions. This does not mean to imply, of course, that the history of art has been actually written down in an unbroken line *since* those

barbarian or Germanic-led invasions of the Roman Empire in the fourth and fifth centuries of our era, and still less does it mean that art had no history before these "Great" invasions. It means, rather, that a true history of art became possible only after that moment, at the turn of the nineteenth century, when the barbarian invasions came to be seen as the decisive event allowing the West to enter into modernity, i.e., into the consciousness of its own historicity. The barbarian invasions, from this point on, were no longer thought of as the major catastrophe that had plunged Europe into the obscurity of the Middle Ages. On the contrary, they were seen as a salutary release from a long period of stagnation that could only have ended in decay. Up until the middle of the eighteenth century, or thereabouts, it had been accepted that the irruption of the barbarians into the Empire had precipitated the latter's decadence and fall. After 1800, the new blood of the Northern races came to mean rather the renewal, the physiological, political, and cultural rejuvenation of the peoples of the Empire: "By opening up springs from beneath, and pouring floods of barbarians over the dry and withered surface, the stagnant life was refreshed by the new blood which was infused into it; and the dry and faded was again clothed with a new verdure."[3]

Such, then, was the picture of the barbarian invasions that became established, for a long time, in people's minds. It was a picture that carried with it the idea of vigorous peoples, overflowing with a creative instinct sadly lacking in the decadent Romans and their subject peoples. As it flowed throughout the Empire, this new blood of the barbarians had thus destroyed nothing. It had preserved, rather, the ancient art, just as it produced a new art that was necessarily anti-Roman and anticlassical. The heritage of this art was still there to be seen in Europe fifteen centuries later. Quite suddenly, with this fantastic narrative, artistic styles became entirely dependent upon race and blood.

A good number of eighteenth- and nineteenth-century historians were happy to depict the barbarians as peoples who were as strong physically as they were racially or ethnically homogeneous. The ethnography of

antiquity, in fact, provided them with models for this, models based on the double postulate of the homogeneity and the continuity of the "foreign" peoples. Had not Tacitus himself, from the end of the first century, described the multitude of peoples that he named Germanic as a single population, without mixture, and of pure race? Their physical traits, he affirmed, are "everywhere the same" (*Germania*, IV). Diversity and complexity at home contrasted thus with uniformity and simplicity elsewhere. A contributor to Diderot and d'Alembert's *Encyclopédie* wrote that men resembled each other far more among wild peoples than among the civilized.[4] Added to this, as we see in Pliny, is the principle of the continuity of peoples through time. They are understood to never disappear and to always keep the same physical and moral traits.[5] The history of art was built upon such anthropological paradigms. In tasking itself with describing the objects produced by peoples assumed to be homogeneous, enduring from century to century and always unchanging, it sought to make of these objects the irrefutable evidence of that identity and homogeneity. It was to this end that the history of art fashioned its own concepts, its tools of interpretation, and these tools have survived the collapse of their very own presuppositions.

The barbarian invasions were thus in large part a romantic invention, inseparable from the formation of the nation states and the rise of nationalism in Europe, and they have since continued to be a controversial and sensitive subject among historians. Was the decay of the Empire inevitable, or was it caused by the arrival of the Germanic peoples? Did the latter suddenly coalesce and invade in compact masses, or was their entry into the Empire a long and drawn-out process? Did the Romans themselves ask for it? Were the Germanic peoples peaceful or warlike? Were they peasants? "Roman civilization did not die its own quiet death. It was murdered."[6] These famous words, written under the Nazi occupation by a French historian, were published in 1947, shortly after a war with a perceived hereditary enemy. They tell much about the extent to which the position of the

observer, in space and time, is always a determining factor in the writing of history.

The idea generally accepted up until the time of the Second World War—that the Empire had collapsed through its own internal decay—has never completely disappeared, even though it has become difficult today to speak of a Roman "decadence." In addition, the picture of cruel and destructive barbarian hordes (a picture that appeared destined to belong forever to the European imaginary) was nonetheless strikingly transformed around the turn of the twenty-first century, rejoining, as a result, the views of Fustel de Coulanges at the end of the nineteenth century. Was it really possible to speak of "Germanic invasions" when these barbarians, who were not even nomads,[7] had been deliberately called or attracted to Rome, and when, furthermore, "none of them were Germans"?[8] Today, most historians agree on two points: it is no longer possible to consider the groups entering the territory of the Empire as homogeneous peoples, and those peoples, who had always been called Germanic, included very few "Germans." It was Tacitus's *Germania*, rediscovered in the fifteenth century, Jordanes's *History of the Goths*, and Paul the Deacon's *History of the Lombards* that allowed a few humanists in the sixteenth century to imagine that the numerous barbarian peoples living beyond the Rhine and the Danube—Burgundians, Saxons, Alamanni, Goths, Vandals, Franks, Herules, Visigoths, Alans, etc.—were all "Germanic" tribes (*Stämme*) and that they were accordingly the most authentic ancestors of modern Germans.[9] This notion of an absolute continuity between the "Germani" and the modern Germans has persisted. Still today, some historians claim to be writing "a synthesis of the German past from the arrival of the Germanic peoples in the Western world up to the Reunification of 1990," as if it were possible to write a two-thousand-year history of a single and unchanging "German people."[10]

Yet as soon as one accepted, along with Tacitus, the fiction of a Germanness common to these heterogeneous populations, it was very easy to make the "Germanic peoples" the source of modern Europe. German patriotism in the eighteenth century, thoroughly anti-French in its outlook, did not

deny it. For Herder, it was at the point when the Roman Empire appeared exhausted, agitated, and dislocated that "in the north a *new human being was born ... Goths, Vandals, Burgundians, Angles, Huns, Heruli, Franks* and *Bulgarians, Slavs* and *Lombards* came—settled, and the whole modern world from the Mediterranean to the Black Sea, from the Atlantic to the North Sea is their work, their race, their constitution!"[11] A few years after this, a minister of Frederick II, who was, like Herder, opposed to the "Romanist" views of the sovereign, wrote: "The Franks, Burgundians, Anglo-Saxons, Lombards, Vandals, Goths, Rugians, and the Heruli, the major peoples who destroyed the Roman Empire, and who founded the present monarchies of Europe, were all of Germanic origin."[12] It was fictions of "racial" unity such as these that allowed the barbarian invasions to be made, during the next two centuries, into a decisive episode in the eternal war waged by the "Germanic races" against what were soon to be called the "Latin races."[13]

Late antiquity, however, did not speak of the "migration of peoples" (nor of *Völkerwanderung* or *migratio gentium*), and the barbarians who infiltrated the Empire were quite unaware that they belonged to the "Germanic" peoples.[14] Rather, the distinction between a *populus romanus*, possessing a history and a constitution, and the more or less wild *gentes*, living beyond the Rhine and the Danube, was a Roman political construction that was to persist well after the fourth and fifth centuries, while the differences between Romans and barbarians were to become increasingly uncertain. At the same time, however, this persistent opposition between an "us" and a "them" survived equally well, but in reverse, in a certain Germanic and Germanist tradition. It did so by way of other oppositions: *Kultur* against *Zivilisation*, of course, but also "civilisations sympathiques" against "civilisations politiques,"[15] and, more generally, through the contrast between populations judged to be racially homogeneous and those that seemed to be made up only of a simple, political conglomerate, and were lacking an "organic" foundation. In drawing up these rudimentary taxonomies, the modern thinkers deliberately ignored all those individuals who

were simultaneously Roman and barbarian, just as, more broadly, they ignored the extreme fluidity of social, political, and "ethnic" identities that blurred the frontiers more than could any incursions by armed bands. As for these latter, Fustel de Coulanges was already arguing that "many of these Visigoths, Burgundians, and Vandals, that we read about in history, were Italians, Gauls, Spaniards, Africans. They intermixed with the Germanic peoples, and merged with them. They made the invaded populations believe that the invaders were very numerous; and they have made posterity believe it as well."[16]

To compound the confusion, the names that the Romans gave to often heteroclite populations covered groups whose members could change considerably over time. The continuity of the name thus created the false and misleading idea of a great "ethnic," i.e., biological, continuity. These, then, were not the names of "nations." They were, rather, "claims for unity under leaders who hoped to monopolize and to embody the traditions associated with these names. At the same time, these leaders were appropriating disparate traditions and inventing new ones."[17] Ethnic homogeneity and continuity were therefore essentially romantic and singularly reductive descriptors. Europe was projecting its own national and racial aims onto its own past. As Fustel de Coulanges was to say, with his usual gift for understatement, "the modern spirit is everywhere taken with ethnographic theories, and it brings this prejudice to the study of history."[18]

Now, it was through the adoption of these two fundamental theses of ethnic/racial homogeneity and continuity that the history of art was to come to be an integral part of the great narrative of the war between the races. This narrative, through the history of art, was to take on a new cultural and political significance once the art object was called upon to speak to the identity no longer of its individual creator, but also to that of the ethnic group—"people" or "race"—that was understood to have produced it. In seeking to cast a historical light upon their objects, the two great tutelary figures of the discipline of the history of art, Giorgio Vasari and Johann Joachim Winckelmann, had both, with two centuries between

them, conceived the development of art according to the template of life. For Vasari, the history of the fine arts had been interrupted by the arrival of the barbarians, and it began again only with the Medici. For Winckelmann, the history of great art had been definitively curtailed by the barbarian invasions. Vasari sought to establish biographies of artists, thus creating vague local genealogies—what were later to be called "schools." His famous *Lives of the Most Eminent Painters, Sculptors and Architects* (1550 and 1568), a monumental work dedicated to the glory of Florence and the grand duke of Tuscany, was assuredly based upon a biological conception of art. Accordingly, just as an artist's style developed and reached maturity in a way that was analogous to his or her own life, the development of the arts in general went through all of the stages leading from childhood to old age and decrepitude. Thus the decline of art in the Roman Empire appeared to Vasari at times to be as inevitable as the decline in the life of a human being, while at other times he hinted that causes of this decline were to be found not in the Empire itself but, rather, in Christian iconoclasm and in the destructions of the barbarians who did away with the most notable classical models. Two centuries later, Winckelmann's *History of Ancient Art*, a work that culminated in the analysis of that art's "downfall" and "death," inaugurated a new biological conception of style. What was for Vasari something essentially individual here becomes collective. According to Winckelmann, each of the peoples of antiquity had developed a particular style that was born, lived, and died with them. And yet, all the while claiming that the life of a style was to be thoroughly identified with the life of its people, Winckelmann nonetheless extolled, in an utterly contradictory fashion, the atemporality of classical art—a norm set up against the art of his time, which he saw as decadent.

It was against the atemporality of classicism, against this norm proclaimed as eternal, that scholars and artists began to praise precisely those sorts of forms that the norm had, up until then, rejected or simply ignored. The history of art was thus born under the sign of anticlassicism, and with the conscious invocation of the barbarians and their arts. Local and historical

particularities were brandished therefore as weapons in an arsenal aimed at classicism's purported universalism. If it so happened that the first objects chosen to this end were the bizarre forms and outlandish proportions of the "Gothic taste," then this was because, in many European countries, the Gothic style was soon to be seen as a style that was everywhere "national," providing clear evidence of the inextricable link between its natural inspiration and its barbarian origins. As soon as they were compared with the columns and capitals that shouted out their "Greco-Roman" ancestry, the skyward-thrusting cathedrals, shooting up like so many trees rooted in the national soil, their decorative features echoing the native vegetation, bore witness to another lineage. Thus it was that this Gothic style—which Vasari once called, lamenting its ugliness, "tudesque"—was to become, from the end of the eighteenth century, an object of national pride first in Great Britain[19] and then in France and Germany,[20] these three countries being foremost in proclaiming ever more loudly their heritage and descent from barbarian forebears. Modern racial theory was therefore to put itself forward as the theory of the racial determination of cultural forms: the new blood brought in by the Germanic invasions had not only caused the end of classical antiquity, it had also created the new Christian art and thus the opposition, destined to last for centuries, between the "Genius of the North" and "Latinity."[21] The influx of new blood had shifted the entire history of the West from an ancient, pagan, and Mediterranean culture to the thoroughly modern and profoundly Christian culture of the North. Hegel's thought was certainly marked by this new mapping of history. Without, however, giving in to the racialism of many of his contemporaries, Hegel laid out, in his *Lectures on the Philosophy of History*, the exceptional fate of the "Germanic peoples." For Hegel, it was the Germanic peoples who had brought Christianity, and so the Germanic world spirit was to be totally identified with the Christian spirit of the modern world. It had begun with the appearance of the Germanic nations in the Roman Empire, and was pursuing its course "until our time." In the *Lectures on Aesthetics* that Hegel gave in Berlin in the 1820s, what he called

"romantic" art was not the same as the romanticism of the first years of the nineteenth century. Hegel's "romantic" art followed directly upon the classical art of pagan antiquity; it began with the decline and fall of the Roman Empire, merging entirely with Christian art.

Since the end of the eighteenth century, an increasing number of voices had been claiming that the decisive moment in the history of Europe was not to be written based solely upon Roman sources, but from the point of view of the "Germanic peoples." As there were no actual barbarian texts, it was the study of "barbarian antiquities," they argued,[22] that would shed a new light on a Roman history that had been up to then "written by Romans with the aim of self-promotion, and by Greeks whose aim was flattery."[23] Only in this way would it be possible to get away from the exclusive admiration and the sterile and deleterious imitation of the Romans. Essentially, at issue was understanding oneself as part of *another* genealogy, and it was a case of finally making one's cultural heritage coincide with the biological one. In 1805, as Napoleon's troops occupied the Rhineland, it seemed obvious to Goethe that, after so many centuries, no one could expect the Germans to show any admiration, or to go in for any imitation, of the Greek and Roman "divine models." Thus he claimed: "We Northerners cannot be exclusively referred to their example. *We have other ancestors to be proud of and many other models to bear in mind.*"[24]

In the rest of Europe, of course, claims of barbarian descent were different. The myth of the Frankish origin of the French nobility, introduced by Boulainvilliers, offered a clear case of social and political domination by one "race" over another: a Frankish, i.e., Germanic, aristocracy wielded power over a Gallo-Roman third estate. Montesquieu's words here are well known: "Our ancestors, the Germans ..." "those ancestors who conquered the Roman empire."[25] Phrases such as these were not at all unusual in Europe. After the successive incoming waves of Suebi, Vandals, and Alans, Spain was invaded by the Visigoths whose kingdom, it is true, did not survive the arrival and conquest of the Moors in 711. The Visigoths, however, did bequeath to Spain its "Gothic myth," the mark of which is

still there in the language: in its entry for "Godo," the *Diccionario de la Real Academia Española* gives *"hacerse de los godos* (to boast of one's nobility)," and *"ser godo* (to be of ancient nobility)."[26] In England or in Scotland, there were many who claimed descent from the Angles, Saxons, Goths, and above all the Normans—so many peoples reputed to be "Germanic" and whose successive conquests clearly attested to their superiority over the indigenous "Celts." It is only the Langobards or Lombards in the north of Italy, the last barbarians to enter the Empire, who (at least until the Lega Nord)[27] seem to have inspired no pretensions to titles of nobility or superiority.[28]

Yet the nature of the interest taken in the barbarians did begin to change over the course of the nineteenth century. The historians had so swelled their numbers that the barbarians appeared less a conquering elite than a huge mass of people, migrating from the vague immensity of a borderless Scythia, and coming to impregnate the native populations of Western Europe. The idea of such a migration was certainly not new. Leibniz, at the dawn of the eighteenth century, seeking an explanation for the numerous "common roots" of certain European languages, was already postulating that "this fact comes from the common origin of all these people descended from the Scythians, who, having come from the Black Sea, passed the Danube and the Vistula, and of whom one part may have gone into Greece, the other have filled Germany and the Gauls; a consequence of the hypothesis which makes the Europeans come from Asia."[29]

Recalling, no doubt, Jordanes, who saw Scandinavia as the "manufacturer of peoples," the romantics were to add to this long migration route the vast detour of the migrants by way of the North. The same delusion of lineage that had so moved Goethe was now to feed, through a new orientalism, the anticlassicism of Pierre Leroux:

> We, men of the North, who had left our native forests, and had left there, along with the bones of our forefathers, the poetry of our forefathers, who had forgotten our songs of Ossian and our old epics, created out of traditions themselves borrowed

from the Orient, but transformed by our ancestors, in the long pilgrimage that took them from the plateaus of Asia to the ice floes of the North, and dispersed them, like a fertile seed, across Germany, England, Spain, and France—we had forgotten all of that, we had abandoned our heritage, repudiated the inheritance that nature gave us, and we had come, so to speak, like little children who are still not old enough to talk, to make ourselves the inheritors and disciples of the Greeks and the Romans.[30]

After the 1840s, when the works of Sir Walter Scott had already taken the continent by storm, excavations carried out almost simultaneously in most of the European countries showed, from Spain to Hungary, a growing interest in the tombs of the Germanic tribes that had supposedly invaded those countries. In France, despite the Académie celtique, founded in 1804 with the purpose of unearthing the monuments of Gallic antiquity to stand against the all-powerful Greco-Roman model,[31] the history of art, unlike archaeology and anthropology, only very briefly sought to give support to the historians' and politicians' Gallic myth.[32] This is because the France of the Restoration, as Renan was to write, was marvelously well prepared to receive from Germany "an infusion of new spirit," and "the Gallic race," he claimed, was in need of being periodically "impregnated by the Germanic race."[33] France, therefore, like Germany, Switzerland, Belgium, or England, had taken to digging in the earth in search of objects that were expected to be capable of recounting, over against the narrative of classicism, the great "barbarian," i.e., essentially Germanic, epic.

"All of the centuries, all of the peoples, are thus hidden in the earth. The Gaul lies down alongside the Roman, and the Roman sleeps beside the Barbarian. It is necessary only to make these men speak and to understand their answers; but for this we must not confuse their languages. We must know how to discern the tones, the nuances, the colors, the physiognomies of each people and of each civilization."[34] But neither the bones nor the

other objects exhumed from the necropolises ever gave a single, univocal answer. So much so that the "Frankish question" in Belgium at the end of the nineteenth century caused violent arguments between Walloon and Flemish archaeologists, profoundly shaken in the sense of their own identity. Were the Walloons really Gallo-Romans, and were the Flemish really Franks? Could archaeologists conclude, from the fact that dead warriors were dressed as Franks, that they were Franks? The answer was no, because the Gallo-Romans of the Merovingian period used to dress in Frankish style when they were in relations with those who wielded power, i.e., the Franks. Gallo-Romans were members of the same armies as Frankish warriors, and so they bore the same arms, and had access to the same military dignities as the Franks; they themselves became counts, dukes, etc.[35]

Archaeology and the history of art thus set themselves the same task: to determine the correct "ethnic" lineage for their objects, whether those objects were works of art or mortal remains. As a purely descriptive science of observation, the history of art also assigned its objects to racial groups on the basis of a few visible signs. Sometimes it was their "tactile" or "optical" qualities that gave them away as "Latin" or "Germanic" (Alois Riegl), and sometimes it was the predominance of linear elements that betrayed a Latin or Southern origin, while the "pictorial" clearly indicated a Germanic or Northern provenance (Heinrich Wölfflin). As for the museums, they tried, from the first years of the nineteenth century, to group fine-arts items according to geographical origins and to the "ethnic" lineage of their creators. However, in the same way that a tomb containing Frankish arms might very well be holding Gallo-Roman bones, the rooms that museums assigned to the artists of the "Schools of the North" could show works that were perfectly "linear." These taxonomies presupposed that a collective "manner" or a "style" could not be acquired or bartered: that it was not socially transmitted, but innate. It would be a vain task to try to prove that the history of art was—or still is—a racist discipline. It was neither more nor less racist than the other social sciences, and all of them were oriented by racial thinking to classify and create hierarchies of people according

to certain somatic and psychological traits. Still, it remains important to understand the nature of the links it forged between people and their works of art, because those links are not yet broken. We give them a semblance of reality each and every time we look at these objects and search for a sign of their "ethnic," i.e., collective, origin. This is because the opinion that remains the most commonplace concerning art is that it embodies, better than anything else, the genius of a people.

The history of art was first formed on the model of the life sciences. It claimed to name, describe, and classify its objects as living beings, assimilating artistic creation to a natural process, and seeking to understand its development. In looking at works of art such as plants, animals, or human beings, and in organizing them according to various grids of similarities and differences, the history of art believed it could bring to light consistencies and continuities, establish genealogies of forms, construct "stylistic families," and reveal ties of kinship. One of the great constructs of nineteenth-century thought was the idea that "physiological heredity ensures our psychological heredity." Thus, for Hippolyte Taine, an individual did not just inherit certain traits from his or her mother or father, but he or she inherited a whole "storehouse" containing all of his or her ancestors "going back to infinity." The consequences of this, Taine added, were considerable, and they allowed one to examine human history through the perspective of the *longue durée*, as one now knew that "the persistence of inherited aptitudes and tendencies" was to play a preponderant part. Thus he could say: "The tenacity of the hereditary and transmitted characteristic explains the obstacles facing a given civilization, religion, or group of mental and moral customs, that seeks to graft itself upon a wild or different stock."[36] This explained why styles were transmissible only through reproduction within the same "stock." It explained also the principle of the impermeability of cultures one to another, a principle that had already been clearly articulated by Herder. Furthermore, as the nineteenth century was to add, if each culture was the emanation of a race, then clashes between cultures were necessarily clashes between races.[37] Certainly, the concept of race

was no more semantically fixed then than it has been at any other point in history, including today.[38] But it has always been used to include and to exclude, and to maintain this impermeability. It caused Maurice Barrès, for example, to declare that he could not understand Greek statues, buildings, and landscapes: "I would have to have the blood of the Hellenes. The blood of the valleys of the Rhine does not allow me to participate in the deep life of the works that surround me. ... Alas, it is all too clear! We are of two races."[39]

The discourse of blood, like today's discourse of the gene, is grounded in a fundamental invisibility. Whether applied to human beings or to art objects, these discourses always connect the visible differences between bodies with natural causes that remain hidden, and those causes are understood to ensure unfailingly the transmission of differences. In this way, these discourses maintain not only that culture is *in* nature but also that it *proceeds* from nature.[40] They strive, therefore, to construct a more or less stable world in which the arts forever resemble their respective peoples—and vice versa.

From "National Taste" to "Racial Style"

The diplomat and art theorist Roger de Piles chose to conclude his massive tome *An Abridgement of the Lives of the Painters* (1699) with a brief eight-page essay entitled "Of the Taste of Several Nations."[1] Up to that point in his treatise, however, his presentation of the lives of European artists had been organized according not to "nations" but to "schools." This latter method of arrangement had recently arrived in France from Italy. Giovanni Bellori's *The Lives of the Modern Painters, Sculptors and Architects* (1672) had included the following quotation of a fragment from an unpublished treatise by the scholar Giovanni Battista Agucchi: "Four kinds of painting can thus be discerned in Italy: Roman, Venetian, Lombard, and Tuscan." Agucchi, who was the first to have made this observation, identified the works of each of these "schools" by their distinct *maniera*.[2] But De Piles's *Lives* was something of a French war machine set against the painfully long Italian dominance in the field of the fine arts. De Piles saw no reason to limit his survey to the Italian schools, since for the previous thirty years the French Academy, established by Colbert, had existed in Rome. Its goal was to train the best painters in Europe, painters supposed to be capable of improving on the Italian models. Furthermore, since, according to the legend handed on by Vasari, the fine arts had become extinct in Italy as a result of the

barbarian invasions, and since the Florentine Senate had brought in artists from Greece in order to "reestablish painting in Tuscany," De Piles found it perfectly natural to begin his *Lives* with six painters from ancient Greece, starting with Zeuxis and finishing with Protogenes. He followed this with a division into schools: "The Lives of the Roman and Florentine Painters," "The Lives of the Venetian Painters," "The Lives of the Lombard Painters," "The Lives of the German and Flemish Painters," and, finally, the glorious capstone to his ambitious survey, "The Lives of the French Painters."

In his much shorter treatise on the tastes of the nations, De Piles used a slightly different method of arrangement. He attributed to each *school* a distinct *taste*, taking no account of the difference of scale that separated the Italian schools (bearing the names of regions or towns) from the national schools of other European countries. Throughout the eighteenth century, however, a consistent and unmistakable semantic chain of connections was to bind the terms *taste*, *manner*, and then *style* to the idea of a nation. Already, toward the end of the previous century, Père Bouhours had noted: "each nation has its own taste, in mind as well as in beauty, in dress, and everything else."[3] But for De Piles, taste was first of all a matter of judgment, something intellectual, whereas manner had to do with the body, and in particular, the *hand*. Slowly, a theory of the hereditary transmission of styles came to be built up. It happened against all the evidence provided by formal training and subsequent ingrained habits, and it was established on the basis of the distinction between taste and manner, between a *faculty* understood as something essentially social, and a *form*, understood as a product of the physical body.

For De Piles, and for the entire eighteenth century along with him, taste was formed and was itself formative. It was formed on the collective level of the nation as well as on the level of the individual artist, but it always remained fundamentally social. Voltaire, in the article in the *Encyclopédie* devoted to "Taste," had this to say: "When there is little sociability, the mind shrinks and grows dull because there is nothing to educate its taste." A lesser-known writer, Paul Landois, who composed the last section of this

same article, made a careful distinction between the "taste of the nation" and "individual taste":

> The taste of the nation is that which reigns supreme in a nation, which makes it such that one can recognize that a painting is from a particular school; there are as many tastes of the nations as there are schools. ... The individual taste is that which each painter makes for himself, such that one can recognize that a given painting is by a given painter, although the taste of his nation always reigns over it.[4]

The interlocking of these concepts, however, was not always semantically consistent. There was no doubt that an artist's taste formed part of the taste particular to that artist's nation, a taste that defined a school. However, according to Chevalier de Jaucourt, if it was usual to understand by "school" "the painters who have become famous in a country, and who have followed its taste," the term "school" could also designate, in a more restrictive way, the students of a master or "those who worked in his manner." Since it was common to speak of the schools of Raphael, of the brothers Carracci, or Rubens, it was also the case that manner could be a sign of belonging to a school. Still, there was a difference here with taste, since "manner" was primarily a mark of a practice and individual performance. Manner was understood basically as the formal expression of an individual being. Taste, on the other hand, was seen as both a faculty that had to be formed and a force that was itself formative. Later in the century, Johann Georg Sulzer was to say that "*the formation and purification of taste* is a great business of the nation," and this formula was to remain famous for a long time in Germany and in France. Paillot de Montabert quoted it in his *Treatise* of 1829, in order to underline the decisive importance of the fine arts in "influencing moral behavior."[5]

The Italians, following the publication of the Vasari's *Lives*, had begun to make use of the term *maniera* to mark out not only the styles of individual

artists, but also "national" styles (*maniera Italiana* or *d'Italia, maniera Fiaminga, maniera Tedesca*) or even ancient styles (*maniera Greca* or *maniera Gotica*) in opposition to the rebirth of the *bella maniera* or *maniera moderna*, which was, of course, *Italiana*. However, in France, the term *maniera* was used to refer much more to a painter's individual style. In the middle of the eighteenth century, the naturalist and art lover Dezallier d'Argenville could claim that if the same taste could be felt in all the works of the Italians, whether from Rome, Florence or Lombardy, they differed amongst themselves only by their distinct "manners of painting." Manner was thus "like a style of writing," something that distinguished one artist from another.[6]

In his short treatise on the taste of nations, De Piles noted: "One may Reason of the Taste of the Mind, in some measure, as that of the Body." This was possible, he argued, because in the same way that the physical organ, as it tastes a thing, experiences a sensation that becomes habitual, the mind, as it also tastes a thing, applies to that thing a judgment that "repeated, produces a Habitude, and that Habitude a settled Idea, which gives us a continual inclination to the Things that we have approv'd, and are of our Choice."[7] De Piles distinguished three orders of taste in painting: natural, artificial, and national. The *natural taste* arose out of "the sight of simple Nature." The Germans and Flemish, he added, rarely strayed from it. The *artificial taste* was formed "by Education," whether provided by exposure to works of art or to the teaching of the masters. He defined the *taste of the nation* thus: "the *Gout* of each Nation is an *Idea*, which the works that are seen in any particular Country forms in the Mind of those who dwell in it."[8]

The *taste of the nation*, at once individual and collective, unique and also shared, formed and formative, was therefore, by means of habit or custom, an essential vehicle of social homogenization, and it was primarily through this vehicle that it was possible to connect a work to its origin, to its place of birth.

Even more striking was the way in which De Piles went on to characterize each of the six *tastes of the nations*. Differences between them came down,

essentially, to varying degrees of *natural taste* and *artificial taste*. The greater the share of artificial taste in the artistic production of a nation, the higher that nation stood in the hierarchy of "schools." For this reason, it was the *Roman taste*, defined as "an *Idea* of the Works that are to be met in Rome," that came at the top of the hierarchy. Formed on the basis of "those we call *Antiques*, and the modern Productions made in imitation of them," and thus on the basis of a second nature that had removed all trace of the first one, the *Roman taste* was therefore the most "artificial" and the most "educated." The *Venetian taste* came second, and this was because, since Venice owned very few classical antiquities and works in the Roman taste, they "apply'd themselves to express Beautiful Nature, which they took from Objects in their own Country," and they characterized these objects with "an harmonious Vigour of *Colouring*." In third place, there was the *Lombard taste*, "in which a fine choice of Nature, is mingled with a little of the Antique," followed by the *German* or *Gothic taste*, of which De Piles wrote: "'Tis an Idea of Nature, as we see her generally with her Defects, and not as she might be in her Purity." For De Piles, the Germans imitated nature "without Choice," and they clothed their insipid figures with "dry and broken" drapery. With scant few exceptions, they were more interested in precision of line than in elegance of arrangement. The *Flemish taste* was less attached to unadorned nature, and it differed by its "greater Union of well chosen Colours, in an excellent *Claro Oscuro*, and in a more mellow Pencil." As for the *French taste*, with which De Piles concludes his inventory, he is forced to confess his difficulty: "The French Taste has always been so divided, that 'tis difficult to give a just Idea of it. The Painters of that Nation seem to differ very much from each other in their Productions." Their differences came from the fact that some of them had acquired the taste of Rome because they had gone there to study, others the taste of Venice because they had spent much time in that city, while still others "apply'd themselves with all their Industry, to imitate Nature as they found Her."[9]

For at least a century after this, all of the French attempts at a classification of the European "schools" of painting were to be inspired by De Piles's

example: sometimes following it to the letter, sometimes removing one school or another from the list, or adding another. But always, in these comparative surveys, the characteristics applied to the "schools" of painting were identified with the "tastes of the nations." This concept was thus to play a crucial role in the construction of "national characters," a literary-philosophical genre that flourished throughout the eighteenth century.

However, once the classification of painters according to national flags became firmly established, the simplicity of its taxonomy could not conceal its lack of solid foundations. Was it place of birth that determined the presence of a given painter in a particular European school, or rather, was it the place where an artist worked and expressed his talent? In other words, which habits and customs were important here—those acquired through a primary natural education or those acquired later by study, often carried out far from the place of birth? The reasons varied. De Piles did not include among the Lombard painters those who had followed the Roman or Venetian school "because, in this case, I have more regard to the *Manner* they follow'd, than to the Country where they were born."[10] Indeed, the Abbé Jean-Baptiste Dubos had written many years before this: "It has been in all times observed, that the influence of climate is stronger than that of origin and blood."[11] Furthermore, since Palma the Elder or Lorenzo Lotto had worked in the manner of Giorgione and Titian, to have assigned them, as some had done, to the Lombard school would have created confusion by making people think that the Lombard and Venetian schools were one and the same. De Piles chose, therefore, to split a painter into two schools rather than lead his readers into such an error. The painter Annibale Carracci, from the time that he was called to Rome, took on so forcefully the Roman taste that, for De Piles, only his work prior to the decoration of the Farnese Gallery could be called Lombard. De Piles also removed from the *Flemish taste* three or four of Raphael's disciples who had brought their teacher's manner back from Italy. He also excluded Rubens and Vandeix because they "view'd Nature with Penetrating Eyes," and thus rose above the "common Painters of that Nation." However, he

noted, they had nonetheless "retain'd something of the *Flemmish Taste* in the *Gout* of *Design*."

In the eighteenth century, the "Beautiful Nature" of a given country was soon to be called, adopting the terminology of wine tasting, the *taste of the soil*. Some writers, such as the connoisseur and collector Pierre Jean Mariette, thought it impossible for a painter to entirely escape the influence of this primary natural education.[12] Dezallier d'Argenville was also to say that Rubens "would have reached artistic perfection if not for the taste of the country of his birth; however hard he tried to extricate himself from this taste of the soil, he never succeeded." All that Rubens lacked, therefore, was to "have been raised in the Roman School."[13] Yet in the first discourse of his *Abrégé de la vie des plus fameux peintres*, published in 1745, Dezallier challenged the widespread idea that a painter's first natural education had an inescapably determining influence on his art. Merging together all of the Italian schools, Dezallier identified only three national tastes: Italian, Flemish, and French. Thus he was able, by smoothing out a few differences of nuance, to reduce the prestige of the Italians and to put the three countries on an equal footing: "All of these nations, when they study antiquity and the works of the old masters, often reshape the taste of their soil, and they make it infinitely better."[14] In this way, having made of the various tastes of the nations so many tastes of the soil reshaped through antiquity, Dezallier could fairly easily include the Germans, Dutch, and English in the "Flanders School," since they had all acquired "the same manner, that one calls customarily *the Flemish taste*." For the same reason, Dezallier classified the *Spanish* "among the Neapolitans," whilst Peter Lely and Sir Godfrey Kneller, even though they were natives of Germany, were placed with the English, i.e., in the Flemish school. The arbitrary nature of this taxonomy was no barrier here; the important thing was to make the French taste paramount.[15]

Roger de Piles, in his rather equivocal description of French taste at the end of his essay, was convinced that, in spite of the fact that it was "difficult to give a just Idea of it," the most skillful French painters were "possest of

so many fine parts of their *Art*," and they "managed their Subjects with so much *Elevation*, that their Works will always be the *Ornament* of *France*, and the *Admiration* of Posterity."[16] Sixty years later, this lack of a peculiar and well-defined taste was to become a sign of superiority. The great scholar Antoine Pernety was to describe the French School as

> indebted to all the other schools; it has never had a distinctive character, unless one counts the beauty of its organization, the wisdom and brilliance of its creation and composition, and a certain gaiety in its works. People are apt to say that it is weak in matters of color; but there is general agreement today that it is superior to all of the others.[17]

David Hume was to put forward the same type of argument in favor of the English: if they were "the most remarkable of any people that perhaps ever were in the world," this was because of the "wonderful mixture of manners and characters" that made them the people with "the least of a national character; unless this very singularity may appear to pass for such."[18] Espiard de La Borde, in his *Essais sur le génie et le caractère des nations*, was to see this lack of character as the mark of supreme elegance. After drawing an audacious parallel between Athenian Atticism, far removed from all taste of the soil, and the French courtier speaking his language without an accent, he extolled France for having "no style of its own." Compared to the Spanish writers who were "puffed up by their own grandeur," or Italy, that was "light and lax in its turn of language," France alone was able to connect with "the taste of the most pure antiquity."[19]

As Jacques Barzun has pointed out, as long there was in Europe a sort of cosmopolitan ideal—i.e., as long as the division of European society into classes was a deeper and stronger force than its division into nations—the attribution of national characters could remain a mere pastime.[20] Moreover, in the eighteenth century, the characters that were said to be "national" really concerned only the ruling classes of the countries, people who were simply applying these labels amongst themselves. The citizens

of the Republic of Letters, who belonged no less to the ruling class, easily fell into the error that Hume had exposed when he castigated the "vulgar" who were always in such a hurry to apply this or that characteristic, without exception, to an entire people. Thus these essays on national characters, taking as their subject the comparative merits and faults of European peoples and the schools of painting that assumed to represent them, betrayed strong national rivalries in the struggle for prestige and hegemony. One notable exception to all this was the philosopher d'Alembert, who was wise enough to recognize the superiority of the "Italian School"—"despite its faults"—over the French school:

> Let no man accuse me of trying to debase my nation. No one is more admiring than I am of the excellent works it has produced, but it seems to me a ridiculous thing to ascribe to it superiority in all genres, just as it is unjust to refuse it in several of them.[21]

The French did see themselves, of course, in competition with the Italians, from whom they were eager to steal first place. This was abundantly clear in the *Réflexions critiques sur les différentes écoles de peinture* (1752) by the tedious Marquis d'Argens. Antonio Palomino catered to Spanish national pride with his *El Parnaso español pintoresco laureado* (1724), partially translated into English (1739), then into French (1749), and German (1781). The Italians, while they often recognized the decline of their own artistic production, were still more likely to either mock or rail against French pretensions to hegemony. The English, for their part, complained that their painters went unrecognized abroad through the lack of an "English School" and an "Academy." In 1706, the English translator of De Piles's *Lives* wrote:

> *Had we an Academy we might see how high the* English *Genius would soar, and as it excels all other Nations in* Poetry, *so, no doubt, it would equal, if not excel, the greatest of them all in* Painting, *were her Wings as well imp'd as those of* Italy, Flanders *and* France.[22]

———

23

Armed with this absolute certainty, he added to his translation a substantial section aiming to repair De Piles's painful omission—the eighty pages making up "An Essay towards an English School of Painters," in which he argued vehemently for the rights of the English over countless Dutch painters.[23]

TASTE TO STYLE: SOCIAL AND BIOLOGICAL TRANSMISSION

Jacob Burckhardt noted, in 1845, that it was Winckelmann who "began the history of style."[24] Winckelmann, he argued, was the first to differentiate periods in the art of antiquity and to place them in the context of universal history, and as a result he made art history a branch of the history of civilizations (*Kulturgeschichte*). However, in pointing out the links that were to exist from then on between style and history, Burckhardt left out of consideration the concept of taste. Now, in the course of time, it is true that for Winckelmann style had almost completely replaced taste, yet his *Reflections on the Imitation of Greek Works in Painting and Sculpture* (1755) was written entirely in the light of taste, and it was conceived as a weapon aimed at the "baroque taste" and the rococo that he associated with French bad taste. It began with this strident profession of faith: "Good taste, which is becoming more prevalent throughout the world, had its origins under the skies of Greece." As we have seen, "taste," with its normative meaning, derived from the theory of classical art that had emerged in France after the middle of the seventeenth century.[25] Precisely because it was normative, this discourse about classical art took artistic works to be objects that, through their entry into the fabric of life of a society, were capable of transforming that society. In calling upon the artists who were his contemporaries to imitate the ancients, not nature or the moderns, Winckelmann was, therefore, making the assumption that the practice of art was an activity that could be profoundly, even entirely, governed by the effects of fashion and by mimetic contagion. In this sense alone, art was to remain, in the *Reflections*, an eminently social activity, and the meaning of "taste" was

always such that it was never a question of the imitation of an ancient *style* but always of a "Greek taste"—a taste such as guided Raphael, supposedly, even as he worked in imitation of nature.[26]

In a letter in 1785 to Bianconi, Winckelmann gave high praise to the Comte de Caylus for having been "the first to go into the substance of the artistic style of the ancient peoples."[27] But in fact, Caylus used the terms *taste*, *style*, and *manner* almost synonymously when describing an object and assigning its production to a particular people. For example, we find in Caylus expressions such as "*Manner* can be compared to style," and he describes one figure both as "moving away from the Egyptian manner" and as being "arranged in the Etruscan style."[28] On several occasions, he uses the phrase "taste and manner," and applies it to the works of a "nation." Finally, and most importantly, he defines manner in painting as "a dependence on acquired habits." Comparing manner to style, he connects the latter implicitly to custom, to a shared practice. Caylus took up Dezallier's metaphor of writing, arguing that since it was easy to observe "several modes of expression in the productions of the mind," it was easy to recognize "the styles of the different nations." He arrived thus at a description of the connoisseur: although all of the letters used in the various languages of Europe derived from the Roman characters, it was easy for the connoisseur to say without error "*This writing is Spanish, Italian, French, etc.*" It was the same for the identification of the various manners in painting and sculpture, since it was always the case that an artist sought

> in vain to copy Nature as he sees her. This is what he seeks, and yet even though he may believe that he has achieved it, his nation, his surroundings, his particular habit seduce him, blind him, and are such as to make us recognize his country, his school, and this down to his very hand once we have a grasp of his *manner*; that is to say, once we have compared a sufficient number of works for us to be able to read, so to speak, the author, the school, and the nation.[29]

Undoubtedly, therefore, for Caylus, taste, manner, and style were never to be understood as the natural and spontaneous manifestations of an individual or of a single social group; rather, they were in every case the result of a complex network of collective and individual habits. The task of the connoisseur, as Caylus understood it, was precisely to identify these various *habitus*. In fact, he was using the term *habitus* with the meaning that it was to have in the twentieth century for Marcel Mauss, who connected it to techniques of the body,[30] or Pierre Bourdieu, for whom it was a synonym of taste, and often of manner. If we bear in mind that the *habitus*, according to Bourdieu, are differentiated but also differentiating, i.e., they generate and unify "the intrinsic and relational characteristics of a [social] position into a unitary lifestyle,"[31] then we would not be far from seeing Caylus as a sociologist of the ancient world. But Caylus, as a historian of antiquity, was not concerned with differences of class among the ancient peoples; he was interested rather in the resemblances and differences between the peoples themselves; and their various tastes were, for him, the surest signs of those resemblances and differences.

Most remarkable, however, is the fact that Caylus, as a connoisseur and historian, was not content just to state, like Dezallier, that "the taste of the country in which a work was produced is the mark of its school,"[32] he was able to actually observe and interpret, in the objects themselves, signs of relations and exchanges between peoples. Consider this description he gives of his practice:

> The historian of the ancient world delights in finding, in its monuments, a mixture of the tastes of the nations. He comes to this knowledge not only by observing the objects of superstition that peoples have exchanged among themselves, but also by the various manners in the arts that they have adopted. The historian sees how the various tastes gradually converge, and then he finds them mixed and intermingled in a single work. The sight of this recalls to him the happy or unfortunate revolutions that

have changed the face of the Universe: those celebrated epochs in which empires were destroyed by other, more powerful or more unjust, empires, and the inhabitants of various countries subjected to the domination of a single one. Men have in all times been weak and imitative creatures: they have adopted new errors; copied the observances of religions that they saw; corrupted or perfected the arts; and they have followed in their works a foreign manner without, however, losing the taste that was their own. Such is the spectacle that monuments offer to the imagination, and, in particular, this one: a Grecian Venus, of Roman workmanship, seated in the attitude and the taste of an Egyptian Isis. How striking are these connections [figure 1.1].[33]

Now, we should note that this "mixture of national tastes" did not involve, for Caylus, a negative judgment. There was no lament for any sort of lost purity. Quite the contrary: his interest was all the more aroused in all of the phenomena of transmission, adoption, and imitation that were at work among peoples (it had recently become common to speak of *transfers*). It is true that he did write, in his foreword to the first volume of the *Recueil*, "a people's taste differs from that of another almost as markedly as the primitive colors differ one from another." However, his empirical study of the objects led him to observe more keenly the transmission of forms and techniques from one people to another, as well as the movement and transmission of art from one historical period to another. This was because the objects bore witness not only to the "mixture of national tastes" but also to a mixture in time and across historical periods. They blurred the boundary between the emergence and the decadence of art. How could we know, for example, if a given Gaulish monument had been created before the Roman conquest or "toward the end of their [the Romans] authority over the Gauls?" For Caylus, it often seemed to be difficult—even impossible—to date these objects, and this was because, as he emphasized with remarkable

1.1 Comte de Caylus, 1756: "... A Grecian Venus, of Roman workmanship, seated in the attitude and the taste of an Egyptian Isis."

astuteness, "the first establishment and the decadence of the arts produce similar effects."[34] He offered as an example the aforementioned "Grecian Venus, of Roman workmanship, seated in the attitude and the taste of an Egyptian Isis." It symbolized, for him, one of those key moments in history where, between genesis and decline, horizontal mimetic phenomena took center stage, eclipsing vertical mimetic transmission from one generation to another. It was one of those moments, therefore, when, through the greater intermingling of peoples, social interconnections were increasing, the circulation of objects was increasing, and so also was the circulation of *manners* and *national tastes*. This movement was often such that reputedly national, vertically transmitted artistic traditions became unrecognizable. Caylus clearly understood that the mimetic phenomena that produced collective characteristics and tastes within national boundaries were the very same ones that created disruption, going so far as to dissolve equally those tastes and boundaries. He was struck, he said, by "the inconstancy of men, for whom fashion, this flighty Goddess, has been and will always be one of the most cherished divinities."[35] In emphasizing the extent to which people were "weak and imitative creatures," he proved himself to be closer to Hume, for whom imitation was the wellspring of national character, always arising from the circulation "by contagion" of "passions and inclinations,"[36] than he was to the climate-based theories of Dubos or Montesquieu, whom he occasionally quoted.

Caylus sought, therefore, to be a keen and impassioned observer of the migration of cultures, and of their exchanges. He delighted in the fact that chance had "procured [for him] works where one could see the taste of a country intermingled with that of the people who had brought it to light." He added, with genuine modesty,

> I took advantage of this to educate myself, and to prove the commerce that certain peoples have had one with another. Moreover, I have been at pains to make my reasoning clear, and if I have sometimes fallen into error, the reader will have the satisfaction of learning what it is that led me astray.

Whenever he could, he pointed out the "pleasure" that he experienced in "discovering the exchanges between the ancient peoples":[37] between Egyptians and Persians, Etruscans and Egyptians, Egyptians and Greeks, or again between Greeks and Etruscans. Accordingly, he gave no credit whatsoever to the ancient Greeks' claim to have been the first inventors of the arts. He wrote:

> the love of fame [had degenerated] among the Greeks to a vanity so full of ingratitude that they tried to forget everything that they owed to the Egyptians, and to persuade the Universe that Greece had herself created the arts that she practiced most successfully. However, this opinion has not stood the test of time.[38]

Caylus recommended, above all, restraint in the historian of the ancient world, and he warned against the spirit of system and against interpretations that were too clear-cut and accompanied by a "too imperious tone." To these he preferred "conjectures that are offered for what they are worth." Always quick to recognize the part played by chance in the most fortunate discoveries, he feared nothing so much as the blindness caused by presuppositions: "I would like the historian of the ancient world to banish entirely all types of systems from his work. I consider them to be a sickness of the mind, caused by inflammation of self-regard, and this blind feeling prevents the historian from making the slightest adjustment to his project."[39]

At the opposite pole to this "spirit of modesty and free inquiry"[40] so characteristic of Caylus's *Recueil*, we have the overweening ambition of Winckelmann and his promotion of the spirit of system.[41] Winckelmann opens the Preface to his *History of the Art of Antiquity* with this strident statement:

> The history of art of antiquity that I have endeavored to write
> is no mere narrative of the chronology and alterations of art,

for I take the word history in the wider sense that it has in the Greek language and my intention is to provide a system (*einen Versuch eines Lehrgebäudes zu liefern*).[42]

Paradoxically, his *History* begins, nonetheless, with the "Investigation of Art with Regard to its Essence," and, as he made clear in his Preface, it was the "essence of art" that was to remain the "focus" of each of the two major parts of the work. Thus, as has often been noted, historicity and normativity were to be in constant conflict. Far quicker to see Caylus's errors than to acknowledge his debt toward him, Winckelmann set himself up against Caylus, but also—and contrary to all the evidence—as a fervent defender of the indigenous nature of the arts, and of the primacy of the ancient Greeks in the invention of the fine arts. But since he could not fail to acknowledge the existence of texts that mentioned the ancient manufacture of "shapes" in Egypt and Chaldea, he argued, rather, that art could have no particular territory of its own, since "there are not adequate grounds to assign one particular homeland to it. Every people has found within itself the first seeds of necessity." There could be no doubt that art had started later among the Greeks than among other peoples of the East, but it behooved us, he argued, to believe the Greeks when they claimed "not to have gathered the first seeds for their art from another people." Better still, they were truly the "original inventors" of art, since they were the first to give human form to their gods.[43] In order to further support his thesis of the uniqueness and absolute originality of Greek art, Winckelmann came thus to deny any borrowing on the part of the Greeks from other peoples, including the Egyptians. Gottfried Herder, in fact, held this very much against him. For Herder, the similarities between the archaic Greek style and the Egyptian style were so evident that he wished for "a specific study of the common origins of one art and another, one people and another; and on this point I side with Goguet and Caylus."[44] In response to Winckelmann's claim for the indigenous nature of Greek art, Herder argued that the Greeks were not "native to the land they inhabited," and that the migration of peoples

was always a source of imitation rather than of creation. Why, he thought, should we accept the "unrealistic idea according to which everything with the Greeks sprang up spontaneously and with no foreign seed?"[45]

A great deal was at stake in this opposition between Caylus and Winckelmann. The former stressed the central role, in the setting up of a "national taste," of exchanges and mimetic processes that were capable of creating forms so fluid that it became difficult to differentiate moments of genesis from periods of decline. In contrast, Winckelmann set out to describe "the origin, growth, change, and fall of art, together with the various styles of peoples, periods, and artists."[46] As such, for the author of the *History of the Art of Antiquity*, the story of the birth, life, and death of art was not just about artists (as it had been for Giorgio Vasari, Carel van Mander, or Roger de Piles who, in their *Lives*, merely juxtaposed the biographies of artists); it was, rather, the story of entire peoples and their styles. For the first time, therefore, we see the emergence of the idea that the life of a style corresponded to the life of a people, and that to describe the life cycle of a style, from its birth to its decline, was to write the biography of a people, from that people's first appearance in history to its ultimate decline. Once Winckelmann had established this intimate and organic link between a people and its art, it became customary to see art not simply as a social activity (as it was for Caylus), but as a peculiarly natural function of the body of a people: i.e., as a sort of bodily secretion of the nation as a whole. Only then did a theory of the hereditary transmission of styles become possible. All of the metaphors suggesting that the transmission of forms was not socially constructed but genetically hereditary were soon to be borrowed from the models of plant and, still more, human reproduction. It would then be up to the nineteenth century to see sap, semen, and blood as fluids capable of ensuring a vertical transmission guaranteeing the very self-identity of a people or race, through time, through the organ of its art.

———

"As One Man"

Caylus, commenting upon a chapter on painting in Pliny's *Natural History*, noted that the Greeks had at first made a distinction between only two schools: "the Hellenic and the Asiatic, or the Attic and the Ionian," before they added "the Sicyonic" after the painter Eupompus of Sicyon had made his talent well known. Pliny had reported this latter fact without comment, and Caylus assumed that

> the schools or the various manners having become very numerous in Greece, people had given up this approach and they spoke only, as we do today, of particular masters and their students.[47]

Hippolyte Fortoul, a former Saint-Simonian and future minister of public education under Napoleon III, when he was a professor at the University of Toulouse, contributed in 1841 a long essay on painting to Pierre Leroux's *Encyclopédie nouvelle*. In this essay, the first real analysis of the notion of a "school" of painting, Fortoul referred to Caylus's comment. Reading Pliny, he said, Caylus had not thought it worthwhile to consider divisions into schools, because that way of speaking had been abandoned in Caylus's own time, when there was talk only of masters and students. Fortoul took strong objection to this. By isolating artists from their schools, he argued, the eighteenth century was perhaps seeking to "increase their [the artists'] importance," but in effect, this "took away all their meaning." His own era, Fortoul was happy to say, had

> taken possession again of the truth, now that it has come to see *each school as one man*, and to see the artists of each school as the different seasons or varied faculties of one life.[48]

In his criticism of Caylus, Fortoul allied himself very clearly with Winckelmann and his idea of there being organic links between a people and its

art. Like Winckelmann, Fortoul insisted upon the demarcation of traditions, schools, and styles; they were in all cases the expression of a "people" or a "race." This demarcation was essential, he thought, if we were to properly understand peoples and their traditions. At the same time, he stressed, we would deprive ourselves of the means to understand an artist if we isolated and removed that artist from his school, nation, or race. We should, he thought, consider each school "as one man," i.e., as an organic unity, a body, at once political and mystical; and we should see all of the parts of it (the artists) as the moments and skills "of one life." A product of the discourse on national characters, but nonetheless distinct from it, this idea had already begun to take shape in the places where these schools were exhibited.

It was only very slowly, and beginning with the late eighteenth century, that a way of exhibiting works according to "national schools" and by chronological order within each school was to become widespread within the galleries and then the museums of Europe. For example, in the very first Musée du Luxembourg, open to the public of Paris between 1750 and 1779, there was no concern for chronology or for the division into schools in the arrangement of the paintings and drawings in the royal collection. Works were hung with the aim of instructing art lovers as well as artists by offering them the opportunity to compare, one with another, the masterpieces of the masters, and to appreciate the talent that the latter displayed in each of the "parts" of painting as defined by Félibien and Roger de Piles: drawing, color, composition, and expression. A visitor noted that one of the rooms included thirteen paintings and four drawings offering

> to the curious a sampling of five different schools. Such an ingenious and pleasant contrast! ... How rare it is to find in such a small space so happy a mixture of the Lombard, Florentine, Venetian, Flemish, and French schools![49]

34

One exception was the Dresden gallery, where Italian works were gathered together in a single space, although paintings from other countries were displayed in a mixed fashion.[50] However, around 1780, a new principle began to make its appearance in Germany and Austria, and Nicolas de Pigage was one of the first to emphasize its importance. In Düsseldorf, there was a concern to separate and demarcate the Italian and Flemish schools, and the works of those schools were shown in separate rooms: the "Flemish Room" and the "Italian Room."[51] In Vienna, the connoisseur and dealer in engravings Christian von Mechel hung the paintings of the Royal and Imperial Gallery (the Belvedere) according to a "new arrangement" which aimed to "distribute the paintings by schools, and to bring together as much as possible the works of one master in the same room." Added to this principle was the idea of a historical "gradation" that succeeded in turning the gallery into "a depositary of the visible history of art."[52] But this was still controversial, as we can see from the conflicts that arose in 1792 and 1793 between the interior minister, Jean-Marie Rolland, and the scholar and dealer Jean-Baptiste-Pierre Le Brun, over the arrangement of the collections of the National Museum (the future Musée du Louvre). Rolland wanted to "create a real mixture of the works of the various schools" since, as he saw it, the Museum was not supposed to be simply a place of study; rather, it was "a flowerbed that should be adorned with a profusion of color," able to interest art lovers while, at the same time, providing amusement for the curious. The *ad hoc* Commission declared that it wanted to make the Museum "the material and physical encyclopedia of the fine arts," and it sided with the minister. In its opinion, an arrangement showing the childhood, full blossoming, and decline of art, separating art into schools, would have no doubt satisfied the scholars, but it was open to the justifiable charge of being useless. More seriously, such an arrangement would have prevented students from "comparing the masters, their manners, their tastes and, ultimately, their perfections as well as their defects, such as may become clear through a close and immediate examination."[53] Le Brun strongly opposed these arguments; they were, he felt, holdovers from

another age. For him, paintings should "be arranged by order of school, and they should show, by the way in which they are hung, the succeeding epochs of the childhood, progress, perfection, and finally the decadence of the arts."[54] After 1794, it was this point of view that was to triumph—the one that Le Brun shared with Mechel, and also with Lenoir—and the collections of the Louvre were to be arranged by schools and in chronological order; this was soon to be the case in all of the great museums of Europe.

The most obvious and damaging consequence of this development was that the public, henceforth potentially much greater in numbers because it now included every citizen of the "nation," was no longer invited to compare the respective qualities of the individual paintings, but rather to compare the respective qualities that were assumed to be peculiar to each of the national schools. In other words, the public was encouraged to see, in and by means of the space of the museum, a map of the "national characters" supposedly coming into focus on the very surface of the paintings. It was this sort of arrangement of works that delighted Fortoul as he claimed that his period was the first since Caylus to have rediscovered the right path by considering "*each school as one man.*" The second consequence of this turn was that, following Winckelmann, the scale of the "*ages of life*" that allowed for the classification of works according to a progressive schema (childhood, perfection, decline) was transferred from artists to peoples *via* national schools understood "*as one man.*"

At the same time, Fortoul introduced the term "race" into his criticism. This term had been widely used in anthropology since the beginning of the century; however, it was not yet current in the fine arts. Fortoul used "race" almost synonymously with "people," allowing, as did most of his contemporaries, for a certain degree of vagueness in the meaning of these words.

> If we understand them right, the schools are *only the various manners in which the different races understand and practice a same art. They constitute separate traditions in which the particular spirit of each country*

and of each people is expressed and perpetuated even as it transforms its own tradition and people. Therefore there is nothing truer than the names given in turn by the ancients and the moderns to the great sequences of their artists. When the Greeks distinguished between the Hellenic, Asiatic, and later Sicyonic schools, they meant, quite rightly, that they detected in each of these schools the characters of distinct peoples. The Italians, when they made countless distinctions between the schools of Florence, Rome, Venice, Bologna, and lesser known places too numerous to mention, intended us to understand that each of these cities, effectively populated by diverse races, and even after many years of shared servitude, expressed, though the brushwork of their citizens, the particular independence of its spirit.[55]

In Fortoul's terms, as he tied "race" to "country" as much as to a "people," this notion then defined a human group attached to a given geographical space, whether it be a town or a region. If each of the artistic schools stood out from the others, it was because its particular *manner* was the expression of something ethnogeographically unique, i.e., a particular "race" with a particular origin. As we shall see, this idea of an artistic school as the expression of a particular race will be found in Giovanni Morelli (*alias* Ivan Lermolieff) within his famous method of attributing works based on the identification of certain parts of the body—hands, nails, nose, ears—as they appear in painting.

In that very same year, 1841, Fortoul was to give the term "race" a somewhat altered meaning. This time, he understood it as subject to "blood" and memory much more than to a geographical place. In an essay published by the *Revue indépendante*, which Pierre Leroux had just founded along with George Sand and Louis Viardot, Fortoul was noticeably less interested in the association between a school and a race than he was in the relationship between a race and a particular "artistic principle," i.e., with a "style."[56] Everywhere in Germany, Fortoul wrote, one heard the claim that "every

race of men has its own artistic principle, and that the German race can lay claim to the ogival principle as the invention and heritage of its own genius." This claim, he added, with a solid understanding of history, had become widespread at precisely the moment when there emerged a desire to "awaken Teutonic nationality," against the apparent threat posed by the armies of Napoleon. Since this ogival or Gothic architecture seemed to stand in opposition to the neoclassical taste then prevalent in France, "it was judged to be better able to flatter the imagination of the Germans, and *to pit their memories against our taste*." Even if it was, admittedly, quite legitimate to rescue from scorn a form of architecture to which so many generations had given their lives and hopes, it was laughable, Fortoul argued, to claim that this Gothic form of architecture was the only true expression of Christianity, as some continued to say in England, France, and Germany. It made no sense, he fulminated, to restrict the links between Christianity and the arts to the short period from the thirteenth to the sixteenth centuries; for one thing, the semicircular arch had existed for more than a thousand years more than the ogival. Fortoul, therefore, ridiculed the hypothesis that the Gothic style was determined by religion. He took seriously, however, the idea that style was determined by blood, and therefore by race:

> Should we condemn everything the Germans have said about the ogival arch? No, it seems to me that there is an explanation of a higher and absolute order that proves the important role that their race had to play in the creation of the ogival system. Let us suppose that the great invasions had not brought the Teutonic element into the heart of the Western populations, and that the old races had continued their natural development under the influence of Christianity and the protection of Rome. Surely, do you not think, this would have prevented the appearance of the ogival arch? ... If, on the other hand, we mix with the blood of the Roman nations the blood of Goths, Vandals, Alans, Franks, Burgundians, Lombards, Saxons, and

Normans, providing thus for Germanic feeling a share in the direction of modern life, then the ogival arch becomes possible. Thus would I justify the name "Teutonic" that is sometimes applied to ogival architecture; and I would justify even also the name "Gothic," more restrained and less accurate, that popular instinct has up to now given it.[57]

In Germany, Sulpiz Boisserée had already emphasized the importance of the Germanic races (*Stämme*) in the creation of Gothic art, and Karl Schnaase had postulated, as early as 1834, that it was the race (*Stamm*) that "carried the flower of art."[58] But we see here for first time reference being made, in an explicit way, to the crucial role of the "great invasions" of the fifth century in the creation of the Gothic style. If Fortoul did not see any need to account for the mysterious gap of seven or eight centuries separating the Germanic invasions from the emergence of the Gothic style, it was because it was perfectly clear to him that the blood of the Goths, Vandals, Alans, Franks, Burgundians, Lombards, Saxons, and Normans, all fused together in the expression "Teutonic element," contained a peculiar and unique quality that nothing, not even its mixing with Roman blood, could adulterate. The formal characteristics of the Gothic style were thus no longer, like the categories of taste and manner, connected simply to so many national characters built upon social imitation; they now became immanent in the German blood, and transmitted by it from generation to generation. Seventy years later, this thesis was to resurface, perfectly intact, in Wilhelm Worringer's celebrated work on Gothic art. The term "race" in the meantime had become common in studies of the history of art, and, imprecise as it was, it was increasingly used in association with "style" (in France notably in the writings of Viollet-le-Duc, Hippolyte Taine, and Louis Courajod). This was to be the case until, in the years 1913–1915, Heinrich Wölfflin and his disciple, Gerstenberg, forged the expression *Rassenstil*, "racial style." This development should not surprise us as, since the beginning of the nineteenth century, the notion of race had

slowly become established as one of the most potent means to understand human history.

<div align="center">RACES—PEOPLES—NATIONS: INTERFUSION AND CONFUSION</div>

After the midpoint of the eighteenth century, the term "race" was to take on a wide range of meanings. Indeed, it was to change meaning constantly from one scholar to another, often according to changing circumstances and often within the writings of a single author. As a signifier, therefore, it was extremely porous, and it was invested with qualities that were not only biological but also political, religious, social, linguistic, and, more generally, cultural. The term "race" was interwoven with the terms "people," "tribe," or "horde" (the Germanic *Stamm*), then later "ethnic group," and also "nation," insofar as the latter had been for a long time defined by "bloodline" (still often today the criterion guaranteeing access to nationality). At the beginning of the nineteenth century, the nationalist Friedrich Ludwig Jahn wrote: "*The nation* results from the ties binding the various families,"[59] and in France during the 1860s, Littré was to define "race" as "the family considered in its temporal duration." The same reference to family ensured, in both cases, that it was blood that created the tie, horizontally and vertically, synchronically and diachronically.

Despite these semantic nuances, central to all uses of the term was the idea that a given human group had a common origin, and furthermore, that it was blood that ensured the hereditary transmission of certain physical characteristics. Kant, in his own attempt to define "race," had made a distinction between traits that were "inherited *unfailingly*"[60] and those that were not. Over the course of the last third of the nineteenth century, the idea of the hereditary transmission of psychological characteristics would be added to that of physical transmission. According to Théodule Ribot, drawing explicitly upon the arguments of several great European scholars,[61] "psychological heredity" was henceforth to be thought of as the necessary consequence of "physiological heredity."[62] In this way, relying not

just on physical characteristics but also on psychological characteristics, now defined as hereditary in nature, the differentiation of human groups according to racial categories evolved rapidly toward a "psychology of the races."[63] With the decline of the colonial empires, and by way of a slight shifting in terminology, this, in its turn, became an "ethno-psychology" that was to reformulate in terms of "ethnic groups" those psychological characteristics that had formerly been assigned to the "races."[64] However, by substituting the term "ethnic group" for "race," and then also for "people," our modern era only added to the confusion inasmuch as the diversity of cultures was to be seen for a long time as the direct consequence of the diversity of races. The uncertainty surrounding relations of causality between physical differences and differences of culture were deep and long-lasting. In 1971, the United Nations International Year for Action to Combat Racism and Racial Prejudice, Claude Lévi-Strauss was invited by UNESCO to give a lecture on the theme of "Race and Culture." This was to be a follow-up to his famous pamphlet of 1952 entitled *Race and History*. Since the beginning of the nineteenth century, Lévi-Strauss declared, people had asked themselves if race influenced culture and, if so, what the nature of that influence really was. He continued:

> we now realize that the reverse situation exists: the cultural forms adopted in various places by human beings ... determine to a very great extent the rhythm of their biological evolution and its direction.[65]

Such was also the very question that Darwin had asked when he wondered whether certain tastes might not be transmitted by heredity, and thus "each race would possess its own innate ideal standard of beauty."[66]

It is striking that, at least until the twentieth century, almost all of the scholarly writings on race had the propensity to criticize the confusion and lack of clarity in all prior discussions of the subject. This tendency began as early as the very first appearances of the term "race" in the burgeoning

science of anthropology. In 1766, the German traveler Merzahn von Kling-stöd criticized Buffon for an error in the latter's *Histoire naturelle* (1749) where Buffon had considered "as a single nation the Lapps, the Samoyeds and all of the Tartar peoples of the North." Von Klingstöd argued that one had only to look at "the diversity of features, customs, and even languages of these peoples, to see that they are of different races."[67] Buffon sidestepped the confusion between race and nation, replying to this criticism by saying only that he had not taken these peoples as one nation, since he had given them separate names and described them separately. He was, he said, fully aware of the differences of language and customs; however, these peoples had "so many similarities between them" that he considered them as being "of the same nature or of the same *race*." He wrote, in conclusion, that if indeed he himself had taken "the word 'race' in the widest possible sense," Von Klingstöd was taking it "on the contrary, in the narrowest sense," and so the latter's criticism missed its mark.[68] Buffon was certainly not wrong in this; however, Von Klingstöd, by taking the words "race," "people," and "nation" as synonyms, was only following Buffon's own use of the terms. Convinced by the observations of travelers that there existed "as many varieties in the Black race as in the White," Buffon thought, for example, that it was "necessary to divide the Blacks into distinct races," and, prin-cipally, into "those of Negroes and Kaffirs," and these, in turn, were to be seen as composed of "distinct peoples" with numerous "varieties." If the terms "race," "variety," "nation" were practically synonymous for Buffon, it was because he saw the diversity among human groups as the result of climate, and he paid no attention to relations of descent. In this respect, he differed greatly from the anthropology of the end of the eighteenth and the entire nineteenth centuries.[69] When Gobineau, a century after Buffon, was to use the terms "people," "race," and "nation" interchangeably, it was, on the contrary, relations of descent that lay at the heart of his arguments about the inequality of the races.[70]

There were many other ways in which these terms were used. Indeed, the confusion only increased. In 1820, Guizot brought up the age-old struggle

between the Gauls and the Franks, referring to them equally as "two primitive races" or "two enemy nations."[71] At the time of the July Monarchy, the liberal thinker Simonde de Sismondi pointed out that when the terms "people" and "nation" were not used synonymously, the first was used for small societies with independent governments, and the second for "families of peoples of the same race, or with the same language."[72] The range of meanings was thus extremely wide. During the same historical period, the sixth edition (1835) of the *Dictionnaire de l'Académie française* included for the first time a physical dimension. According to its entry, "race" referred, following the usage common since the seventeenth century, not only to the "lineage, [of] all of those belonging to the same family (The kings of the first, second, and third races)," but also, by extension, to "a multitude of men who have their origins in the same land, and who resemble each other by facial features, and by an external conformity." In Germany, as has been rightly noted, the failed revolution of 1848 brought to light "ethnic" conflicts through recourse to the "principle of nationalities." Claims to Slavic, Magyar, Latin, and Germanic ancestry were complicated, on the one hand, by the progress of Aryanism, and, on the other, by the assimilation of the concept of nationality to that of race.[73] But Johann Friedrich Blumenbach, whose book *De generis humani varietate nativa* (1798) was one of the foundational works of racial anthropology, had already used the terms *nation* and *national* with the physical meaning that we give today to *race* and *racial* (without, however, explicitly including the notion of heredity) when he distinguished between "national varieties" (*Nationalverschiedenheiten*) in the faces and skulls of various "peoples."[74] In the majority of European languages, we find the same seepage of meaning between the terms that philosophers, anthropologists, historians, and naturalists used as they sought to define the forms of collectivity or human grouping that existed beyond political or historical contingencies.

In 1859, the zoologist Isidore Geoffroy Saint-Hilaire attempted to impose some sort of order on all this. He proposed the idea of distinguishing between the everyday use of the term "race" and its scientific meaning.

In ordinary language, he recalled, race or lineage referred to the entirety of the individuals having the same origin; in other words, it was "the family in all its extension." In conformity with the designation of the "three royal races" of France, the notion here depended only upon the lineage of individuals, with no reference made to resemblances existing between descendants and their ancestors. It was in the move from ordinary language to scientific language that the meaning became more limited. "Community of origin and hereditary transmission of the same organic conditions" were to become the determining characteristics of race. Henceforth, in order to say that two human beings were of the same race, it was no longer sufficient to show that they shared the same origin, it was also necessary that they resemble each another, i.e., "that they be of the same *type* and of the same *blood*."[75]

GIOVANNI MORELLI: RACIAL MARKERS

In the fine arts, the ways in which the concept of race was understood were no less clear and consistent than they were in the rest of the human sciences. They merely mirrored the same confusion. One very revealing example of this is Giovanni Morelli who, in the 1870s and under the pseudonym Ivan Lermolieff, developed his famous, supposedly scientific, method for attributing works of art. Since Edgar Wind's 1963 essay "The Critique of Connoisseurship," many scholars have cited and commented upon those parts of Morelli's arguments where he compared the way in which a speaker slips into his way of speaking certain habits and tics "which escape him without his being aware of it" to the way in which an artist

> reproduces certain of his own physical defects in his work. ... Anyone, therefore, intending to study a painter more closely and to become better acquainted with him, must take into consideration even these material trifles (a student of calligraphy would call them flourishes), and know how to discover them.[76]

In 1979, Carlo Ginzburg, synthesizing a number of previous studies,[77] developed the concept of the "evidential paradigm"[78] to describe a state of affairs in the human sciences where any investigation is based upon processes leading up to the identification of an individual element within a system. Constrained by this paradigm, scholarly attention has tended to be limited to those parts of Morelli's writings pertaining to his method for the authentication of a single painting through a reading of features allowing the connoisseur to identify the particular artist responsible for the work. What is forgotten here is that, in practice, the connoisseur always made an implicit, and often quite explicit, preliminary attribution of a work to a wider ensemble of works, whether this ensemble be thought of as a regional, national, or racial school of art. Carol Gibson-Wood is almost alone in having seen that, despite Morelli's clear interest in the attribution of works to individuals, his understanding of the development of the art of the Renaissance in Italy was based not on individuals, i.e., on the great masters, but on regional schools.[79] Just like all connoisseurs before him, Morelli established the community of origin of works—i.e., their belonging to a particular school—by relying upon a few distinct features showing a similarity between them. But, for Morelli, belonging to a particular school also meant belonging to a particular "race," and *vice versa*. Hippolyte Fortoul, we should recall, had argued against Caylus that a school should be seen "as one man." Morelli then, in his turn, was to say that the true nature of an artistic school could be understood only if one saw it, and studied it, as "a living being" whose development, from the very first seeds, grew through stages until its eventual extinction. A given school could, no doubt, learn from and appropriate the techniques of another; however, he wrote: "the conception and the feeling in a work of art are inherent and vital qualities belonging, like speech, to each nationality and race."[80] For this reason, Morelli believed, each school had its own unique and inviolable character.

Taking, as a further example, the "Venetian School," Morelli made it clear that he understood by that name not only the school of the city of Venice, but also

all the schools of painting of all of the peoples (*Völkerschaften*) in those portions of Upper Italy which once belonged to the Republic, and which, while showing more or less the influence of the City of Waters, did not forfeit their respective local (*heimisch*) characteristics.

Extrapolating from the Venetian example to the Italian schools as a whole, Morelli came to define what was, for him, the "physiognomy" of a school by the few parameters that made it a living organism, like a plant:

> This provincial character, this peculiar physiognomy, the offspring of *difference of race*, stronger in one province and weaker in another, is not a thing to be studied and learned in picture galleries, chiefly brought together on the most eclectic principles. No, it must be sought on the very soil whence it grew, and with which it stands in the closest organic connexion; for nowhere in the world has painting been so spontaneously the language of a people as in Italy.[81]

By emphasizing, through his own use of italics, that the physiognomy of each school of painting was determined by *difference of race*, Giovanni Morelli was showing that he saw race as fulfilling an essential function in the development of the schools. Because he assigned to a given race a very limited geographical space (as small as the area covered by an Italian province), he was able to attribute to race a decisive role in the production of works of art, marking, as it did, such works with its own particular "character." Thus the limits of a school could coincide with those of a race, and the latter could be contained by the limits of a region or province. As a fervent defender of the idea of the indigenous growth of the arts, Morelli would surely have sided with Winckelmann against Caylus and the latter's passion for the "mixture of national tastes." Instead of trying, as Caylus did, to detect in objects signs of the relations and exchanges between

peoples, Morelli was concerned, above all, to attribute works to "a living organism." He sought, of course, to assign works to individual artists; but first and foremost, he attributed them to "peoples," "nations," and "races." He bemoaned unceasingly the fact that art was generally seen as an accidental phenomenon "standing in no relation to the distinctive character of the people among whom it flourishes," while, as he saw it, this "living growth" developed from its native soil alone, and "speaking everywhere the native language, the local dialect."[82] He railed against historians of art who were always looking for the influences of the Flemish, Florentine, or other painters on such and such a school, and he claimed to have discovered the "proof" that these schools had "ever preserved their essentially local character."[83] Thus he was convinced that the Venetian school "had the good fortune to be undisturbed by foreign influences"—so much so that one could describe its evolution "from the time of the Byzantines, so-called, down to Tiepolo and Pietro Longhi."[84]

The most solid proof of such continuities, Morelli claimed, was to be found in what he called "physiognomy." He used this term to refer both to the general "physiognomy" of a given school and to the figures painted by the artists of that same school. These two physiognomies were soon to merge, in his writing, with the physiognomy of race. Indeed, it was to this racial physiognomy that both of the other physiognomies would be said to owe their "local character," the organic link being so narrow and so strong that they became pure reflections one of one another. Finally, a few works from the Quattrocento, shown at the Berlin Gallery, gave Morelli the opportunity to elucidate still more clearly the relations that he saw between art, race, and nation. Comparing, on one side, Ghirlandaio, Botticelli, and Filippino Lippi, and, on the other, Cosmè Tura and Lorenzo Costa, he described them as

> representative men of two of the most artistically-gifted tribes (*Volkstämme*) of the Peninsula, the Florentines and the Ferrarese. These populations (*Völkerschaften*), though separated only by

Po and the Appenines, are yet of widely different physiogno-
mies. But now confront these Florentines and Ferrarese with a
Dürer, a Cranach, a Burkmayr, or say, with a Van der Weyden,
a Memling, a Quentin Matsys; the local characters of these Ital-
ians would at once retire into the background, while the com-
mon national character of their country would be overpower-
ingly conspicuous in their features. Is not this a confirmation
of the maxim that the outer visible form is conditioned by the
spirit that animates it, and this again partly by the composition
of the blood, and partly by the external nature, in the midst of
which a man grows up and lives.[85]

Analyzing these rather astonishing remarks, Carol Gibson-Wood has
wondered whether Morelli meant that artists depicted in their works the
physical types of their fellow citizens, or whether he was suggesting that
the styles were themselves physiognomic.[86] But there is, in fact, no real
need to choose between these two interpretations. For Morelli, painters
could not help but give to their figures the traits typical of the "race" or the
"tribe" to which they belonged, and that, in and of itself, defined the style
and the "physiognomy" of their school. It was on this supreme circularity
of reasoning that connoisseur Morelli's "science" was built, and in this he
displayed neither more nor less rigor than most of his contemporaries in
the use of the terms *race, people, nation, tribe,* or *clan.* Indeed, since the end
of the eighteenth century, this same circularity of reasoning had been at
the center of those relations that historians of art and anthropologists were
trying to establish between a people's morphology and the artistic forms
they produced.

Self-Mimesis and Self-Portrait Gods

Winckelmann secured his own fame and the fame of his *Reflections on the Imitation of Greek Works in Painting and Sculpture* with this striking opening statement: "The only way for us to become great or, if this be possible, inimitable, is to imitate the ancients."[1] Much ink has been spilled over this paradoxical injunction to imitate in order to be inimitable; but what are we to make of Winckelmann's "for us" (*für uns*)? To whom did these two words refer? Was Winckelmann's work addressed to the Germans, or was it addressed much more widely to the Moderns who were still carrying on their long-standing quarrel with the Ancients? But surely there can be no doubt about the answer: dedicating it, as he did, to Augustus III, King of Poland and Elector of Saxony, Winckelmann was addressing the *Reflections*, first and foremost, to the Germans. It was among the Germans that "good taste," born under the skies of ancient Greece, was to be freshly distributed: this good taste that painting and sculpture had long since forgotten, and that had been spoiled even more in the ornate decoration that Winckelmann called, with an irony tinged with bitterness, "extravagant scrolls and precious shell-work." In the *Reflections*, Winckelmann was thus waging war against the "baroque taste" of the moderns. He saw it as a false artistic freedom that came from France and that had, alas, he thought, reached the

German elites. However, despite the fact that the *Reflections* was aimed at French bad taste,[2] the explicitly normative discourse it contained actually derived from the French style of art theory, i.e., it was prescriptive. Now, this French style of prescriptive art theory had, since the seventeenth century, shown itself to be strongly imbued with an ambition to influence the development of the fine arts. In other words, it aimed to educate and mold the tastes of artists and art lovers. Yet Winckelmann imitated the French only as a means to better deny their legacy. Coming, as it did, from one who claimed that each people depicted itself in its own art, there was no small contradiction in Winckelmann's injunction to the Germans to turn away from French art in order to "imitate the ancients" and thus to depict themselves as Greeks, not as Frenchmen—classical rather than baroque; nonetheless, a half-century later, Winckelmann had clearly convinced the Germans. The great historian Niebuhr was to assert: "Greece is the Germany of Antiquity," a phrase that, under Bismarck, would turn into the triumphal "Germany is the Greece of Modernity."[3] The art historian Gustav Friedrich Waagen also acknowledged: "the natural feeling of the Greek and of the Germanic races in the department of art—these two races being the chief representatives of the cultivation of the ancient and the modern world."[4]

Fundamentally, however, Winckelmann was far less concerned to attack the art of his contemporaries (although he certainly did consider it decadent) than he was to cast aspersions on their flesh-and-blood bodies in which he detected, with much melancholy, an advanced degeneracy. He declared that "the most beautiful body of one of us" would seem feeble compared with any of those ancient Greeks "trained from infancy in wrestling and swimming." He gave many reasons why the Greek sculptures were of such great beauty: because the Greeks devoted themselves from an early age to the most rigorous physical exercise; because they were forbidden to grow fat; because they shunned any deformation of the body, going so far as, like Alcibiades, refusing to learn to play the flute; because their clothes did not constrict them in the way of modern dress; because they knew many

more ways to produce beautiful children than were imagined in Quillet's *Callipaedia*;[5] because they had instituted beauty contests; because they had no experience of smallpox or of any of the venereal diseases causing rickets; and, finally, because they had no knowledge of the bourgeois "savoir-vivre" that was an impediment to moral freedom. Thus, Winckelmann was able to say: "their physical beauty excelled ours by far."[6] Just as, with an evident feeling of shame, he compared the bodies of the ancient Greeks to those of the modern Germans, he compared the skin depicted by the masterworks of antiquity, "gently drawn over flesh which fills it firmly," to the frightful "small wrinkles distinct from the flesh beneath them" displayed by modern sculptures. In this way, he fully identified what he called "the beautiful bodily forms of the Greeks" with the creation of the bodies in marble by the "masters." In his opinion, artistic production and biological reproduction were inseparable. It is clear, however, that for Winckelmann the natural and living body was both the origin and the end of art, its first model and sole destination, and that the regeneration of man was at least as much his concern as the regeneration of art—the latter was, essentially, the instrument of the former. Yet which path was he to follow in this endeavor? An abyss now separated the Greeks' nature from that of Winckelmann's contemporaries; and, as he put it, "our nature will not easily bring forth such a perfect body as that of Antinous Admirandus." Nature herself having been profoundly degraded since antiquity, and the beautiful natural bodies of the ancients being no longer accessible, what mattered now, for Winckelmann, was not to copy simple nature, as did the Dutch, but rather to copy the beautiful statues of the Greeks who, by consolidating scattered forms of beauty, pointed the way to "general beauty and ideal images."[7]

But hardly had Winckelmann established this classic distinction between natural and ideal beauty (a distinction that he borrowed most obviously from Bellori and Charles Perrault) than he set about *naturalizing the ideal*. Having noticed that the same profile found in the ideal representations of gods and goddesses was also to be found on the coins embellished with

the heads of famous women, "intentionally modeled after idealized concepts," he came to assume that "this profile was as peculiar to the ancient Greeks as flat noses are to the Kalmucks, and small eyes to the Chinese."[8] Without realizing it, Winckelmann was thus thoroughly undermining the theory of ideal beauty based upon an exclusively intellectual work of selection and consolidation. The ideal beauty of the Greeks suddenly became natural—as natural as was the extreme ugliness of the Kalmucks.

THE INVENTION OF THE GREEK PROFILE

So it was, therefore, that Winckelmann invented the Greek profile; and very soon, it was to become one of the most obsessional themes in his inquiry into the relative merits of the peoples of antiquity and their arts. Certainly, before Winckelmann, Aristotle had mentioned the "most beautiful straightness" of the nose (*Politics* V, 9, 23), but no one had thought to make this nose the almost exclusive property of the Greek people.[9] Winckelmann, in contrast, when he arrived in Rome in November 1755 (a few months after the publication of the *Reflections*), began to look for visible confirmation of the assumptions he had been making back in Dresden. Just as he saw authentic Greek works in late-Roman copies, certain young Italians appeared to him to be directly descended from the people of Pericles and Phidias. At Tivoli, he declared, one could find the most "beautiful blood" in Italy, since it was "not uncommon to see a Greek profile."[10] With rather more restraint, Montesquieu had noted, thirty years earlier,

> since the time of the Greeks and the Romans, nations have moved about so much, everything has been so disturbed that all of the ancient physiognomies of the peoples have been lost, and new ones have been formed, and there is no longer to be found in the world a Greek or Roman face. It is extraordinary how much we are fooled by our own imagination.[11]

Accordingly, Montesquieu advised that sculptors should "neither take the Greek statues as their models, nor judge Greek statues by comparison with our modern figures."[12] Far removed from this moderate view of the movements of history and their consequences, Winckelmann was convinced that in Italy, equally near to the Greek sky[13] and faithful inheritor of ancient Greece, nature kept close to "the most beautiful of forms," i.e., the straight line from the forehead to the nose. Furthermore, he added, he was able to experience for himself "the pleasure of confirming this judgment every day with my young Romans" who numbered, he claimed, among the most beautiful of men.[14] While, in the *Reflections*, he had not entirely ruled out the hypothesis of a purely ideal Greek profile, this Roman experience now led Winckelmann to a more forceful conclusion: if this profile could characterize equally the flesh of the moderns and the art of the ancients, if it were not only exemplified by a few ancient marbles, but could define and model the living reality of his Roman contemporaries, then this profile could not be the sole fruit of the work of the mind and the chisel.

In the *History of the Art of Antiquity*, published in 1764, Winckelmann abandoned all of his former hesitations about the relationship between art and nature. Suddenly, he rejected the very basis of the *Reflections*, namely the injunction to imitate the ancients and not nature in order to find the path of true beauty, as he came to examine the beauty of the various parts of the body—all of them determined by the beauty of the face. Here, therefore, in utter contrast to his previous position, nature became once again "the best of masters." Henceforth, what Winckelmann meant by "Greek" was no longer a form fashioned by art but a form produced by nature herself— the form of beings of flesh and blood. He wrote thus:

> In the appearance of the face, the so-called Greek profile is the chief characteristic of high beauty. This profile consists of a nearly straight or gently concave line, which describes the forehead and nose on youthful heads, especially female ones.

Nature forms this profile less in a cold climate than in a mild one, but wherever it is found, the form of the face can be beautiful.

Therefore, he continued, when we find this form in Greek works of art, it could not have come from the imitation of an "older style," and this was sufficiently proven by the "strongly concave nose of Egyptian figures."[15] After all, Winckelmann stressed, "The Egyptians had no knowledge of the soft profile of Greek heads. Instead, the bridge of the nose is the same as in vulgar nature."[16] If this nose belonged "exclusively" to the ancient Greeks, then it was surely nature—"the best of teachers"—that had guided them in their art. Such was the lesson, moreover, that was to be drawn in France and in Germany from Winckelmann's work.[17]

The philosopher Jean-Baptiste-René Robinet, co-translator of the first French version of Winckelmann's *History*, was to claim, with absolutely no reservations, that the Greek artists had established "the ideas of beauty on the basis of the models of their nation."[18] He thus corroborated Winckelmann's great principle (to be taken up later by Morelli, and to which we shall refer below) according to which "in every country artists have given their figures the facial features peculiar to their nation."[19] Scarcely fifteen years later, Herder, in his *Sculpture*, was actually reluctant to approach a subject that he felt was commonplace: "The *Greek profile* is so famed I fear to speak of it." If it is true that he was often critical of some of Winckelmann's ideas, Herder nonetheless agreed with Winckelmann that such a profile had to be natural rather than a pure product of art: "If a source of beauty is not to be found in *living nature*, it is not to be found in dead statues." Perhaps, he added, "there is also only one part of the earth [Greece] that can allow large numbers of people to acquire this profile." If such were the case, he wrote, "I would trace its cause more to the character of the *people* than to the effect of *land* or the *climate*." Yet, as he sought to reconcile the ideality of such a profile with its biologically hereditary nature, Herder maintained a perfect ambiguity: "However fine the features presented by his people,

the artist could not proceed without ennobling his subject."[20] All the same, therefore, Herder could not conceive of a form of imitation in the visual arts that was entirely cut off from its attachment to nature.

In 1805, and very much in the spirit of Winckelmann, the Institut de France posed this question: *What were the causes of the perfection of ancient sculpture, and what were the means of attaining that perfection?* The historian Émeric-David submitted a response, saying that, among the causes, we should include the celebrated straight nose of the statues of Minerva or Venus, and he specified that this nose was in accordance with "a principle given by nature and that the Greeks held dear."[21] Moreover, in 1808, the painter Antoine L. Castellan went further by saying that one could find in Morea those beautiful heads of women "whose profile is so pure." Imbued with his readings of Winckelmann, he called on painters and sculptors to seek

> today the Greek form in all of its primitive beauty. It is still the land of Mars and Venus, of all the gods and heroes of myth that the ancient artists showed us in their statues as typical of true beauty. *You will see that this ideal beauty exists only in Nature, more perfect than anything that the imagination can create or even conceive.*[22]

We find the same virulent protest against the supposed preeminence of the ideal in ancient sculpture in the painter Nicolas Ponce's address to the Institute in 1806. He explained differences in style and perfection between ancient and modern statues simply by differences between "the perfection of the forms of the [ancient] Greeks and the forms of modern peoples." The ancient Greeks, Ponce argued, attached such importance to beauty that they tried "to reproduce it in all its purity, above all by refusing to mix their blood with the blood of other peoples." If one added to that the mildness of their climate, customs, and institutions, it was obvious that all of these things made nature and the imitation of nature much more perfect in their country than in any other land in the world: "This is why

the perfection of the Greek statues seems to suggest that they are the representations of a race of men that is superior to our own." Ponce continued: "The primitive nature of the Greeks held the same superiority over that of the modern nations as the ancient statues hold over the statues of the modern nations." Thus, to attribute this superiority to an "ideal system," as one often did, was just as absurd as it might be, for example, for a people "disgraced by nature" such as the Lapps, in comparing their hypothetical artistic works with those of Frenchmen, to attribute the superiority of the French to an ideal system instead of recognizing the latter's superiority in nature. This was explanation enough for the form of the Greek nose: "They were straight because the Greeks generally all had straight noses, just as Hottentots have upward-tilting noses. For the same reason, the profiles of Greek figures were usually straight."[23]

Without explicitly developing the hypothesis of a similar hierarchy of beauty, the eminent archaeologist Karl Otfried Müller nonetheless confirmed, in 1830, that if it did perhaps owe something to "certain sculptural requirements," the Greek profile of the heroes and gods, "far from having been created arbitrarily, or formed from the union of diverse parts, was certainly borrowed from nature."[24]

Standing quite apart from this general wave of enthusiasm, Lavater railed, in the French edition of his *Physiognomische Fragmente*, against "the mania for Greek profiles," and against those marble faces that "were in no way natural." He continued: "What monotony! What mind-numbing stiffness! ... I must confess my shame at the very aspect of ... heads as uniform as these are so tiresome, and they try my patience; a whole society, a whole nation so composed would be unbearable to me." Furthermore, he went on, this line existed nowhere in nature, the sworn and relentless enemy of all perpendiculars and plumb lines: "A straight profile, whether Greek or otherwise, is nothing but a chimaera, and can be found nowhere in reality."[25] In a remarkable fashion, Lavater was thus condemning the straight profile for precisely the same reason that Herder praised it; namely, that the imitation of a form without natural foundation seemed to him

to be absurd. For his part, the artist and anatomist Petrus Camper, who declared he had discovered Winckelmann's *Reflections* in 1769, undertook to show that the "ideal beauty" attributed by Winckelmann to the works of antiquity was "in reality based upon the laws of optics." Describing Winckelmann's famous "facial line ... drawn the length of the brow to the upper lip," which was to play a major role in the physical anthropology of the following century,[26] Camper wrote that through the variation of its inclination, it "indicated this difference in national physiognomy; and also pointed out the degree of similarity between a Negroe [*sic*] and the ape."[27] Taking no account of the protuberance of the nose, and considering only those of the jaw and the forehead, Camper's line was thus quite different to Winckelmann's cherished "Greek profile"; although the two were to be constantly lumped together, a common confusion that we find, for example, in Hegel. There were two reasons for this confusion. First of all, both Camper and Winckelmann set up the classical profile as an unsurpassable model; secondly, Camper, in the gradations of his *facial line*, attributed an angle of one hundred degrees to the heads of the ancient statues, thus putting the forehead and the nose on the same line (figure 2.1).

Camper wrote that the facial line extended from seventy to one hundred degrees "from the Negro to the sublime beauty of the Grecian antique," adding: "make it under 70, and you describe an ourang or an ape: lessen it still more, and you have the head of a dog. Increase the minimum and you form a fowl, a snipe, for example, the facial line of which is nearly parallel with the horizon."[28] As for the question "What is meant by a fine countenance?" Camper had no doubt that it was:

> That in which the facial line ... makes an angle of 100 degrees with the horizon. The ancient Greeks have consequently chosen this angle. ... It is certain that such a form is never to be met with among moderns; and I doubt whether the ancient Greeks themselves had living models of the form. ... This antique beauty therefore is not in nature; but to use the term of

2.1 Petrus Camper, 1791: Facial line of 100 (the figure at top left).

Winckelmann, it is an ideal beauty. Thus when the Greeks formed medallions of the Roman emperors, although they were obliged to observe a resemblance, yet they added something of the ideal beauty.[29]

Camper's interpretation of Winckelmann certainly went against what the illustrious archaeologist had actually written. But it is true also that Camper's remarks were themselves often taken beyond their literal meaning. Diderot, after he met Camper at The Hague in 1773, when Camper had already completed a first version of his treatise, described him as a man knowing so well the "national physiognomies"[30] that he could unerringly identify a Greek or a Kalmuck. But in referring to Camper's famous "New Method of Sketching Heads, National Features, and Portraits of Individuals," Diderot went so far as to claim that Camper provided in it "principles by which one might, without interruption, go from the figures of the gods to figure of any nation one might desire; from the national figures of man, of the Negro, to that that of the monkey; and from this latter all the way to the head of a bird, a heron, and a crane."[31] This interpretation was certainly marked by the evolutionism that has for a long time been seen as part of Diderot's thought; but evolution here goes in a direction that was not that of Camper since it *descended*, progressively and "without interruption," from the gods to national figures, and then from the latter to the Negro, the monkey, and the bird.

In the following century, when anthropologists mentioned Camper's work, they would almost always give it an evolutionist interpretation. It is true that the plates included in his "Treatise on the Natural Difference of Features in Persons of Different Countries and Periods of Life; and on Beauty in Ancient Sculpture" did lend themselves very much to that type of interpretation, producing, for example, for Lavater, those "lines of animality" progressing from the profile of the frog to that of Apollo—a progression that was to be reversed in Grandville's famous caricature of 1844 (figure 2.2). The very first plate in Camper's essay (figure 2.3) showed an

(Par J.-J. GRANDVILLE.)

2.2 Grandville, 1844: From Apollo to the frog.

2.3 Petrus Camper, 1791: "Two monkey heads, then a Negro, and finally a Kalmuck."

alignment of four profiles: "Two monkey heads, then a Negro, and finally a Kalmuck." This is Camper's comment on the plate:

> The striking resemblance between the race of Monkies [*sic*] and of Blacks, particularly upon a superficial view, has induced some philosophers to conjecture that the race of blacks originated from the commerce of the whites with ourangs and pongos; or that these monsters, by gradual improvements, finally became men. This is not the place to attempt a full confutation of so extravagant a notion.[32]

Still, despite Camper's insistence that if one really wanted to associate monkeys with other individuals, then it was "less with men that they should be classified, and more with dogs," it is a well-known fact that since the eighteenth century the equating of black people with monkeys has constantly been one of the most common visually based pseudo-arguments of racist theories based upon an elementary evolutionism. Winckelmann, it is true, did grant that black people had their own beauty; but, contrary to Camper, he stressed their proximity to monkeys: "The thick, pouting mouth that the Moors have in common with the apes in their land is a superfluous growth and a swelling caused by the heat of their climate."[33] Inspired by Buffon, the climate-based causality that Winckelmann drew upon here was to lose its credibility for the naturalists and anthropologists of the nineteenth century. As far as the "Negro race" was concerned, they preferred to call attention, along with the great anatomist Cuvier, to how much the "projection of the lower parts of the face, and the thick lips, evidently approximate it to the monkey."[34] It was, however, the very same Cuvier who, in his famous "Advisory note on research into the anatomical differences of the various human races," complained that the greatest painters had poorly captured "the character of the Negro" to the point of making him "a White covered in soot." Even when drawn from life, Cuvier noted, their portraits were less faithful to their living models than

to the rules learned in the schools of Europe.[35] Prejudice is often powerful enough to make us see what we want to see, and in France it was only in 1898 that, with the publication of an "Essay on the lips from the point of view of Anthropology," anthropology expressly acknowledged that it was the "white man" whose lips are thin, and who is "in this respect, closer to the monkey than is the Negro."[36] The racist hallucination equating black people with monkeys, shared by countless anatomists and anthropologists, lasting more than a hundred years and leading them to falsely attribute fleshy lips to monkeys, was echoed in reverse by the hallucinations of the nineteenth-century travelers who, having once set foot upon Greek soil, saw, in every woman they came across, "the Greek profile" of the ancient sculptures.

Hegel, in an extensive section (a dozen pages) devoted to *The Greek Profile* in his *Aesthetics*, claimed to be following Winckelmann in considering "ideal and beautiful sculpture." Yet, as he posed the question of whether the Greek profile was "a physical necessity or merely a national or artistic accident," he assimilated it immediately and completely with the facial line by which "the well-known Dutch physiologist" Camper had attempted to differentiate animal species and human varieties. Hegel proclaimed that it was ultimately by this "line of beauty," connecting, in a straight line, forehead to nose, that man was to be distinguished from animals. It was, therefore, thanks to this "gentle and unbroken connection between the forehead and the nose" that the sense of smell no longer served to scent nourishment; it became "a theoretical smelling ... a keen nose for the spiritual."[37] With Lavater, Hegel, and—doubtless to some extent—both with and in spite of Camper, the Greek profile was to become one of the essential tropes of anthropology, even more so than the separation of man and beast. It was to set up a separation between nature at its most brutish and the highest degree of human culture—the orang-utan and the "Negro" on one side and, on the other, the sculpture of Apollo, the brilliant symbol of those white Europeans that Johann Friedrich Blumenbach, drawing upon an obscure myth of origin, named the "Caucasian race."[38]

Today, there is a general awareness of the important role that aesthetic criteria played, from the seventeenth century onward, in European judgments about distant peoples. Consider, for example, the short text, published anonymously in 1684 in the *Journal des Sçavans*, that set out in its first section a "new division of the earth," based not so much on geography as on a distribution according to the "various species or races of men who inhabit it." Its author, the famous traveler-philosopher François Bernier,[39] a disciple of Gassendi, devoted the second part of his text exclusively to the "beauty of women" he had met throughout the world. He supposed Europeans to be so well known to his readers that he did not bother to say anything about them. Assessing the beauty of the women of other continents, he compared them sometimes to the beautiful "Venus of the Farnese Palace in Rome," and sometimes to the beautiful women of Georgia and Circassia, those regions of the Caucasus where, "as the inhabitants of the Levant, and all travelers, will attest, we find the most beautiful women in the world." If François Bernier was articulating here "in a completely new way the construction of race and sex,"[40] he was setting up an aesthetic norm that was to govern racial hierarchies for the next three centuries. His criterion of beauty was, in effect, twofold: on the one hand, a model from classical art,[41] and on the other the living models of a "race" that one was soon to call "Caucasian," much vaunted by the Venetian and Genoese slave merchants from the thirteenth to the fifteenth century, who bought and sold, by the thousands in the ports of the Black Sea, Georgians, Armenians, Circassians, Mingrelians, and other white peoples of the Caucasian region.[42] Hence, we have the two types that classical aesthetics always presented as mirror images of one another: the fiction of art corresponding to the living beauty of an imaginary "Caucasian" race—so much the more beautiful in that it was reputed to be the ever-living, pure and white source of the most beautiful peoples of Europe.

In the following century, around 1775, Johann Friedrich Blumenbach, constructing what was to be one of the most enduring racial taxonomies,[43] distinguished between five main "national varieties" based upon

63

skin color. A solid defender, like Buffon, of the principle of the unity of a species, Blumenbach asserted: "our black brethren ... can scarcely be considered inferior to any other race of mankind taken altogether,"[44] yet he nonetheless classified the distinct "national colors" according to what was, in truth, an aesthetic hierarchy. The superiority of the Europeans seemed to him to be so evident that he proclaimed, with no explanation, "In the first place, then, there is an almost insensible and indefinable transition from the pure white skin of the German lady through the yellow, the red, and the dark nations."[45] The whiteness of the Europeans took first place, and thus was ahead of the "yellow" of the Mongolian nations, the "copper-color" of the peoples of America, the "tawny" color of the Malays and the inhabitants of the Australian archipelago, and finally ahead of black—a color that was, however, not a unique property of black people, since it was found mixed in with the principal colors of the other varieties. Blumenbach gave the white variety the racial name "Caucasian" because "the most beautiful race of men ... the Georgian" lived around Mount Caucasus, and because, he wrote, "in that region if anywhere it seems we ought with the greatest probability to place the autochthones of mankind." Just as, in effect, the whiteness of the Georgians degenerated toward a darkish color as one moved further away from this place of origin, equally so, all other skulls appeared to "diverge" from the beautiful form of the Georgians' skulls, going all the way to the skulls of "Mongolians" and "Negroes" who were evidently the most distant.[46] Some ten years later, Christoph Meiners produced a taxonomy that was even more radical: "The human species today consists in two main stocks: the stock of the people who are light and beautiful, and the stock of the peoples who are dark in color, and ugly."[47] Meiners, a philosopher and naturalist from Göttingen, was thus making the claim that the most crucial criterion for judging peoples, stocks, or races (Stämmen) was the beauty or ugliness of faces and bodies. For Meiners, since the time of Lucian and Pausanias only the Caucasians deserved to be considered beautiful, just as it was perfectly legitimate to consider the Mongolian nations ugly. These were not qualities of the

will, but the result of climate—beauty was a flower indigenous to certain regions, while ugliness was an ineradicable weed.[48] As Cuvier was to explain it:

> The race from which we are descended has been called Caucasian, because tradition and the filiation of nations seem to refer its origin to that group of mountains situated between the Caspian and the Black seas, whence, as from a centre, it has been extended like the radii of a circle. Various nations in the vicinity of Caucasus, the Georgians and Circassians, are still considered the handsomest on earth. ... It is by this great and venerable branch of the Caucasian stock, that philosophy, the arts, and the sciences have been carried to the greatest perfection, and remained in the keeping of the nations which compose it for more than three thousand years.[49]

Anthropology and aesthetics were thus to merge and to stay that way for many years, as is indicated by an illustration in Virey's *Histoire naturelle du genre humain*, published in 1801 (figure 2.4), and, fifty-three years later, by a plate printed in *Types of Mankind* (figure 2.5), the famous work by the American anthropologist J. C. Nott, legitimizing the enslavement of black people through the use of reproductions of works of antiquity.

Josiah Nott's treatise and the first edition of Julien-Joseph Virey's *Histoire* both included a comparison of three profiles coming from two perfectly heterogeneous categories: a work of art, and members of the hominid species. In each case, we see two hominids: a man and a monkey (orang-utan or chimpanzee). While Camper had arranged the figures he compared in a horizontal fashion, Nott and Virey arranged theirs vertically. This strongly hierarchizing visual rhetoric had the immediate effect of associating man to monkey in the lower part of the engravings, with these two "natural" figures being dominated from above by the splendor, not of a man, but of a classical sculpture garnished with a Greek nose.

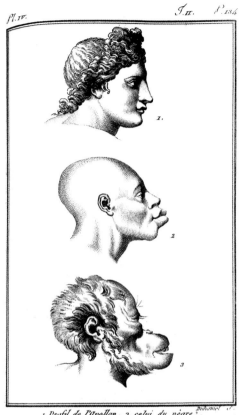

2.4 Julien-Joseph Virey, 1801: "1. Profile of Apollo. 2. Of a Negro. 3. Of an Orangutan." Engraving by Duhamel.

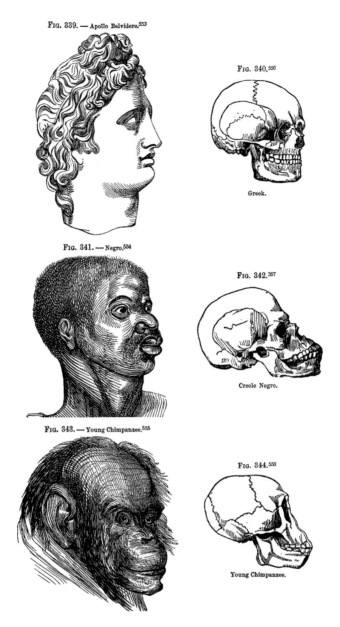

FIG. 339. — Apollo Belvidere.[553]

FIG. 340.[556]

Greek.

FIG. 341. — Negro.[554]

FIG. 342.[357]

Creole Negro.

FIG. 343. — Young Chimpanzee.[555]

FIG. 344.[556]

Young Chimpanzee.

2.5 J. C. Nott, Geo. R. Gliddon, 1854: "Apollo Belvedere, Negro, Young Chimpanzee."

In 1824, however, in the second edition of his work, Virey substituted for the figure of Apollo a Christ-like, bearded figure (figure 2.6). This was more in keeping with the Catholic spirit of the Restoration; but perhaps he was already assuming, as Émile Burnouf soon would,[50] the Aryan origins of Christ, who here still keeps the profile of Apollo. Virey's polygenist profession of faith became ever more explicit as he now described these profiles as belonging not to three "races" but to three distinct "species," each one marked by the "permanence of characteristic traits."[51]

Not until the twentieth century did the Swiss archaeologist Waldemar Deonna settle the question unequivocally: the Greek profile was in no way the result of the imitation of nature, and it was in no measure "a special characteristic of the Greek race, as Winckelmann had thought." It was an idealization and a stylization of the human type—a form that had been merely temporary in Greek art, and that characterized essentially the classical period, "the idealist fifth century." All things duly considered, Deonna noted, one could argue that this "pure Greek profile" was the result of a long development, and of a necessary prior stage that had been reached not only by Greek art, but also by Egyptian, Chaldean, and, later still, by the Christian art of the thirteenth century.[52]

SELF-PORTRAIT GODS AND SELF-MIMESIS

Winckelmann, who was a close reader of the Abbé Dubos and of Buffon,[53] brought together certain consequences of climate theory that his predecessors had envisaged separately. Like Buffon, he attributed superior human beauty to the virtues of a temperate climate where nature's productions were the most "regular." Along with Dubos,[54] he thought that the fine arts owed their existence to the influence of a clement sky and of a nature that, in Greece, had miraculously stayed at "its putative midpoint" between hot and cold, summer and winter. Thus, for Winckelmann, the intellectual concept of beauty and the physical generation of beautiful human forms

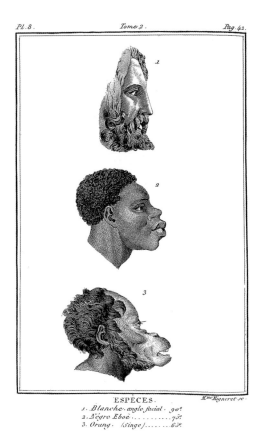

2.6 Julien-Joseph Virey, 1824: "Species. 1—White—Facial angle 90°. 2—Eboe Negro—Facial angle 75°. 3—Oran (monkey)—Facial angle 65°."

were bound together by nature herself.[55] We might think, therefore, that he considered the climate responsible for the creation of beauty, able to exert itself as much on the works of the mind as on those of the body. But this was not the case. When Winckelmann referred to the "correct" idea of beauty, he meant the beauty of living bodies before that of works of art, because the former were the condition of the latter: "Thus, our own and the Greek concepts of beauty, which are taken from the most regular appearance, are more correct than those conceived by peoples who—to use a thought of a modern poet—are at a half remove from the exact likeness of their Creator."[56] Each people, he thought, could have its own idea of beauty, but the real value of this ideal beauty depended upon the physical beauty of the people who conceived it. No proper idea of beauty could be born of a spirit clothed in an ill-formed body, such as nature always produced, he wrote, "the more it approaches its extremes and contends with either heat or cold."[57]

In his *History*, therefore, Winckelmann kept the normative and ahistorical dimension that characterized the *Reflections*, only now he was making this aesthetic norm into the threshold, the heart, and the very axis of a historical narrative. It was with the ancient Greeks, and in accord with "highest beauty ... in God," that ideal beauty, purely spiritual beauty, became incarnate for the first time in history. At least as much as this was an explicitly acknowledged form of Platonism, it was a narrative structured by a Christian paradigm. The ideal was the incarnation of the Spirit in history—the history of ancient Greece. On the one hand, Winckelmann turned the idea of supreme beauty into an absolute "in God,"[58] simple, unique, and characterized by "unspecifiability" (he invented the term *Unbezeichnung* for this purpose); on the other hand, as Père Bouhours had done before with "beautiful language,"[59] he compared this supreme beauty to the most pure water, which had no particular flavor because it was "clear of all foreign particles."[60] Yet on the other hand, Winckelmann asserted that this ideal beauty, radiating from the statues of the gods, derived from the bodies of the Greeks themselves. So, on the one hand, as a good Christian, he

was claiming that God had made man in his own image; while on the other hand, he was reversing the biblical formula: the Greeks had made their gods in their own image, since they had, like all artists, "given their figures the facial features peculiar to their nation."[61] Winckelmann was doubtless bringing up here a very old idea according to which each people was said to attribute to its gods what it took to be its own qualities. Such older ideas had also underscored the symbolic quality of this sort of projection, but almost always in order to morally condemn the transfer of human characteristics to the gods.

Before Winckelmann, therefore, it was the incommensurability of human and divine natures that had nearly always been emphasized. When Xenophanes, for example, attacked the anthropomorphism he saw in the poems of Homer and Hesiod, saying: "But if cattle and horses or lions had hands, or were able to draw with their hands and do the works that men can do, horses would draw the forms of the gods like horses, and cattle like cattle, and they would make their bodies such as they each had themselves;"[62] or when Aristotle wrote in *Politics*: "Men model the gods' forms on themselves, and similarly their way of life too;"[63] or when Montaigne, in his turn, quoted Xenophanes,[64] or when Spinoza argued that if a triangle were endowed with language, "it would say that God is eminently triangular,"[65] it was, each time, to argue for this incommensurability. Winckelmann, on the contrary, was taking up a more recent idea introduced by Montesquieu in the *Lettres persanes* according to which anthropomorphism was an impulse so utterly irresistible that it had to be seen as a natural law of the species. In the *Lettres*, Rica writes to Usbek:

> It seems to me, Usbek, that we never judge anything without secretly considering it in relation to our own self. I am not surprised that black men depict the devil as brilliantly white, and their own gods as coal-black ... that all idolators have depicted their gods with human faces, and have endowed them with their own propensities. It has been quite correctly

observed that if triangles were to make themselves a god, they would give him three sides.[66]

Petrus Camper also, for his part, saw self-love as responsible for the tendency of each of the peoples of the earth to see themselves as the most beautiful; they all represented their gods in human form "with the characteristic features and in the dress of their own land."[67]

As we have seen, Montesquieu reversed the long-standing argument against anthropomorphism, turning it into the statement of a positive universal law. Winckelmann, however, went well beyond this by claiming, on the basis of this reversal of the usual argument, that the art of a people was entirely bound up with the making of its gods. Art, he argued, had its true origin in the worship of the gods, once peoples began to honor "the higher powers they imagined by giving them tangible forms."[68] In this respect, he was forced to recognize that art was born later among the Greeks than among the Egyptians or Chaldeans; however, he still thought it legitimate to make the Greeks the "original inventors" of art because, before them, no people had represented its gods in "human form," and because, before them, the material objects of worship had been only simple blocks of wood or stone, such as those columns (sometimes with added heads) known as the *hermae*.[69] The excellence of the Greeks, Winckelmann concluded, was owing to their worship of the forms of their own beautiful human nature—they admired themselves at the same time as they honored the gods.

Everywhere man creates gods in his own image. What distinguished Winckelmann from Xenophanes and Montesquieu when they associated a people's color to that of their gods was that Winckelmann took the aphorism literally. While the formula had generally always been used for moral purposes—as, for example, in Prévost's *Histoire générale des voyages*, where the author notes that for lack of "right ideas about the Divinity, the Kamchadals made the gods in their own image, as other peoples have done"[70]—Winckelmann, unlike anyone before him, gave this aphorism a literal, physical, and biological meaning. With the Etruscans, he wrote, as with all

other peoples, art had necessarily been formed in a single manner; namely, "By the imitation of nature, its model."[71] So that if, with other peoples, art had not attained "the heights that it did among the Greeks," it was no doubt partly because of their religion, laws, and science, but it was first and foremost because of their "physical appearance." Thus it was also for the Egyptians, who "did not have that excellence" that the Greeks received from nature, and was "needed to inspire the artist to ideas of high beauty."[72] In the opening section of his *History*, Winckelmann asked what were the causes of the artistic diversity among peoples. His answer was unequivocal: the diversity of art was the result of the diversity of peoples, and it was the Greeks alone, because they were already favored by nature, who had been able to construct their own beautiful human nature through the physical exercises in the gymnasium, where they combined *physis* and *paideia*[73] and thus aimed to produce ideal living models. It was in the image of these models that they made their gods. It is to Winckelmann that we owe not only the discovery of the Greek profile, but also this perfectly ideal relationship between the bodies of men and those of the gods; so perfectly ideal that they became mirrors of each other.

Now, this construct, delusional and yet enduring, by which Winckelmann attributed to the Greeks the idea of gods entirely similar to men, has been definitively refuted. As Françoise Frontisi-Ducroux has put it: "All of the Greek religion, on the contrary, was aimed at marking the separation and defining the boundaries between the race of the gods and the race of men."[74] In terms of bodily qualities (where the two races were the most similar) these *differences* were emphasized as much in sculpture as in written texts. Thus the resemblance between human form and that of the gods was *corrected* by the size of the cult image that was sometimes very much smaller in size than the human figure (e.g., the small wooden effigy known as xoanon), and sometimes very much larger. In the fourth century, for example, a stone god would often measure from three to ten meters in height. By a decree mentioned by Lucian (*Images*, 11), the governing rules of Olympia, where the statues of the winning athletes were

consecrated, clearly forbade that those statues be given a size greater than that of a human. Going further in the same direction, the finery of dress of the cult images, with their bright colors and the frequent restoration of the imperishable bodies of the gods, made impossible any confusion between the bodies of the gods and those representing humans. Winckelmann, who had read, and often quoted, Lucian and Pausanias, must have been aware of this. Nonetheless, he was to write: "The appearance of beauty began with the singular beauty, in the imitation of a beautiful subject (*Vorwurf*) as well as in the representation of the gods." Thus, he explained, they had made goddesses in the image of beautiful women—including those who "whose favors were common and venal"—while the gymnasia, where one went "to see beautiful youth," were, in reality, the "schools" where artists learned to recognize the bodily beauty with which they adorned the gods.[75]

As soon as Winckelmann had put forward this biological, aesthetic, and racial interpretation of the "miracle" of Greek art, it was to spread widely and ceaselessly, taking ever-new paths. Without Winckelmann, Taine would never have described Greek statuary as the perfect "correspondence of art and life": "To produce man in marble or bronze, the Greeks first formed the living man, perfect sculpture being developed at the same moment as the institution through which was produced the perfect body."[76] Without Winckelmann, it is probable that Taine would not have exhorted his students to look at Fra Bartolomeo's *Saint Vincent*, Andrea del Sarto's *Madonna del Sacco*, Raphael's *School of Athens*, the Medici Chapel, and the vault of the Sistine Chapel, declaring: "behold the bodies that we ought to have; in the presence of this race of men, others are either weak, effeminate, gross or badly balanced."[77] Like Winckelmann, Taine saw such a power of mimetic attraction in these artistic figures that he, in his turn, made them models for the living.

Winckelmann was surely not the first to introduce these ideas about self-imitation into the field of art; however, if he inherited, in this respect, theories formulated by painters since the Renaissance, there was an utter

abyss separating him from them because he substituted a *collective* principle of identification for the critique of the narcissistic experience of the artist. The Renaissance saying *Ogni pittore dipinge sè* (Every painter paints himself) was fashionable in Florence at the end of the Quattrocento, and, in fact, it often implied much more a conceptual than a physical self-mimesis. Thus, for Savonarola, the painter "did not paint himself as a man ... but as a painter, that is, according to his idea."[78] Such was not, however, the way that Leonardo da Vinci understood a painter's spontaneous self-mimesis. Having noted that "each peculiarity in a painting has its prototype in the painter's own peculiarity," Leonardo added:

> I have often pondered the cause of this defect and it seems to me that we may conclude that the very soul which rules and governs each body directs our judgement before it is our own. Therefore it has completed the whole figure of a man in a way that it has judged looks good, be it long, short, or snub-nosed. And in this way its height and shape are determined, and this judgement is powerful enough to move the arm of the painter and makes him repeat himself and it seems to this soul that this is the true way of representing a man and that those who do not do as it does commit an error.[79]

Leonardo denounced the narcissistic bent in self-mimesis because it was, for him, "the greatest fault of painters": a defect that everyone should struggle against by submitting themselves to the judgment of others. A denunciation of narcissism such as this surely echoed philosophy's long-standing condemnation of anthropomorphism. Nevertheless, there was an essential difference between Winckelmann and the Tuscan artists of the Renaissance. Winckelmann no longer thought of self-mimesis as an individual phenomenon (as Antoine Coypel still did at the beginning of the eighteenth century)[80] but, rather, as a collective phenomenon affecting peoples or races. Such a change of scale was not to be free of consequences,

as Morelli was later to understand, citing this same passage from da Vinci in support of his own theses on the determination of art by race.[81] At the same time, it is likely that Winckelmann no longer differed on this point from his contemporaries. In 1769, the French translator of Algarotti's *Essai sur la Peinture* pointed out in his preface that "man depicts himself in his works, a nation in the works of its artists, who are the organs of its tastes."[82]

THE NATURAL *CIRCULUS*

Winckelmann—for whom, we must not forget, the natural, living human body was both the founding origin and the goal of art—had emphasized in the *Reflections* how much the Greeks were concerned to give birth to beautiful children. To this end, he said, they had invented more ways of doing so than were mentioned by Claude Quillet in his modern *Callipaedia* (1655).[83] Ten years later, Lessing took up this idea wholeheartedly, albeit with an irony quite lacking in Winckelmann:

> The plastic arts in particular—aside from the inevitable influence they exert on the character of the nation—have an effect that demands close supervision by the law. If beautiful men created beautiful statues, these statues in turn affected the men, and thus the state owed thanks also to beautiful statues for beautiful men.[84]

This remarkable circularity of art and life that Winckelmann believed had allowed the ancient Greeks to aspire toward perfection was soon to take on the dimensions of a thoroughgoing anthropological principle. It would become the ground of what Michelet would call the "new criticism" of religions and of their history, and Michelet would become one of its most fervent apostles. Well before Taine, Michelet sought to understand the Greek miracle as the fruit of a rigorous correspondence

between art and life—between the ideal and the real. Greece, he wrote, admired and worshiped itself in the wondrous beauty that it sought to make eternal:

> Observe that before all statuary, the living statue existed; that the powerful gymnical and harmonical creation had made out of the real the most perfect ideal ever dreamed of. Art at first copied; it began with portraits. It did not amuse itself by sculpturing gods at hazard. It made the likeness of those it saw.[85]

Michelet, much more than Taine, was able to grasp and describe this "natural *circulus*" by demonstrating the movement by which peoples, as they made their gods, made themselves:

> A new criticism, stronger and more serious, is now offered. Religions, so profoundly studied at present, have been subordinated to the genius that made them, to the soul which created them, and to the moral condition of which they are the fruit. We must first locate the race with its proper aptitudes, its surroundings, and its natural inclinations; then we may study it in the fabrication of its gods, who in their turn influence the race. This is the natural *circulus*. These gods are effects and causes. But it is essential to first prove that they are effects, the offspring of the human soul; if on the other hand we admit that they came down from heaven and suffer them to domineer over us, they oppress, absorb, and darken history. Such is the modern method, most clearly and decidedly. It has recently given its principles and its examples.[86]

As contradictory as his thinking might appear with regard to race (always rejected as a "basic element," yet still kept as a creation of soil and climate),[87] Michelet here makes race the paradoxical tool of a humanity freeing itself

from the bond of biological fate. Taine, in contrast, applied the "new criticism" rigorously, *positing race first* before presenting, setting out, describing, and commenting upon the cultures that he assumed derived from it. Taine's entire historical doctrine is bound up in this formulation, and we can see here his inability to conceive of any history that might not be natural:

> I shall first show you the seed, that is to say the race, with its fundamental and indelible qualities, those that persist through all circumstances and in all climates; and next the plant, that is to say the people itself, with its original qualities expanded or contracted, in any case grafted on and transformed by its surroundings and its history; and finally the flower, that is to say the art, and especially painting, in which this development culminates.[88]

Here, therefore, the plant metaphor (constantly in currency in writings on the history of art) has the magical virtue of immediately transforming this social activity (the production of art) into a natural process contained within a cycle comparable to that of the seasons. This metaphor, at the very least, allowed art to be seen as the natural prolongation of a race, and as the medium through which it propagated itself.[89]

A long time, therefore, before Élie Faure was to assert: "Art has defined the races,"[90] Hippolyte Taine, in the nineteenth century, provided the first extensive formulation of the theory of the self-production of the race by means of art. Like the majority of his contemporaries, Taine thought of peoples as functions of categories that were much wider in scope, and of more crucial importance: "Beneath the characters of peoples are the characters of races."[91] It was thanks to this taxonomy, and to this nesting-box arrangement of characters, that Taine was able to bring together races and historical periods in order to better contrast them, grouping "the classical centuries and the Latin races" on one side, and "the Romantic centuries and the Germanic races" on the other.[92] Thus, quite naturally, he was

able to distinguish "the principal workers of modern civilization" into two groups: the "Latin or Latinized" peoples, and the "Germanic peoples" (amongst whom he classified the Americans). To study, on the one hand, the art of the Italians, and, on the other, the art of the Flemish and Dutch, was, he asserted, to study modern art in its "greatest and most opposing" representatives.

Still, unlike many of his contemporaries who boasted of their affiliation with the barbarians of the North, and were convinced that the Latin races had had their day, Taine felt an affinity with the entirety of the Latin peoples. Above all, he felt an affinity with the Italians, whom he described as this intelligent race that offered "the advantage of not having been *Germanized*, i.e., crushed and transformed to the same extent as the other countries of Europe by the invasion of the peoples from the North." Happily, he stressed, the "Germanic crust"[93] extending over the Italian nation had remained very thin; so much so that the "innate aptitude of the race," along with certain favorable circumstances, had produced "the great and perfect painting of the human body." One had only, he added, to go down into the streets or to go into the Italian studios to see it "spring forth from itself." It was as if the fictive bodies of the studios merged in single spontaneous growth with the bodies of flesh.[94] Winckelmann's syndrome, the refusal to distinguish the figures of art from their living models, was on the way to becoming a genuine heuristic principle.

One day in 1867, as he was working on Renaissance art (the subject of the course he was giving at the École des Beaux-Arts), he wrote to his friend, the critic Paul de Saint-Victor, to say that he was now thoroughly convinced that for the painters and sculptors of the Renaissance:

> the mold [*sic*] of thought was different to what it is with us. They thought in colored forms, and we think in abstract words. ... Their works along with the Greek statues struck me as coming from a distinct race, absolutely alive, and comparable to the

living races I have seen such as the French, English, Germans, and Italians.[95]

Unsurprisingly, Taine was to soon define a hallucination as a "spontaneous sensation" and external perception as a "correct hallucination." "Thus external perception is an internal dream which proves to be in harmony with external things."[96] Elsewhere again, reflecting upon "the entire German race," and comparing "its whiter and softer skin" with that of the Latin peoples, he wrote: "*If we were to take them* [the German peoples] *as works of art*, the living figures would betray a bizarre and heavy hand in their more incorrect and flaccid design."[97] Here, at this precise point in time, Taine transformed this disquiet into a general artistic theory. The fictive bodies of art were not simply mirrors of the "race" that had painted or sculpted them, they were *productive* mirrors, endowed with the capacity to mold, in their own turn, the race that had engendered them. In this way, he was to write, "the genius of the masters consists in making a bodily race," adding soon afterward:

> The greater the artist, the more he shows profoundly the temperament of his race; with confidence, he supplies the most fruitful documents to history; he extracts and amplifies the core of the physical being ... and the historian perceives in its paintings the structure and the bodily predispositions of a people.[98]

Fundamentally, there would be no great difference between Taine's idea here and that of Algarotti's French translator who, a century beforehand, had thought that a nation's most eminent artists were "the organs of its tastes," if it were not for the entirely new addition of the concept of racial heredity.

In 1873, commenting upon Théodule Ribot's important work on heredity, Taine claimed to see in heredity one of the "greatest historical forces." This force was so much the more effective in that

each people, by the selection that it carries out within itself, works incessantly to increase it, by refusing existence or development to individuals whose character does not agree with its own. It is clear that, in a nation delivered over to itself, national traits have a tendency to deepen, and that, therefore, the national character tends to become exaggerated.[99]

In this way, Taine formulated his own version of Michelet's "natural *circulus*." It was through the mediation of its great artists that a people enacted within itself a process of selection. Through its artists, a people or a race provided itself with the models for its own biological reproduction. Thus works of art enabled the traits and characteristics of a race to endure, to be refined, and to become more marked. Short of an "adulteration of the blood," a conquest or an invasion producing "racial mixing,"[100] a people always remained identical to themselves, with their own instincts and abilities that were "in the blood and transmitted with it." Since heredity transmitted "not only the primitive basis, but still more the subsequent acquisitions,"[101] art fulfilled an essential function in the "natural *circulus*." By selecting and amplifying certain characteristics peculiar to a given race in order to make images of them, artists added to innate nature the advantages of things learned when they offered their images as models for biological transmission. Precisely one century after Winckelmann's *History of the Art of Antiquity*, the oneness of the ideal and the real appears to have been so widely accepted that the great German historian and archaeologist Ernst Curtius could see the art of the ancient Greeks as the pure reflection of their physical condition:

> Apollo and Hermes, Achilles and Theseus, as they stand before our eyes in stone or painting, are, after all, merely glorified Greeks; and the noble harmony of the members of their bodies, the mild and simple lines of the face, the large eye, the short forehead, the straight nose, the fine mouth, belonged to the people, and were its natural characteristics.[102]

In fact, archaeology was to hold for a long time to the heuristic principle of the morphological unity of artists and the figures they made. In 1891, examining the beginnings of Greek ceramics, Paul Milliet was to say, with complete confidence, that since each race created its own art, the "unconscious and instinctive expression of its tastes, its ideal, often even its physical type," could not help but be the "faithful mirror of [its] ethnographic characteristics." The primitive artists, he added, ignored individual traits in order to produce only the type of their race. Painting studios had kept to the old proverb, verified as much by the naïve drawings of children as by the works of primitive artists: "You make what you see, and you see what you are." Since an artist, in his first works, "unconsciously paints his own portrait," it could never be the case that a people whose individual members were tall and slender could ever have an initial inkling of first drawing "short and stocky men." Better yet, Milliet was convinced that it was possible to identify, in the first figurative monuments of Hellenic art, the "principal races whose happy mixture built the Greek race."[103] In this way, taking as a model the classic theory of an ideal beauty produced by means of selection out of dispersed natural beauties, Milliet came up with the idea of the formation of an ideal Greek race through the mixing of its constitutive racial parts—parts that were supposedly preserved in marble. Archaeology had produced a miracle—flesh, having produced its effigy in stone, was itself engendered by stone.

During these same years, Édouard Piette, the famous archaeologist and prehistorian to whom we owe one of the most important collections of prehistoric art, was elaborating a theory of the faithful self-figuration of the "Quaternary races." The recent discoveries at Laugerie-Basse, Mas d'Azil, and Brassempouy led him to declare solemnly before the Société d'anthropologie de Paris that if one wanted to fill the immense gaps in our knowledge of the human races that had populated France during the Solutrean and Magdalenian epochs, one would need to "examine the statuettes and the cave paintings by which [these races] represented themselves."[104] Looking closely at certain statuettes representing female figures, Piette

believed he could distinguish clearly between two races characterized by the adipose form ("race *stéatogyne*") or thinness ("race *sarcogyne*") These races, he claimed, "lived together in caves," one wearing "the rudiments of clothing," the other going unclothed. Édouard Piette concluded from this, with a triumphal and quite stupefying presumption, that "mixing must have been common between the two races. M. de Vibraye's *Immodest Venus*, sculpted in ivory, appears to be of mixed race" (figure 2.7).[105] Never before, since Winckelmann, had anyone deduced, with so much of a sense of authority, the real existence of imaginary races from the fictions of art.

Newly discovered fragments of statuettes were soon to make Piette think that these sculptures "were not without analogy to those of Egyptian art," and that they were the latter's "precursory attempts."[106] Pointing out that steatopygia, always widespread in Africa, had been common "in ancient times, in the land of the Pharaohs and in neighboring lands," he assumed there had been significant migrations from the Pyrenees to Egypt:

> We should not be surprised that it was on the banks of the Nile, after the brilliant flowering of the visual arts in our country, during the Solutrean and Magdalenian periods, and coming out of a long period of dormancy, that these arts reawoke with a new cachet stamped by the climate, the period and the differences that always appear even between races that are more or less neighboring; the journey from the land of Gaul to that of Egypt was facilitated for them by the affinity of the populations.[107]

Against all expectations, this undoubtedly audacious hypothesis did not go unheeded. For one thing, it fit in well with a growing interest in the theory of the periodical "awakenings" of certain formal traits in the art of a "race"; the latter being understood to be always identical to itself, and unchanging.[108] In fact, ten years after this, in 1904, the archaeologist Jean Capart, in his turn, observed a genuine continuity between the art of the

2.7 Henri Breuil, 1907: Ivory female statuette known as the "Immodest Venus."

Pyrenees in the Quaternary period and the beginnings of Egyptian art, and he saw the proof of this in imaginary similarities of "race."[109] Despite the strong objections of archaeologists such as Joseph Déchelette or Waldemar Deonna, who rejected such delusional ties of kinship "between our Troglodytes and the inhabitants of Early Egypt,"[110] the willful disregard of all forms of artistic convention in favor of what was called at the time "ethnographic theory" (i.e., racial theory) remained unstoppable.

The history of art was, of course, to remain at the forefront of the theory of racial self-representation that it shared with archaeology, ethnography, and anthropology. André Michel, a student of Taine and a curator of sculpture along with Louis Courajod at the Louvre, and the initiator of the monumental *Histoire de l'art* that would influence several generations of French art historians, was to note in the *Grande Encyclopédie* of 1898 that "among Negroes, who appear, however, like most of the Central and Southern African races, very backward in all matters pertaining to art, we find idols representing men, and that reproduce 'with a grotesque faithfulness' the characteristics of the Negro race."[111] This thesis—borrowed, moreover, almost word for word from the great English naturalist Sir John Lubbock[112]—was notable for this dual trait of mimetic and "grotesque" faithfulness that implicitly referred the idol back to its assumed model. Once more, the gods, however grotesque they might be, could not be other than the self-portraits of the races who had fashioned them.

The Physiognomical Principle

"With regard to the first, namely, the human appearance (*Bildung*), our eyes convince us that just as the soul is expressed in the face, so too in many cases is the character of the nation." Winckelmann followed these words almost immediately with the statement: "That the art of antiquity took its forms from the appearance of its people is shown by a similar relation of art to appearance in recent times."[113] In this way, if the soul and character of a nation were visible and legible on the faces of men, they

were also to be read on the art objects that reflected those faces. The "ethnic" (i.e., national or racial) interpretation of works of art thus found its basis in physiognomy.[114] In return, physiognomy supplied anthropology with its criteria for aesthetic evaluation. Physiognomy, equally applicable to the morphology of other peoples and to the latter's gods and artistic works, was to be found everywhere. Lavater was to write: "Everything in Nature has a physiognomy," and Jean-Joseph Sue said the same at the end of the century: "all living creatures have a set of features and complexion, forming so many pages of that great book of Nature which it is our duty to learn."[115]

Lavater's *Physiognomische Fragmente*, published between 1775 and 1778, culminated with this vaguely Platonic postulate concerning the correspondence of the inner and the outer being: "The beauty and deformity of the countenance is in a just and determinate proportion to the moral beauty and deformity of the man. The morally best, the most beautiful. The morally worst, the most deformed."[116] Yet in many respects Lavater's thinking was fully in line with that of Winckelmann, to whom he refers on several occasions. For example, following Winckelmann, Lavater wrote: "the Greek race was more beautiful than ours, they were worth more than us, and the present generation is cruelly degraded." Everything, he argued, went to show that the human species had degenerated: "We are nothing but the dregs left over from times past."[117] However, unlike Winckelmann, he did not believe that salvation could come through art, since art had never managed to surpass nature and produce ideal beauty. Certainly, "in the Greeks, nature was more beautiful than it is with us," but art, with the ancients as well as the moderns, had always been, and would always be, inferior to its model: "What we call the ideal beauty of the Ancients can well appear ideal to us. But in relation to themselves, it was probably only a pale and less than satisfying imitation of nature."[118]

Lavater chose for his work the epigraph *Gott schuf den Menschen sich zum Bilde* (God created man in his own image). He believed that if art was incapable of redeeming degraded human nature, Christianity, in contrast, could beautify everything "according to the individual, inner dispositions

of each subject to whom it extends its action." But, for this to happen, one had to distinguish between outward show and true beauty: "It is the inner, the feeling, the good use of the faculties that gives beauty and nobleness to the human form." Winckelmann had suggested that by the imitation of the Greeks and their statuary one could gain access to divine beauty; Lavater's response was the imitation of Christ: of the god made man. He asked: "What is it, in fact, that leads us to Divinity, if it is not the knowledge of man; and what makes us know man, if it is not his face and form?"[119] Beyond the moral-aesthetic aspect, Lavater offered physiognomy as an observational science that took as its subject "everything that can be expressed by signs and communicated by rules." Its field was infinite in scope, and as physiognomy became, in effect, semiotics, Lavater felt justified in making it "the science of sciences."[120]

From Buffon to Lichtenberg, almost all of the Enlightenment philosophers and naturalists violently rejected the "'imaginary science' that the ancients, since Aristotle, called *physiognomy*." There was no doubt, wrote Buffon, that the passions, as movements of the soul, could be known by the changing movements of the face and body; but it was impossible to judge a soul by the shape of the body or the form of the face: "An ill-formed body may contain an amiable mind; nor is the good or bad disposition of a person to be determined by the features of the face, these features having no analogy with the nature of the soul on which any reasonable conjectures may be founded."[121] In *Anthropology from a Pragmatic Point of View* (1798), Kant was also to attack this false science, and his attack was aimed, in particular, at Lavater, who was mainly responsible for its revival since the Renaissance. In the few pages that he devoted to Lavater (under the general title of the second part: "On the Way of Cognizing the Interior of the Human Being from the Exterior"), Kant gave the classic definition of physiognomy as "the art of judging a human being's way of sensing or way of thinking according to his visible form," and he denounced Lavater's pretensions to raise this "art" to a rank of knowledge that would supposedly be scientific because it was based on the objectivity of natural signs. Kant's tone here quickly becomes ironic and somewhat scornful; the fashion for

this pseudo-science had passed, and physiognomy was no longer a valid subject of study: "nothing remains of it but the art of cultivating taste."[122] Still, Kant had—ironically enough—already provided material for his own denunciation since he had noted, in his *Observations on the Feeling of the Beautiful and Sublime*, that a remark coming from a black man might have "something in this that deserved to be considered; but in short, this fellow was quite black from head to foot, a clear proof that what he said was stupid."[123]

Wilhelm von Humboldt was soon to argue that the detractors of physiognomy were caught in contradictory attitudes: they "reject it in theory, but use it every day in practice."[124] Hegel was to condemn the pretensions of physiognomy despite the fact that he himself was to see corporality as the exteriority of the soul, and as its (albeit possibly arbitrary) *sign*: "Spirit is, therefore, absolutely finite and isolated in the human figure as sign. It is, to be sure, its existent form, but at the same time the human figure is something entirely contingent in its physiognomic and pathogonomic determinacy for the spirit." But he immediately added: "Thus to want to raise physiognomy ... to the level of science is one of the emptiest ideas there could be, emptier than a *signatura rerum*."[125] Karl Schnaase, who had been a student of Hegel's in Berlin, was no doubt to recall this metaphor of the body as *the soul's artwork* when he came to make the art of a people the expression of its collective soul.[126]

Lavater's *Physiognomy*, with fifty-seven editions in six languages, published from 1775 to 1810 and popularized by numerous great thinkers from Kant to Goethe and Hegel, rapidly became one of the most common interpretative frameworks for the young sciences of man. However, this did not happen without some twisting and rearranging. If physical beauty was, for Lavater, the indubitable sign of moral beauty, it was to become, for nineteenth-century anthropology, the equally indubitable sign of the level of intelligence and "degree of civilization" of the races. Indeed, it was a physiognomical principle that Georges Cuvier was to employ in his instructions to naturalists setting out to encounter "the different races of

men" in the Southern latitudes. Arguing forcibly against Daubenton, who still believed, in the middle of the eighteenth century, that the "skulls of Negroes, Chinese, and Kalmucks" showed no noticeable difference with the skulls of Europeans, Cuvier, as we have seen, complained that the greatest painters had failed to grasp the "character of the Negro"—so much so that they made him "a White covered in soot." Even when done from life, he complained, their drawings reflected less their subjects than they did the rules learned in the schools of Europe.

Cuvier addressed his instructions first to painters. In order to allow naturalists to carry out true and rigorous comparisons, painters were henceforth to include a portrait in "pure profile" along with the frontal portrait, and they were to leave out, as much as possible, the costumes and marks "by which the savages disfigure themselves," which "serve only to mask the true character of their physiognomy." They were also to ensure that the hair did not hide the forehead, that the form of the skull be clearly visible, and finally they were exhorted to study "Camper's famous dissertation on the ways of rendering the characters of the different human races." Well before Bertillon's anthropometric photography, Cuvier thus envisaged a body entirely divested of all signs of culture, an ideally natural body. In contrast to Daubenton, Cuvier emphasized the morphological differences between the races in order to show that the proportions and structures of the skull, which he took to be peculiar to each race, had a necessary influence on its "intellectual and moral faculties." This proof of the intimate relation between the body and the mind seemed to him to be sufficiently novel as to inspire this remarkable comment: "Experience seems to agree with theory in everything having to do with the relations between the perfection of the mind and the beauty of the figure."[127] Published more than a century after its composition in 1800, this remark was indicative of a movement of thought that was assuredly much broader, and was affecting all of the human sciences. Seventeen years later, in 1817, Cuvier stressed the extent to which the white or Caucasian race, distinguished from other races by its beauty, had "given birth to the most civilized peoples." It was

the "great and respectable ... Indian, German, and Pelagic branch" that had "carried furthest Philosophy, Science, and the Arts, and it had been their depositary for thirty centuries."[128]

Since the end of the nineteenth century, the ethnocentrism of the Europeans has, of course, been routinely denounced. However, this has mostly been done in general terms, and with little mention of this link (nonetheless systematically assumed) between intellectual superiority and physical beauty that allowed Europeans to classify human groups. Yet this intimate connection no more began with Cuvier than it ended with him. As Michel Foucault has pointed out, with the rise of biological determinism,

> To classify, therefore, will no longer mean to refer the visible back to itself, while allotting one of its elements the task of representing the others; it will mean, in a movement that makes analysis pivot on its axis, to relate the visible to the invisible, to its deeper cause, as it were, then to rise upwards once more from that hidden architecture towards the more obvious signs displayed on the surface of bodies.[129]

The anthropologist Julien-Joseph Virey, who divided humanity, as did Meiners, into two major classes of races, the "white and beautiful," and the "black or brown and ugly," made great use of this two-way inductive method in order to justify both his own "tastes" and European world rule:

> The Celtic line, and even the Sarmatian and Esclavon, have a pleasant and very symmetrical oval face. ... In short, the proud and noble forms, a generous soul, an active character, frankness, beauty, moral distinction, intelligence, perfection and social virtues elevate this race of men above the servile flock of other mortals who crawl, sadly attached to the earth, in vile uniformity. What would our world be like without the Europeans?[130]

In a lecture given in 1847 to the Société ethnologique de Paris, the Saint-Simonian Victor Courtet de l'Isle also went straight to the point: the map of the populations of the world revealed the "basic truth" that "the more the typical form of a race is beautiful, the more advanced is its civilization; the more the typical form of a race is ugly, the more that race is imperfect. As for the idea I have of relative beauty and ugliness," Courtet innocently added, "it is the same as one can easily see by taking for comparison, on the one hand, the figure of Apollo or Minerva, and, on the other hand, the features most approximating a brute." Since "the most brilliant civilization belongs to the most beautiful European type," he concluded, with no evident surprise, "everything conspires to make the Europeans the true lords of the earth."[131]

The same physiognomical principle was still present in the remarks of the liberal Charles Dunoyer, as he sought to prove that the "obscure races" could not be free. "If the phenomena of intelligence were to in no way depend upon physical organization," he wrote, "we would see no coincidence between the enlightenment of a people and the way they are physically built." All of the races would be equally skillful and prosperous, and "the Ethiopian, the Mongolian, and the European would be all equally civilized. It would have to be that way. We find, on the contrary, that superiority of civilization coincides generally with superiority in physical organization, and that the races with the best anatomy are also the most civilized." Accordingly, for Dunoyer, certain "vices" went along with certain "complexions." From the "inferiority of obscure races" Dunoyer deduced "that being less open and receptive to culture than the white race, they are less open and receptive to freedom." Certainly, he did not wish to "flatter the vanity of the latter" or to "offend the dignity of the former." His sole purpose was to

> state [this truth] that the freedom of men depends, above all things, on the natural perfection of their faculties. ... The superior civilization of the white race is not the product ... of any

SELF-MIMESIS AND SELF-PORTRAIT GODS

external circumstance, nor of any fortunate accident; it is the result, therefore, of its nature, and it comes from the superiority of its anatomy.[132]

The naturalist Bory de Saint-Vincent, a contemporary of Dunoyer, was evidently seeking to legitimize this very same European rule when he attacked those ignorant artists who had given the dominated peoples the traits of the colonizers. The Europeans had been misled when, at the end of the eighteenth century, one had shown them the inhabitants of the new lands "as the best of human beings, lending to them the ancient forms of the Medici Venus, Apollo, and the god Mars" (figure 2.8). One should attach no credibility, he wrote, "concerning their physiognomy and their supposed beauty, to those pretty plates engraved during Cook's voyages, based on drawings clearly made in London or Paris by painters who had never seen any of them." No more should one believe, he continued, other modern reports "in which Melanian and Australasian savages, in reality gangly, almost beardless, with hideous faces, and the most ungainly gait among all men, were depicted by French artists after the figures in academic paintings and reliefs that were based on Greek divinities and on the bodies of *les forts de nos halles* [the strong men who carried goods into the French food markets]."[133]

To lend to savage and hideous peoples the forms of the Greek gods was a gross case of *miscasting*. How could one have deprived the Medici Venus, Mars, and Apollo of their freedom; how could one have used *them* in such a way? Without any doubt, the heyday years of the theory of the self-portrait gods overlapped with those that saw the justification of slavery and the unquestioning belief in European domination. Yet, in parallel to this, another epoch began. This was the period of the legitimization of the rule of the peoples of the North within Europe—the time of the rehabilitation of the barbarians.

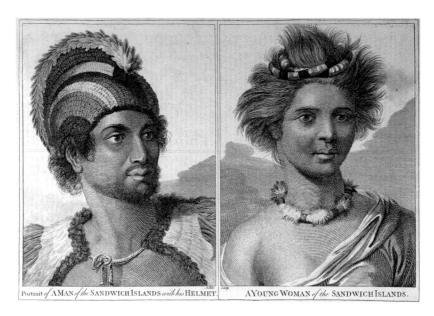

2.8 *Portrait of a Man of the Sandwich Islands with his Helmet. A Young Woman of the Sandwich Islands.* Engraved by Noble after J. K. Sherwi.

The Barbarian Invasions and the Racialization of Art History

If the German peoples had not been able to shake off the Roman yoke ... instead of this rich and free Europe, we would only have Rome, in which everything was mixed and confused. Instead of the history of European kingdoms, we would have nothing but the annals of Roman history, offering the sad uniformity of Chinese chronicles.

—*Friedrich Schlegel, 1809*

Yes, we are Oriental—by race—.We are doubly Oriental, both because of our Celtic origins and because of our Germanic incursions of the fourth to the tenth centuries. We are only Latin and Graeco-Roman through our literary education.

—*Louis Courajod, 1891*

Since the beginning of the nineteenth century, a single historical and cultural interpretative framework has determined art-historical writing in Europe. Possessing the full force of myth, it has been remarkably strong and enduring. Quite astonishingly, given how profound a stamp it has left

on the field (right down to the formal categories with which the discipline has sought to order its objects scientifically), this underlying framework has gone almost unnoticed in the historiography of art. In eighteenth-century Europe, and especially in France, even before Edward Gibbon published his monumental *History of the Decline and Fall of the Roman Empire* (1776– 1788), the role of the "barbarians" in the formation of the European nations had been widely debated. But no one had as yet assigned to "the barbarian invasions" a pivotal role in European history, and no one had seen them as the origin and wellspring of the conflicts that existed at that time. It was not until the time of the barbarians returned at the heart of European romanticism (as part of its reaction against the Enlightenment, the French Revolution, and the Napoleonic empire) that the opposition between the Germanic and the Latin races was to emerge as the most commonly used framework for interpreting the products of culture—so commonplace as to become almost invisible in the discourse on art, where even now it is actively disseminated.[1] It is essential, therefore, to provide an outline here of the development of this framework, and of its influence on the ideas of some of those art historians who contributed in a significant way to the foundation of the discipline.

On the basis of the geographical and climatic opposition between the North and the South that it inherited from the eighteenth century, the nineteenth century developed with surprising consistency a whole arsenal of oppositions that the twentieth century then refined further.[2] Central to this way of thinking was the idea that the young peoples of the North— the barbarians—regenerated through their male energies what was essentially a feminine and decadent old Roman Europe, thus propelling Europe into modernity. It was the Northerners who shifted the history of Europe northward, spreading a Christian religion that they soon embodied in an art that differed in every aspect from the art of classical antiquity. A new art was therefore born, and this art was referred to almost interchangeably as "Romantic," "Gothic," or "Germanic." It was through these Northerners that Europe was able to surpass the paganism of antiquity, to escape

the gloom of Latin classicism and the crushing norms of Rome that stifled the spirit of the peoples Rome had conquered. At last, as Montesquieu put it, the North had "forged the tools that broke the chains framed in the South."[3]

DEBARBARIZING THE BARBARIANS

Rome and the barbarians: this model was easily transposed to Napoleonic Europe, especially after 1806, by which time the Germanic Holy Roman Empire had disappeared and Napoleon I had conquered part of Prussia. In line with this, Herder's conviction of the necessity of *another history*, one not written by the victors, was to make its way into occupied Germany. Herder had described the fall of Rome thus:

> The wall and dam around Rome burst. ... Finally, when everything *broke*, how the South was flooded by the North! And after all the turmoil and atrocities, what a *new Northern-Southern world*! ... Everything was *exhausted, unnerved, shattered* ... when in the North a *new man* was born. ... *Goths, Vandals, Burgundians, Angles, Huns, Herules, Franks* and *Bulgarians, Slavs* and *Lombards* came, settled down—and the whole new world, from the Mediterranean to the Black Sea, from the Atlantic to the North Sea, is *their work, their race, their constitution!*[4]

After 1806, this *other history* no longer took the North and South as a whole but pitted them against each other, often accentuating their irreducible characteristics. Friedrich Schlegel was one of the most active artisans of this violent opposition. At first an uncompromising admirer of Hellenism, Schlegel soon became convinced that the time had come to found a new religion, with Novalis as Christ and himself as Novalis's "valiant St Paul." Starting in May 1799, Schlegel was to give this new religion, which he called his "Bible project," a full-blown purificatory and eschatological

dimension. Just as primitive Christianity had, against all expectations, engulfed the Roman Empire, Schlegel saw this new project as a "great catastrophe, [that] through its increasingly rapid expansion, will swallow up the French Revolution, whose most lasting value was perhaps to have incited it."[5] Visiting the ruins of the Basilica of Saint-Denis in 1806, he recalled with nostalgia the "ancient days when France was conquered and governed by Germans," and thought the term "German architecture" should be assigned to the Gothic style common to all Germanic peoples.[6]

Six years later, Schlegel, who was working at that time in the service of Metternich, began teaching contemporary history in Vienna. Like Fichte—who, in his "Address to the German Nation," delivered in Berlin in 1807 and 1808, had compared the French conquest of Prussia with the Roman invasions of the first century CE, and had urged Germans to resist just as their ancestors had before them—Schlegel posited that the era of invasions held the key to understanding his own time correctly, and vice versa. The past alone, he said, allowed his contemporaries to evaluate the present, and the present served to illuminate the obscurity of the past: "How many pages of history not understood until now have, because of the events of the last few years, clarified themselves to us!"[7] The migrations of peoples, usually seen as a kind of overflowing of barbarian hordes, were, for Schlegel, essentially a struggle between the Germanic tribes and Rome, and the arrival of the more distant Huns, in limited numbers, had not, in fact, made any significant impact. This truth could be reestablished only after the barbarians were debarbarized and the unjust but widespread opinion that the ancient Germans were "completely barbaric peoples," comparable to American savages, was demolished. Only then could the phenomenon that the French and Italians obstinately referred to as "the barbarian invasions" be seen finally in all its brilliance and decisive importance—as a migration that, as Schlegel declared, constituted the "wall of separation that divides the ancient and the modern world."[8]

Thus modern European history was thought to have flowed directly from this extraordinary event, and its consequences were incalculable. Had

these migrations not occurred, Schlegel argued, and had the "Germanic peoples" not thrown off "the Roman yoke," and had

> the rest of northern Europe been incorporated into Rome; had the freedom and individuality proper to its nations been here too destroyed, and had they been all transformed with like uniformity into provinces, then would that noble rivalry, that rich development of the human mind, which distinguishes modern nations, have never taken place.[9]

For Schlegel, therefore, if these migrations had not occurred, then instead of the free, rich, and diverse Europe of his own time, everything would have been mixed and confused within the "dull monotony" of Rome. The migration of peoples, according to Schlegel, was nothing other than the "history of the wars between the free Germanic races and the Roman masters of the world; wars which terminated in the dissolution of the Roman Empire, and in the foundation and first formation of the modern states and nations."[10] In these theses and claims emerging from Vienna, it was easy to see a clear warning directed against the Empire of Napoleon I, the new master of the world.

The same spirit animated Germaine de Staël's book *On Germany*, published in 1813 and translated into English in 1814 (its considerable success helped to spread some of these ideas across Europe). But it was not just from Friedrich Schlegel that de Staël borrowed these ideas; she was equally indebted to his brother, August Wilhelm, and to his "Lectures on Dramatic Art and Literature," which she heard delivered in Vienna before an enthusiastic audience.[11] For the first time, surely, through the writings of Germaine de Staël, the space of European art and literature was *racialized*.[12] De Staël's *On Germany* opened by unambiguously dividing Europe into "three major distinct races: the Latin, the Germanic, and the Slavic." Judging the Slavic race as simply imitative, and setting it aside, de Staël considered that "throughout literary Europe" there were "but two great divisions strongly

marked," and she further specified: "the literature which is imitated from the ancients, and that which owes its birth to the spirit of the Middle Ages; that which in its origin received from the genius of Paganism its color and its charm, and that which owes its impulse and development to a religion intrinsically spiritual."[13] She went on to outline a very elementary racial psychology, expanding on the idea of "national character" that had been developed in the preceding century. To all appearances, the wars between the free German peoples and the Roman masters of the world were being reenacted before her very eyes, splitting Europe in two. The Italians, the French, the Spanish, and the Portuguese had supposedly inherited their civilization, their languages, and their taste for earthly pleasures and goods from pagan Rome. As she expressed it, "like their instructors, the Romans, they alone know how to practice the art of domination." In the North, the Germans, the Swiss, the English, the Swedes, the Danes, and the Dutch belonged to those "Germanic nations" who "almost constantly resisted the Roman yoke." Civilized later by the advent of Christianity, these nations "passed instantaneously from a sort of barbarism to the refinement of Christian intercourse." Ultimately, one always found the same character traits among the various peoples of Germanic origin: they were independent, loyal, faithful, and good.[14] From the time the peoples of the North conquered those of the South, fundamentally nothing, or almost nothing, had changed in their respective characters, except perhaps—but this is an essential point—that the conquerors of yesterday now complained of being oppressed themselves.

In defining the term "Romanticism," which she qualified as "recently introduced to Germany" (curiously, she does not say where it came from), de Staël also lists the opposing forces that, she stressed, split the literary empire between them, namely "paganism and Christianity, North and South, antiquity and the Middle Ages, chivalry and Greco-Roman institutions." Anyone who rejected this partition was prevented not only from judging the "antique and the modern tastes," but also from understanding that this division pertained "also to two distinct eras of the world: that

which preceded the establishment of Christianity and that which followed it."[15] The propaganda in her book finally made it clear to the French that the wars between the romantics and the classicists were repeating and continuing those wars that had pitted the Germans against Romans, and Christians against pagans.[16] Even before the Prussian "wars of liberation" (1813–1815) against the Napoleonic empire, romanticism had begun to fight the classical order. It saw itself as a formal transgression, an aesthetic assault launched by an oppressed but young and vigorous popular spirit rising up against the constraining norms of a dull and uniform Rome, and assuredly destined to bring about its fall. The future was on its side, as it had been, in earlier times, on the side of the Germans against Rome.

The varying accounts of "barbarian invasions" that had provided France and Germany with their respective myths of origin now enjoyed a second flowering: the "barbarian invasions" and the "Frankish conquest" on the one hand, and the "migration of peoples" (*Völkerwanderung*)—that is, the migration of ancient Germans, as idealized in Tacitus's *Germania*—on the other.[17] The languages themselves transmitted two very different versions of history. Whereas *incursions*, *aggressions*, and *occupations* were recorded in French, in German we see a preference for the more neutral concept of a *displacement* of peoples. And while in France the term "barbarian invasions" referred essentially to the "German invasions" of the fifth century that had given birth to the *Regnum Francorum*, German historians had for a long time been careful to distinguish the "ancient Germans" from "barbarians." As a matter of fact, a peculiar role reversal had taken place between the Germans and the French. Throughout the eighteenth century, the court and the elites in German states were almost completely dominated by French culture, while France saw the development of the theory of "two races," which, by attributing Frankish origin to the French aristocracy, confirmed the "Germans" as the real rulers of an essentially "Gallic" French populace. So while Latin classicism imposed its aesthetic and ideological law on the German lands, in France it was "Germanic blood" that imposed its civic and political laws onto a "Latin" and "Gallo-Roman" population. On both

sides, a conflict between races doubled as a conflict between classes: the German side denounced the French and classical culture of the cultivated elites, which alienated them from the German people, while in France, the aristocracy was denounced by the revolutionaries for its German origins. In each case, racial hierarchies seemed to merge with social hierarchies.

At the beginning of the eighteenth century, the Comte de Boulainvilliers sought to turn the "barbarian invasions" into the mythical origin of the French nobility. In his view, the French aristocracy, having descended from the Franks (a coalition of separate Germanic tribes) and deriving its rights from the conquest of Roman Gaul in the fifth century, had a totally different origin from that of the common people. As a political tool designed to maintain and reinforce the rights of the aristocracy in the face of an alliance between the monarchy and the bourgeoisie (the Third Estate), this origin myth defined the French nobility as free "companions" and "equals" of the king. The "Gauls," on the other hand, were the subjects of the Germanic nobility, "as much by right of conquest as by the necessary obedience due to those with power."[18] In 1789, in a famous pamphlet that threatened the barbarians with expulsion, the Abbé Sieyès ironically turned this argument on its head, asking why the Third Estate had not sent back to the Frankish forests "all the families who clung to the foolish pretension of being the descendants of a conquering race and inheriting its rights?" But by this he meant only to better demonstrate that freedom was not a privilege of birth but the basic right of all peoples, regardless of whether they were descended from the Gauls or the Romans or the Sycambrians or "any other savages who had emerged from the forests and lakes of ancient Germany."[19]

However, after the fall of Napoleon, the restoration of the monarchy, and the return to France of aristocratic *émigrés* who, like Montesquieu, firmly believed in their Germanic origins, the time of the barbarians seemed to merge with romantic modernity. Now not only the French Revolution, which had identified with Rome and the classical antiquity that had been its model, but also the "Latin races" that had incarnated antiquity, could

be thrown onto the trash heap of history. Their decadence recalled that of Rome, and their time was on the wane, so it was said, while that of the "Germanic races" was about to start or start again, in tandem with the rebirth of Christianity in Europe. After the Congress of Vienna, which had dismantled the short-lived Napoleonic empire, a set of closely linked religious, political, cultural, and artistic reactions began to take place. In 1842, Sulpiz Boisserée, who had recently reaffirmed the exclusively German origin of the Gothic style, took pleasure in the fact that the French had been defeated "not only on military but also on moral, literary, and artistic grounds," and were even forced to "accept religious subjects" in painting.[20] Thirty years later, Philarète Chasles, a professor of German studies at the Collège de France, took a more extended view of things: "The Germanic element has been advancing for the past two centuries while the Roman has been dying on all sides." Napoleon, a man of the South, had been its last and most sublime representative, organizing and arming himself against a Germanic world "whose rise he foresaw."[21] Nevertheless, if the Latin races were visibly in decline, it was clear that the Germanic races had not yet accomplished the task assigned to them by history. Cologne Cathedral was the most striking symbol of this sense of incompleteness. For Sulpiz Boisserée, this monument simultaneously excited both admiration and regret—if in its conception it was the "most grandiose, most imposing, the most perfect of any epoch," the scaffolding that for three centuries had stood as a symbol of the impossibility of finishing the tower's summit brought to mind irresistibly the misfortunes that had prevented the final and complete creation of the nation.[22] Roman classicism was perpetually dying, while German romanticism was perpetually in the process of being born.

ROMANTIC INVERSIONS

Hannah Arendt has argued that the French, as the inheritors of a racial myth of nobility founded on the "Frankish invasions," were the first in Europe to

have been obsessed with Germanic superiority, and, she has claimed, they subsequently built their French racial theories on its premise.[23] In 1820, the same year that François Guizot wrote that the Revolution had been the decisive battle in a thirteen-centuries-long war between "the conquering and the conquered races,"[24] Augustin Thierry pointed to the "racial antipathy" that still divided the French nation: "The genius of conquest has made playthings of nature and time; it still hovers over this unfortunate land."[25] In fact, Thierry would soon add, almost all the European peoples bore the stamp of medieval conquests. The superior and inferior classes of his day were thus nothing other than the conquerors and conquered of a previous age: "The race of the invaders, when it ceased to be a separate nation, remained a privileged class."[26]

From the eighteenth century onward, European dominion over the peoples of other continents had been seen as a natural consequence of European superiority and of the "unequal perfectibility of human races." Now the works of Augustin Thierry and his brother Amédée (whose *Histoire des Gaulois* was published in 1829) propagated the idea that, in the final analysis, the history of Europe itself was intelligible only to those who understood that, here also, races were the real collective forces that had determined, and continued to determine, the course of history. Anthropologists, philosophers, economists, and historians became fascinated with the European aspect of the "problem of race," a fascination that was accompanied by a vast movement to debarbarize the ancient barbarians.[27] With the proliferation of scientific theories seeking to prove the natural inferiority of savages or peoples colonized by Europeans, it became necessary to rehabilitate the "barbarian races," who, after all, as Chateaubriand wrote, had formed "the point of contact where the history of the ancients and that of the moderns came together" in Europe.[28]

This rehabilitation of the barbarians undoubtedly contained a justification of colonialism. As Aimé Césaire clearly understood, "colonization effectively decivilizes the colonizers, brutalizes them in the true sense of the term, degrades them, and awakens in them the buried instincts of

greed, violence, racial hatred, moral relativism ... there is ultimately this poison infused in the veins of Europe, and the slow but sure progress of savagery throughout the continent."[29] Césaire cited the following sentence from Renan's *La Réforme intellectuelle et morale*, written immediately after the French defeat at Sedan: "The regeneration of the inferior and bastardized races by the superior races is part of the providential order of humanity."

In fact, several lines previously, Renan had explicitly legitimized colonization, taking as his prime example the "Germanic conquest":

> Colonization on a grand scale is a political necessity of the greatest importance. A nation that does not colonize is irrevocably on the path to socialism and to the war between the rich and the poor. The conquest of a country peopled by an inferior race by a superior race that establishes itself there in order to govern is in no way shocking. ... The Germanic conquest of the sixth and seventh centuries has become in Europe the basis of all legitimacy and permanence. Conquests among equal races are to be deplored; however, the regeneration of the inferior and bastardized races by the superior races is part of the providential order of humanity.[30]

Forty years earlier, and writing from a totally different perspective, Jules Michelet had been one of the most fervent advocates of the rehabilitation of the barbarians. In the preface to his *History of Rome*, a vivid exemplar of this perspective, he contrasted the reinvigorating vitality of the North with the barrenness of the South:

> If you seek life and freshness, go to the north, into the depths of forests without end or limit, under the green oak, watered by the continuous rains. The barbarian races, with their blond hair, their ruddy cheeks, their eternal youth, are still there. It falls to them to revive the green age of the world; Rome was

once renewed by the invasion of the men of the north; and there was needed, too, a man of the north, a barbarian, to revive the history of Rome.[31]

At this point, in 1831, Michelet introduced the figure of Barthold Georg Niebuhr, the great historian of antiquity who had recently died in Bonn. Michelet said of Niebuhr: "He all the better understands ancient barbarian Rome, in that he bore something of her in himself," and he added: "it is his glory, so far back as 1812 (twelve years before the appearance of Thierry's admirable work), to have thoroughly appreciated the importance of the question of races."[32]

This rehabilitation of the barbarians, contemporaneous with the redis-covery of the Gothic style in Europe and its long ensuing popularity, had remarkable consequences in the field of art and its history. Since the end of the sixteenth century, the traditional view of the matter, as propagated by Giorgio Vasari, had been that the Goths had "ruined the ancient buildings, and killed the architects in the wars."[33] Émeric-David was one of the first in France to rebel against this prejudiced view. For Émeric-David, the Goths, far from having destroyed ancient monuments, had in fact preserved them with great care. He pointed to examples such as Theodoric the Great, Athalaric, and the queen Amalasuntha, who were all involved in main-taining ancient monuments and building new ones. The Burgundians, the Franks, and the Lombards had encouraged artistic and literary production in all the lands they conquered.[34] Indeed, by the time the Gothic armies poured into Italy and Greece, they had "entered a land of ruins": the edifices of paganism had already been overthrown and "their idols destroyed."[35] In the same way, Séroux d'Agincourt argued against those who would impute the decadence of the arts to the barbarians, "those Northern peoples, our great ancestors."[36] Up to this time, the barbarians had been considered by definition to be without art, belonging as they did to a space beyond civilization. By the 1800s, while still not quite transformed into artists, they were no longer seen as the enemies of art. Commenting on Vasari in

1839, future director of the Louvre Philippe Auguste Jeanron was to write: "There remain the Barbarian invasions, an event of immense consequences for the question of art, and perhaps the least understood," even though, he added, they had given birth to modern art.[37]

The fact is that the meaning of barbarism had been completely reversed since Vasari's time. Not only had art, it now appeared, not perished with the arrival of the barbarians, but its real destroyers had ruined it from within, and at a much later date than previously imagined: "In a word, we have been too convinced that the sixteenth century witnessed a rebirth of painting, and quite improperly assigned the word *renaissance* to a period when, on the contrary, art began to bear the marks of its degradation."[38] Soon this became a leitmotiv of the anticlassicism that was spreading throughout Europe. After the splendor lent to art by Christianity, the Renaissance, with its revival of pagan and Roman models, could be nothing other than regression, decline, and decadence. This notion was popularized by Victor Hugo in his *Notre-Dame de Paris* (1831), where he wrote that since the sixteenth century, architecture "was no longer the essential expression of society; it turned miserably into a classical art; once it had been Gallic, European, indigenous, now it became Greek and Roman; once it was true and modern, now it became pseudo-antique. This was the decadence we call the Renaissance."[39]

At once aesthetic, political, racial, and religious, this formidable romantic inversion was, of course, closely linked to a program of propaganda that exalted not only Gothic art but also, soon after that, the baroque and, later, expressionism. It forms the real source of the history of art as a discipline, a discipline that was born precisely from these attacks on the universalism of the classical ideal and its pretense of standing outside of history. The history of art begins, therefore, with the romantic fragmentation of classical eternity—and this descent of art into historical consciousness occurred as a result of this new understanding of the role played by the barbarians. Until the middle of the eighteenth century, an antiquarian like the Comte de Caylus could still be amazed to discover "the tastes and manners" of

many nations, "mixed confusedly in one work."[40] But it was not long before Winckelmann, who had at first celebrated classicism's atemporality, would become the first to formulate the idea that the life of a style was indistinguishable from the life of a people. In 1938, Dagobert Frey outlined what we would today call Winckelmann's *ethno-differentialism*: "It is with Winckelmann that, for the first time, 'national character' was seen to lie at the origin of differences in art."[41] Winckelmann's *History of Ancient Art* (1764) not only led to a *psychology* of peoples based on the analysis works of art, it also laid the foundation for a *biological* concept of style that romanticism would later deploy in its obsessive quest for the national and racial origins of artworks. The practice of what was essentially *racial attributionism* would soon develop in the field of the fine arts, as the history of art modeled itself on the discipline of philology.[42] In this sense, most art-historical writing, at least up until the middle of the twentieth century—from Schnaase to Wölfflin, from Taine to Courajod, and from Riegl to Focillon—can be properly considered "romantic." For all of them, including the avowedly antiracist Focillon, individual art objects were assigned to "styles," styles were assigned to peoples, peoples to nations, and nations to racial entities.[43]

"The Long and Obscure Barbarian Incubation"

Viollet-le-Duc revealed the *political* reason for this *racial* classification when he opposed "Political Civilization" to "Sympathetic Civilization," the respective models of which were the Romans and the Greeks—the latter being related, according to the mythology of Aryan migration, to the "Indo-Germanic" races.[44] The civilizations he called "sympathetic" developed in agglomerations of "men of the same race or races that have certain affinities with each other," and only they could be said to possess an art of their own. Political civilizations, on the other hand, were characterized by the domination, through the means of force and of commerce, of one people over "vast territories occupied by races that have no natural

relationship to the conquerors or to each other." Such was the Roman civilization. For the Romans formed "a political and administrative body rather than a nation." And just as a Roman people could not be said to exist, but only a Roman organization or government, authentic art could not exist in Rome. In Rome, therefore, there could exist only "an organization of arts belonging to foreign *peoples*,—a very perfect organization, I allow, but one which was not and could not be the expression of the genius of a people." Viollet-le-Duc concluded that "through the course of centuries ... we see these questions of races and nationalities rise again with as much warmth and vividness as ever."[45] In 1919, the great German art historian Georg Dehio seemed to agree with him, tracing the different paths the Germans and the French had taken since the thirteenth century:

> The French, a motley conglomeration from the point of view of race, and always politically divided, aspire to spiritual unity through the use of force; while the Germans, incomparably more united by blood, love diversity above all and develop increasingly the specific physiognomy of their individual tribes (*Stämme*) and landscapes.[46]

One could see the same oppositions repeated from century to century, contrasting the political model of Rome, which had attempted to master *racial chaos* at all costs, with the Greek—but also the *Gothic* or *Romantic*—organic model, which was itself based on the idea of one race or of a more or less homogeneous group of races.

If Viollet-le-Duc played Greece against Rome exactly in the manner of the German romantics before him, he did so through his reading of Gobineau, through the filter of Aryan myth and of the myth forged by Thierry and Guizot of a France composed of "two races." This led him to the paradoxical construction whereby the French were both "barbarian" and "Greek," assuming that the Celts could be considered as barbarian as the ancient Germans. For Viollet-le-Duc, France—originally Gallic, with

a genius and art specific to it, and then subject to the Roman Empire, which was a "vast political and administrative organization, much more calculated to stifle the special idiosyncrasies of the peoples than to develop them"—had been regenerated by the influx of good Aryan blood. Hence, "these peoples of the North whom we have been taught at school to call barbarians ... were destined, by this very contribution of a purer blood, to restore to the arts a distinctive character." It was through these Northern peoples that France's racial genius—having survived Roman domination—became incarnate once more in an architecture "called *Gothic*," but which in the final analysis represented nothing other than "the awakening of the ancient Gallic spirit." Nevertheless, Roman domination soon returned in the guise of the Renaissance, suppressing the national spirit right up until the middle of the nineteenth century. For, as Viollet-le-Duc tirelessly repeated, despite their language, despite their laws, and despite their despicable imitation of Roman monuments, the French were not Latin, they were Greeks, from whom they had inherited their "appreciation of form," which they had almost lost, as he put it, "since we have imagined ourselves to be Romans."[47]

At the end of the nineteenth century, the fervently Catholic and romantic Louis Courajod—whose influence would be considerable[48]—took up these same themes, at times using the same words as his spiritual master to describe the same imaginary genealogy. But even more than Viollet-le-Duc, Courajod claimed to read this genealogy in the art objects themselves. With irrepressible hatred, this Catholic anti-communard associated ancient Rome with the "evil Italian stepmother" that had, on two separate occasions, cut France off from its Greek, Gallic, and, most importantly, barbarian roots. An unabashed Germanist, he extolled Montesquieu over and against the Abbé Dubos and the Romanists, whose "classical pedagogy" had tried to minimize the importance of both the Frankish conquest in the history of France and the "barbarian coefficient" in French art. For Courajod, all of the great defenders of the Germanist position since the sixteenth century, and right up to Geoffroy's recent rereading of Tacitus,[49] furnished

110

historical proof that in fact there had been an "open and often violent," and "real, effective and positive conquest" of France by the barbarians of Germanic origin; and, he asserted, "everything comes down to a question of race." He was convinced that from the time of the Roman conquest a terrible conflict had overtaken French lands and the French spirit. This was a conflict "between two completely contradictory intellectual principles that were forever at war: national instinct and foreign influence, freedom and absolute power, the Northern and the Southern spirit, Christianity and Latin paganism." Courajod fought with all his might to lessen the importance accorded to classical antiquity—especially Roman—in the history of culture. As he saw it, this misplaced reverence had fueled the catastrophe of the Renaissance, and brought about the "corruption of the ancient style inherited by Western peoples."[50] The barbarian invasions were therefore central to his thought, and his whole practice was geared toward affirming the notion of racial permanence, which, despite historical vicissitudes, assured the continuity of a Gallo-Germanic French art. He wrote: "I take the word 'barbarian' to refer collectively to all of the peoples of largely Germanic origin who moved into the territory of Gaul from the third to the tenth centuries. ... These peoples have between them enough ties of kinship and points of resemblance for me to be able to consider them provisionally as being part of a single family, and are such that I can include their respective cultures within a single definition."[51]

The French had forgotten, Courajod wrote, that the "Western world, which had fallen asleep pagan and Roman, had woken up Christian and barbarian"; they had forgotten "the barbarians, from whom we indisputably descend"; they had forgotten the powers of race or of "ethnic temperament," and this forgetting made the emergence of the Gothic style incomprehensible to them. As we saw in the Introduction, Pierre Leroux, imbued with the idea of the Aryan myth coming out of the new Oriental studies, had already put forward the notion that the French had forgotten their true ancestors—those men who, after the long pilgrimage they had led over the plains of Asia and the Northern ice-covered lands, had then

dispersed "like a fecund seed" over Germany, England, Spain, and France: "We, men of the North, who had left our native forests ... we had forgotten all of that, we had abandoned our heritage, repudiated the inheritance that nature gave us, and we had come, like little children who are still not old enough to talk, to make ourselves the inheritors and disciples of the Greeks and the Romans."[52]

The continuity of French art since the time of the Gauls, therefore, became intelligible for Courajod only through the "long and obscure barbarian incubation" that preceded the "flowering of the Romanesque School," of which the Gothic was "the predestined offshoot." This notion of a period of incubation was at the core of his racialized concept of art and its history. It resonated with the ideas of *awakening, reminiscence,* and, most importantly, *survival,* that he adroitly manipulated so as to bridge the gap between the biological and the cultural, allowing him to establish the hereditary nature of the transmission of forms in space and time. The "systems of art," he wrote, "circulate in the moral world in the same way that the blood of the races that invented them circulates in the veins of their descendants."[53] And while he did not deny the persistence of classical art, he never explained it using the same arguments about race, heredity, and blood—as he saw it, it was simply a foreign element, one that had survived in a modern culture that was essentially Christian and Germanic.

Accordingly, barbarian brooches and jewels from the fifth and sixth centuries—the ornamentation of which, Courajod assured us, was common to all "Indo-Germanic races"—allowed him to demonstrate not only the "fraternity" of the Celtic and Germanic races and their diffusion across the whole European continent, but also—and especially—the fact that the same "blood" produced the same forms, despite the distance of centuries. This could be seen from Romanesque and Gothic decoration, which furnished proof for the "uninterrupted and direct transmission of the family principle." For in the final analysis, "all people of Aryan origin had drawn on the same precious source"; therefore barbarian decorative art was first and foremost the "art of a race, a distant family heritage," which came from

an "old, Indian and Asiatic incubation."[54] It is undoubtedly Courajod—deploying the idea of a "survival" that was inseparably cultural and biological—whom one must credit with assembling the components of the theory of the ethnic or racial continuity of "styles" that was to determine German and French art history in the first half of the twentieth century.

The *Kunstwollen* of the Germans and Stratified Time

We know that Alois Riegl, far from disputing the importance of the Roman heritage in favor of the Oriental one—as Courajod had done, and Strzygowski would do—saw in the equilibrium between the "orientations of Germanic and Latin art" the possibility of a "worldwide mission" that baroque art in particular had assigned itself.[55] But Riegl also considered the Italian and Germanic civilizations to be radically antagonistic to one another—an antagonism that, he wrote, "persists to the present day."[56] This ambivalence, which can be found throughout Riegl's thought, lies at the heart of his primary work, *Die spätrömische Kunst-Industrie nach den Funden in Österreich-Ungarn (Late Roman Art Industry)*. This work was to have two parts: the first was to be an inquiry into the fate of the decorative arts from the third century CE onward among the Mediterranean peoples, who had until then been at the forefront of civilization. The second would determine the role the barbarian peoples of the North had played in the formation of the fine arts during the five centuries between Constantine the Great and Charlemagne.[57] Only the first part was published during his lifetime, in 1901. In this work, it is generally understood that Riegl sought to demonstrate that the progressive abandonment of the classical ideal had nothing to do with differences in the ethnic composition of the Late Roman Empire after successive Germanic invasions. What had formerly been considered a degeneration of classicism was, for Riegl, the emergence of a new style, corresponding to a new *Kunstwollen*.[58] But since Riegl also wanted to assign each race its own specific *Kunstwollen*, the result was a profound ambiguity.

———

The second part (lecture notes from his courses at the University of Vienna) was published in 1923. It features an interesting introduction, by Riegl himself, that has generally received little attention despite the fact that it sketched out a remarkable parallel between political and artistic events in the Late Roman Empire during the Germanic migrations. Just as "the political events of the migrations were for the most part the consequence of the Will (*des Willens*) of the Romans (even if this was unconscious) ... the artistic productions of the migration period were for the most part the result of the aesthetic Will (*des ästhetischen Wollens*) of the Romans."[59] It was therefore impossible to speak of the art of this period as a "barbarian" art. On the other hand, as Riegl saw it, classical art had been "barbarized" even before Germans entered the history of civilization. From around 375 CE, the classical temperament was already in the process of being lost, and moving closer to the inferior taste of the Germanic barbarians. But, Riegl added, throughout the fourth century one could see

> continual Classical reactions against the thrust of the evolution toward Christianity (that is to say, the cult of a crucified god as state religion). From time to time, the Romans recalled the past and did not want to abandon it; they wanted to stop this evolution by force. Here already we see the so-called barbarian (*das sogenannte Barbarische*) element becoming specifically the element of progress (*das eigentliche Fortschittliche*). Both in the political sphere and in the artistic sphere, it was the interventions of the Germans that cut off the return to the ancients, provoking thereby a decisive turn toward an art constructed on new, non-Classical principles.

Nonetheless, it became possible to differentiate the *Kunstwollen* of the Germans from that of the Latin peoples only after the migrations. But this difference, he specified, "despite everything, must already have been present during the time of the migrations, and the fact that we cannot identify

it at first glance does not free us from the responsibility of trying to understand it."[60]

Otto Pächt, one of Riegl's most fervent disciples, noted that despite Riegl's professed concern for neutrality, his preference for the art of the Northern peoples was clearly discernible.[61] This is surely an understatement. From 1898 onward, Riegl's entire theoretical apparatus, clearly set forth in his *Historical Grammar of the Visual Arts*, was devoted to demonstrating the driving role of the "peoples of the Germanic race" in the evolution of Western culture in general and of Western art in particular. It is difficult not to be perplexed at the immense and lasting success of his theories, given the extreme precariousness of some of the principles on which they are founded. Riegl took the highly fruitful opposition between the "tactile" (or haptic) and the "opticality" of art objects, as formulated by the sculptor Adolf von Hildebrand in 1893, and projected it simultaneously onto history and the psychology of races. Inspired by a German romantic tradition, he decisively transformed Hildebrand's concepts of *Nahbild* (near image) and *Fernbild* (distant image), adding to them the notion of *Normalsicht* (normal vision). Now, when Hildebrand had sought to differentiate "our vast experience of the relations existing between the visual and kinesthetic sensations," he had done so as an artist concerned to justify his own artistic choices, and it was in the name of "experience" that Hildebrand employed these perceptual categories: "our knowledge of the plastic nature of objects is derived originally from movements which we make either with eyes or with hands."[62] It was precisely these purely phenomenological categories that Riegl was to project onto a racialized history, psychology, and geography that he inherited from romanticism.[63] Tactility became for Riegl a property of classical art, one that evolved into the opticality peculiar to modern art, and he transformed these qualities into artistic criteria reflecting the cultural opposition between the German and the Latin models. As Julius von Schlosser, an old colleague of Riegl's from the University of Vienna, pointed out, Riegl had taken up the "highly dubious" notion of a "racial psyche," which he "hypostatized through the opposition of the

optic and the haptic."[64] These opposing visual qualities attributed to artistic objects were not only the products of different racial psychologies. As Riegl asserted in the first part of his *Late Roman Art Industry*, they were, first and foremost, the products of biological dispositions that demanded their own particular artistic response:

> To the sense perception of the ancients, external objects appeared confused and mixed; by means of the visual arts, they took individual objects and represented them as a clearly finished unity. The ultimate goal of visual art during all of antiquity was thus to give back to external objects their clear material individuality.[65]

This reads like a version of embryological parallelism, i.e., for Riegl, the ancients were as sensorially handicapped as a newborn baby. His Hegelianism and evolutionism, as Meyer Schapiro rightly pointed out, had led him to describe a historical process where every "great phase corresponds to a racial disposition."[66] This allowed Riegl to state that after two centuries of dominance in the West, French art had to "surrender its erstwhile leadership to Germanic stock of purer racial consciousness."[67] So the "people of the Germanic race," more spiritual and more "optical" than those of the Mediterranean, were called on by nature to occupy the summit of evolution.

The French art historian Henri Focillon assigned to the ancient Germans the exact opposite position on the ladder of evolution: he claimed that, in a sense, they belonged to prehistory or to "protohistory," and he was just a step away from thinking that twentieth-century Germans could be similarly described. He refused any hint of a linear concept of evolution. For Focillon, just as history was first and foremost "a conflict among what is precocious, actual or merely delayed," the history of art showed "juxtaposed within the very same moment, survivals and anticipations, and slow, outmoded forms that are the contemporaries of bold and rapid

forms."[68] This was because "at any given time, all regions do not inhabit the same epoch," and the present itself was always infinitely stratified.[69] Still, what disturbs us today about Focillon's work is the regularity with which his discussions of these ideas (ideas that were new at the time) about the structure of historical time are to be found side by side with his recourse to the "idea of race," and in particular to the idea of historical and contemporary barbarians. This seductive vision of a history constructed out of survivals and anticipations seems to have emerged for Focillon out of his reflections on the place of the barbarians in history, and in response to the racial theories that a number of his German colleagues were promoting at the time.

In 1915, Focillon condemned the Germans for having founded their empire on "a notion of race ... that objective anthropology no longer accepts as a scientific principle," and for having "restored this outmoded term." But he immediately contradicted himself by presenting the art of the German empire as "the program of a race and the condensed version of its instincts," "a barbaric upshoot in the middle of civilization, sprouting up in the heart of the West."[70] In short, Focillon asserted that this backward race used obsolete notions to prolong its own past and reawaken its inner barbarian. Yet despite his sincere conviction that he was fighting against racial determinations, Focillon, with remarkable obstinacy, continued to use the "notion of race" in its most biological definition. This was because, like many of his antiracist contemporaries, he really believed in the reality of race. Of those of his enemies whose racial prejudices he wanted to combat, he wrote: "they have concretized this unstable force."

Having been raised in the aftermath of the Franco–Prussian War of 1870–1871, having lived through the Great War, and then dying in the United States in 1941, Focillon belonged to a generation for whom each of these wars was a reminder of, if not a return to, the "great Germanic invasions." All of his work devoted to the Middle Ages—which forms the greater part of his *œuvre*—is a commentary on these invasions, culminating in the patriotic exaltation of his last texts, in which he condemned Germany

for being "uncertain of its geographic form, its political form, its moral form," and "haunted by an instinctive nostalgia for those massive migrations of the barbarian peoples, that [in France] we call the invasions."[71]

As he had during his disputes of 1932 and 1934 with the Austrian Josef Strzygowski (the most fanatical of the racist art historians, and a sworn enemy of Riegl), Focillon developed a remarkable argument in *The Life of Forms in Art*.[72] He wrote that he did not want to put forward yet another critique of the "old concept of race ... [that] has, at the hands of ethnology, anthropology, and linguistics, always been beset by a good deal of confusion." Race, he argued, was not stable or constant, and "conservatories in which pure races may be found in flower" could not actually exist anywhere. Nevertheless, it was important to take into account these "age-old deposits laid down by time," which art sometimes revealed in a "strange relief," adding: "They stand out like great rock-faults, tokens of the past in a landscape now at peace." Therefore, even if "families of the mind" could superimpose their network of influence onto the pattern of races, one could still associate races with formal units:

> Has it not been maintained that ... certain formal systems are the authentic possessions of certain races? That the interlace is the image and symbol of a mode of thought characteristic of northern peoples? I would answer that the interlace, and in a more general way, the entire vocabulary of geometry, are the common property of *all* primitive humanity, and when they reappear at the beginning of the high Middle Ages, masking and distorting the anthropomorphism of the Mediterranean world, *they by no means represent the shock of impact between two races, but instead the meeting between two kinds of time, or, to put it more clearly, between two kinds of human society.*[73]

Less linear than Riegl's, Focillon's evolutionism, therefore, did not assign to each race a definite historical position. He introduced into art

history the idea of a layering or stratification of time—similar to what Ernst Bloch, at that period, described as the irruption in the present of the "non-contemporary." And yet, despite all of this, Focillon did follow the nineteenth-century practice of racial differentiation or essentialism, a practice linked to a notion of the limited perfectibility of certain races, and the idea that those races were thereby destined to remain forever tied to the same forms throughout history.

Without doubt, ever since the beginning of the nineteenth century, the barbarian invasions have constituted a mythical place and time, providing the basis on which a nonclassical art history has become possible. If Winckelmann had been the "first to analyze antiquity,"[74] defining the times, the peoples, and the styles of the ancients, one still had to analyze that which was neither antiquity nor its rebirth. In order to move beyond classical eternity, beyond its normative values, one still had to invent new temporalities, which were neither those of Vasari's *Lives* nor the dynastic periods of national histories. The barbarian invasions, a constitutive moment for modern European peoples, were seen by the romantics and by some of their successors as the model for a new and absolute beginning. But the price paid for this new beginning was the construction of other eternities, in some sense parallel to and rivalling classical eternity; and the underpinnings of these new eternities were to be the *races*.

4

A New Barbarian: The Artless Jew

By the middle of the nineteenth century, the barbarians had become thoroughly rehabilitated in Europe. As the worthy inheritors and protectors of ancient Greek culture, they were now fully acknowledged as the creators of what was essentially a new civilization—in conjunction with Christianity, they had reestablished the arts in Europe. At this point in time, the emancipation of the Jews came to be seen as a new threat to European civilization, jeopardizing the cultural identity of each of its peoples. A new anti-Semitic argument also appeared to counter this danger. The Jewish people were suddenly declared to have no art; they were "artless." The Jews were thus assigned to the symbolic place previously occupied by the barbarians. The figure of this new barbarian, the *artless Jew*, marked the transition from a religious anti-Judaism (very much present in Hegel and Feuerbach) to a powerful racially based anti-Semitism whose principal herald was Richard Wagner. The Jews were declared to be artless and incapable of producing anything of artistic worth, and this was now no longer simply because their religion forbade graven images and representations of living forms (Exodus 20:4) but rather, as Wagner wrote in 1850, because of their "race," attributing thus to the Jews traits assumed to be hereditary and immutable.

In order for us to fully understand the reasons and conditions underlying the emergence of this enduring theme (one that will reach its apogee a century later with National Socialism, but will not disappear along with it), we should unravel several threads: the intense reactions to the emancipation of the Jews and the efforts at national unification in Europe; the Second Commandment of the Law of Moses and the Christian dogma of the incarnation of the Father in the Son; and finally, German philosophical idealism and the influence that physical anthropology was to have on philology.[1] Although it is true that the theme of the artless Jew could have arisen only after new functions had been assigned to the fine arts in the European arena, the fundamental reasons behind its appearance were firstly and inextricably religious and political, and only secondarily aesthetic and racial.[2]

Against the universalism of the Enlightenment, Herder had declared that every *Volksgeist*, every spirit of a people, found its unique expression in its own language and folklore, and Karl Schnaase was to make even clearer this new idea according to which the spirit of a people found its supreme incarnation in its art. Schnaase wrote in 1834: "Art is the most faithful consciousness of a people, the incarnation of its judgment of the value of things; what is recognized as spiritual in life takes on form in art."[3] Ten years after this, and having attended Hegel's lectures at Berlin during the 1820s, Schnaase was to claim, in his *History of the Fine Arts*: "the finest and most characteristic traits of the soul of a people can only be known by its artistic creations." For Hegel, the work of art, insofar as it was one of the means by which humanity exteriorized its own being, was a form of reproduction of the self through which the subject attained self-consciousness. However, whereas for Hegel the precise nature of the subject was to remain undetermined, this was not so for Schnaase, who made art the "most faithful consciousness" not of a particular individual, but of a people. So it was in and through art, understood as a *collective* activity, that a people recognized themselves as one people; they took possession of themselves, and constructed their identity as a people. But in order for art's mediation to

properly fulfill its role, a people needed a *mediator*. For Schnaase, every nation revealed its "secret essence" in art as in a "hieroglyph" or a "signature" which might appear obscure at first, but which became perfectly intelligible to those who knew how to read the signs.[4] This, then, was the task of the history of art: to show that the art of each people embodied an "unbroken tradition" (*eine bleibende Tradition*), and to try to bring to light and interpret that tradition. Better still, its purpose was to show that art was a people's "central activity" in which were defined "all of its spiritual, moral, and material aspirations."[5] Therefore it was the historian of art who, by deeply examining the art of a people, could tell that people, better than anyone else, who they were, from whence they came, and where they were going.

More so even than language,[6] art was henceforth to take on the essential role of guarantor of a nation's heritage. Art assured the self-identity of a people or a nation, transmitting to a nation's current and future generations the highest values inherited from its past. The visual arts were increasingly to be seen in Europe as harboring the protecting genius of a nation, the visible incarnation of a people's spirit—the Mediator able to guide each nation toward its final unity. Hence Michelet, in 1846, maintained in his lectures at the Collège de France that every national tradition could be seen in its art: "Yes, the more I study and examine genuine art, the more I find that in so many cases it is an extraordinary exponent of the national genius of a people." Even if "the revelation of the soul of our homeland through art" had emerged only slowly in France, it was nonetheless true that the "national character" could be seen "in its taste for ornamentation and decoration."[7] Since the French Revolution, the removal of the monarchical principle in France and Germany had rapidly had its influence on art, and the legitimacy of artistic practice derived now from its ability to satisfy the expectations not of the monarchy but of the "People." Finding its source in the People, it was all the better able to express the people's "national character." Toward the end of the eighteenth century, the widespread conviction that the continuity of a national genius was set down

and ensured by the fine arts was transforming, little by little, the reception of the works of the past. Giving concrete form and space to the fiction that there existed a spirit peculiar to every nation, museums played an ever greater part in shaping national attitudes to works of art. Museums produced and maintained a national cult of art whose function was to preserve the purity of "autochthonous" values transmitted down the generations.[8] This conviction, assigning primarily to artists the task of expressing the national genius and creating its image, transformed artistic activity, at least symbolically, into an eminently public responsibility.

"An Odious Travesty of the German Spirit"

Quite possibly, it was Richard Wagner who, in 1850, was the first to question the legitimacy of the European Jews' artistic activity. Published shortly after a new step had been taken in the emancipation of the German Jews, and after the failure of the revolutionary movement in Dresden in 1849, Wagner's *Judaism in Music* actually extended to all of the arts his virulent critique of the Jews' active presence in German public life. Wagner wrote:

> A language, with its expression and its evolution, is not the work of scattered units, but of an historical community: only he who has unconsciously grown up within the bond of this community, takes also any share in its creations. But the Jew has stood outside the pale of any such community, stood solitarily with his Jehova in a splintered, soilless stock.

As a result, applying this argument to all of the arts, Wagner declared: "neither can we consider him [the Jew] capable of any sort of artistic utterance of his [inner] essence." Essentially, the ultimate justification for such a blanket denial was racial, not historical—it was to be found in the "Jewish nature." Physically, the Jew showed himself to be "unfitted for artistic activity—not merely in this or that personality, but according to his race."[9]

124

To this racial-aesthetic argument that Wagner was using here to account for what he called "the *involuntary repulsion* aroused in us by the nature and personality of the Jews,"[10] he added a more anthropological argument: "The Jews' concrete sense of Beholding has never been of such a kind as to let plastic artists arise among them: since the dawn of time their sights have been set on far more practical matters than beauty and the spiritual substance of the world of forms."[11] Here, then, was the age-old accusation of materialism held against the Jews; however, Wagner's characterization of Jews as interested only in the "practical principle," and blind to any sort of beauty, also derived directly from Ludwig Feuerbach, whom Wagner admired so much that in the same year, 1850, he dedicated *The Art-Work of the Future* to him. In *The Essence of Christianity*, Feuerbach had said, some years earlier, that the God of Judaism was "the most practical principle in the world,—namely, egoism; and moreover egoism in the form of religion." To the Greeks, who "looked at Nature with the theoretic sense," he symmetrically opposed the "Israelites [who], on the contrary, opened to Nature only the gastric sense." In this way, therefore, the ethnic-racial division of humanity was simultaneously an aesthetic division: "the theoretic view is aesthetic, whereas the practical is unaesthetic."[12]

Wagner took this aesthetic contrast between Greeks and Jews (a theme that was to become essential to modern anti-Semitism) and, in these two works that he composed almost simultaneously, he examined each of the two poles of the antithesis. *Judaism in Music* was, therefore, the necessary complement to *The Art-Work of the Future*. In *Judaism and Music*, Wagner forcefully denounced the Jews for undermining the Greek and Christian ideal, the very same ideal that *The Art-Work of the Future* strongly affirmed. It was "egoism," Wagner said, that was preventing the realization of "the *mutual Art-Work of the Future*" through which "our great redeemer and well-doer, Necessity's viceregent in the flesh,—*the Folk*, will no longer be a severed and peculiar class; for in this Art-Work we shall be *one*."[13] As we know, this communally grounded *Art-Work* of the future was the incarnation and prefiguration of the social and political unity of Germany

for which Wagner hoped, and for which Bayreuth was later to supply the model. Now, as Wagner explained in *Judaism in Music*, these newly emancipated Jews, cultivated and foreign to their own "uncultured" people, who had "held it wise to make a Christian baptism wash away the traces of his [their] origin," remained so perfectly apart from the truth of an art organically tied to the people that they could see that art only as "a venal article of Luxury." Accordingly, Wagner continued: "To him [the Jew], therefore, the most external accidents on our domain of musical life and art must pass for its very essence; and therefore, when as an artist he reflects them back upon us, his adaptations needs must seem to us outlandish, odd, indifferent, cold, unnatural and awry."[14]

Later on, in the years 1860–1870, in his essay "What is German?," Wagner attacked "this invasion of the German nature by an utterly alien element," producing "an odious travesty of the German spirit upheld today before the German Folk, as its imputed likeness." He added: "It is to be feared, ere long the nation may really take this simulacrum for its mirrored image."[15] Thus the old Christian theme of the "deicidal people" was extended to include a Judaism that, through caricature, was seen as deforming and destroying the pure image incarnating the national spirit. But still more deeply, Wagner's accusation took as its fundamental justification the innate inability of the Jews to exercise any power mediated by the visible—the very essence of religion.

The Art-Work of the Future emphasized, in fact, that "Any art that is not intended to be looked at remains unsatisfying ... it remains a thing that merely *wills*, yet never completely *can*."[16] Here again, Wagner's guide was Feuerbach. In thunderous tones, the latter had stigmatized the inability of the Jews to recognize in the Son the beautiful image of their own invisible God. For Feuerbach, in effect, no *hidden God* that is simple desire could ever be an object for religion. To this abstract idea of the "Godhead in general" he had opposed the figure of the Mediator—the Son who provided "the satisfaction of the need for sensuous images," who "converts the abstract being of the reason, the being of the thinking power, into an object of sense or imagination," and who interposed himself precisely in order to *distance*

and *deny* this abstract idea, "because it is no object for religion." In this way, the Son was to take the place of the hidden God whose image he was. Finally, deriding theological sophisms that distinguished between *latreia* and *doulia*,[17] Feuerbach came to this conclusion: since "the image necessarily takes the place of the thing," the "adoration of the saint [*das Heiligen*] in his image is the adoration of the image as the saint." Thus it was that Feuerbach situated "the essence of religion" in the image.[18]

Portraits of Emptiness

Feuerbach, as a "young Hegelian," had certainly understood his master perfectly on this point. In *The Spirit of Christianity and its Fate*, completed around 1799 and thus a dozen years after the emancipation of the French Jews, Hegel had connected in a remarkable fashion the *spiritual inactivity* of the Jewish people to the *emptiness* of their tabernacle that contained no perceptible image of their national God. In the *Critique of Judgment*, Kant had, in fact, emphasized the sublime nature of the Second Commandment, forbidding "any graven image" of the living, and making it "necessary to moderate the momentum of an unbounded imagination" rather than "from fear of the powerlessness of these ideas [the moral law], to turn for help to images and childish devices."[19] In absolute contrast, in the lectures on aesthetics that he would later give in Berlin, Hegel was to oppose the Christian God, who allowed Himself to be represented in his "own determinacy" by a "concrete" content, to the God of "the Jews and the Turks," so deprived of content that He could in no way be expressed by art.[20]

But it was in his earlier work, *The Spirit of Christianity and its Fate*, that Hegel was to set out the argument of Jewish aniconism in its greatest breadth. For the Jews, he explained,

> The infinite subject had to be invisible, since everything visible is something restricted. Before Moses had his tabernacle, he showed to the Israelites only fire and clouds which kept the eye busy on a vague play of continually changing shapes with-

out fixing it on a [specific] form. An image of god was just stone or wood to them; "it sees not, it hears not," etc.—with this litany they fancy themselves wonderfully wise; they despise the image because it does not manage them, and they have no inkling of its deification in the enjoyment of beauty or in a lover's intuition.

Though there was no concrete shape to be an object of religious feeling, devotion and reverence for an invisible object had nonetheless to be given direction and a boundary inclusive of the object. This Moses provided in the Holy of Holies of the tabernacle and the subsequent temple. After Pompey had approached the heart of the temple, the center of adoration, and had hoped to discover in it the root of the national spirit, to find indeed in one central point the life-giving soul of this remarkable people, to gaze on a Being as an object for his devotion, on something significant for his veneration, he might well have been astonished on entering the Arcanum to find himself deceived so far as some of his expectations were concerned, and, for the rest, to find himself in an empty room.[21]

Corresponding to this emptiness of the national spirit—underwritten by the absence of any perceptible content in the Jewish temple—Hegel pointed to the spiritual emptiness of the Sabbath: "But for living men, otherwise free, to keep one day in a complete vacuum, in an inactive unity of spirit, to make the time dedicated to God an empty time, and to let this vacuity return every so often—this could only occur to the legislator of a people for whom the melancholy, unfelt unity is the supreme reality." Since "Spirit alone recognizes spirit," the Jews could see in Jesus "only the man, the Nazarene, the carpenter's son whose brothers and kinfolk lived among them; so much he was, and more he could not be, for he was only one like themselves, and they felt themselves to be nothing."[22]

These speculations were essentially a new formulation of the theory of the self-portrait god—the Jewish God mirrored the moral character of the Jews, a character faithfully portrayed by the emptiness of their temple. Equally striking is the fact that emptiness itself changed its value for Hegel, depending upon whether it was Christian or Jewish. Thus it was precisely when the Crusaders, arriving in Jerusalem, found Christ's tomb empty, that Christianity experienced what Hegel called its "real point of retroversion," saying: "it is in the grave that all the vanity of the Sensuous perishes," affording to them the consciousness of the purely spiritual existence of their God.[23]

In any event, it was certainly on the shoulders of Hegel that Wagner sought to bring about in the *mutual artwork* the radiant unity of the German people, the full and living incarnation of their national god—the exact opposite of the collective nothingness of the Jewish people and their "melancholy, unfelt unity." Wagner aimed to construct this artwork, therefore, as the countertype, opposing emptiness and standing against and in spite of the Jewish people, the naysayers of any divine incarnation and strangers to any "lover's intuition" and "enjoyment of beauty." Thus also the *mutual artwork* was to be a response to the failure of Christianity, a failure that Wagner saw in the dose of "utopia" that Christianity had inherited from Judaism, as it offered to men only "a truly unattainable ideal." From Feuerbach also, for whom the image had banished the jealous God whose place it took, Wagner understood that, "better than a decrepit religion to which the spirit of public intercourse gives the lie direct; more effectually and impressively than an incapable statesmanship which has long since lost its compass," art alone was able to supply the People with "the goal of noble Manhood."[24] From this point on, there could surely be no ideal held in common with the Jews whose God, devoid of any perceptible form, deprived them of any national art and any noble ideal. It was for this reason also that Hegel, as a good Christian, predicted that the Jews' original fate would hound them "until they appease it by the spirit of beauty and so annul it by reconciliation."[25] Likewise, Wagner concluded *Judaism in Music* with these

words: "But bethink ye, that only one thing can redeem you from the burden of your curse: the redemption of Ahasuerus—*Going under!*"[26]

Just like all motifs of anti-Judaism, the theme of the artless Jew was designed to isolate the Jews from all of the peoples of Europe, and to deny them any right to participate in the development of the collective life of the State. This argument was doubtless possible only after art had become a national affair, i.e., after the aesthetic dimension had been characterized (particularly since Kant and Schiller) as having a determining and shaping effect on the shared forms of social relations. For example, François Miel was to write in 1819: "The arts have so much power over individuals and society that they naturally form part of the general system of public administration."[27] But this argument would itself not have been possible before the eclipse of the universal Christian God and its corollary: the resurgence of all of the national gods and spirits. Just as the Christian God had been incarnated in the figure of Christ, so now each national Spirit was to be incarnated in a national art, making the Spirit of its people visible and revealing it to them. Each of the national arts embodied the "real presence" of the Spirit of the people in exactly the same way that the Christian host embodied the real presence of Christ. In this splintering of European Christianity into a multiplicity of forms of worship of national arts, it transpired that the more the nations sought to create what Barrès was to call a "national consciousness," the more loudly they declared that the Jews, whom they had only just emancipated, were artless. Contemporaneous with (or at least closely following upon) the emergence of these national forms of this new religion of art, the complaint against the artless Jew, as we saw quite clearly in the writings of the young Hegel, was grafted onto, and thus perpetuated, one of the oldest themes of Christian anti-Judaism. The content of this discourse was everywhere the same: just as the Jews had not been able to recognize the Messiah in Christ, they were incapable of recognizing the Spirit of a people in any national art; they thus remained fundamentally estranged from all such spirits, whose visible images they were bound to destroy, just as they had once crucified Christ. Once again,

therefore, we have the denial of the very legitimacy of the presence of the Jews within the European nation states. This new complaint against the artless Jew was certainly a secular and temporal response to the emancipation; however, it drew strongly upon archaeology and the history of art, and it appealed to these young sciences of the past in order to justify its condemnation in the present.

Winckelmann's reticence concerning the supposed artlessness of the Jews was soon forgotten. He had been inclined to think that the fine arts, which he qualified as "superfluous to human life," had never been practiced by the Jews to the extent that "sculpture was forbidden to the Jews under Mosaic law, at least with respect to representing the deity in human form"; however, he admitted that it was not possible to conclude from this that the Jews had no art whatsoever: "Their appearance, like that of the Phoenicians, would nevertheless have made them apt to beautiful ideas, and Scaliger observes of their modern descendants that there are no Jews with flattened noses—an observation that I have found to be correct."

It was therefore probable that, despite their lack of high regard for art, they "must have attained a relatively high level of skill in drawing and in artistic craft," since Nebuchadrezzar had taken from Jersualem alone thousands of workers in inlay. Winckelmann commented: "In the largest cities today, it would be difficult to find such a number."[28] Toward the middle of the nineteenth century, however, Daniel Ramée began to contrast "Semites" with "Aryans," according to the *topos* that was by then widespread in Europe. By 1843 he was railing against recent thinking which, through its ignorance of the literature, religion, and history of India, "made everything descend from the Jewish people." He argued that, as a result of research carried out by Hammer, Goerres, Rohde, Creuzer, Schlosser, the "two Schlegel brothers," Bohlen, and Ritter, it was now an accepted fact that the "mother country" of the peoples who made up the "true stock of the entire human species," and were the "origin of civilization," was to be found in Asia, in the region of the Caucasus.[29] Ten years later, in his *Théologie cosmogonique*, Ramée postulated that the "Caucasian race," the race that

made up European humanity, was under threat from the "Semitic race," a tiny minority that had to be, "if not subordinated completely in politics and social life, then sent back to Arabia!" This, he thought, was "the great question throughout Europe, of the greatest current importance, the only question, both general and particular—there are no others."[30] Finally, in 1860, he had no compunction about saying: "there is no art among the Semites because the Semite is always an individual, incapable of raising himself up to the idea of a community. He thinks only of himself and in the present."[31] Still, by itself, the stereotype of the "egotistic" Jew obsessed with his own immediate interests would not have been enough to justify the claim about the Jews' incapacity for art, and therefore their exclusion from the national community—indeed, from the whole of Europe. So for this reason, borrowing from Ernest Renan's recently formulated "desert theory," Ramée grounded his argument for the artistic incapacity of the Jews in their biology—in their "race." The Jews, he wrote,

> contribute absolutely nothing to the progress of civilization and intelligence. ... The Semitic race, built for the nomadic life of the desert, survives in those regions where it descends on the land despite the antagonism that the Aryan race harbors against it. The Aryan race alone can acclimatize itself in all latitudes. ... It is the civilizing race *par excellence*, and the only one that has left to posterity architectural monuments in all of the lands it has reached.[32]

It would be an understatement to say that, in a context such as this, the research carried out by Félicien de Saulcy for his *Histoire de l'art judaïque tirée des textes sacrés et profanes* was poorly received. Reexamining in the light of archaeology the axiom according to which "Judaic art" had "never existed,"[33] his work garnered heavily ironic comments from his contemporaries. Consider, for example, these remarks from Renan:

M. de Saulcy has proven, against those who might doubt it, that the Jews, outside of those periods of great architectural activity (an activity led, it is true, by foreigners), did have a quite well-developed everyday art. However, we can be sure that, by themselves, they never would have attained such a great fecundity as, by covering a land with enduring monuments, to command in some way the future and defy all the agents of destruction.[34]

Up to this point, therefore, the Jews had been judged to be innately incapable of any sort of artistic creation. Now, however, little by little, a new charge came to be leveled against them: they were the *destroyers* of art. Just as the Mosaic ban on "graven images" had been used to deny the existence of any Jewish art, the theme of the Jew as destroyer of idols was metamorphosed into that of the Jew as the destroyer of the art incarnating the national Spirit. Since the art of a nation was the nation itself—as the image of Christ was the Christ—it was essential to keep the Jews away from the now sacred task of giving form to the Spirit of the people. It was the State that was now guardian of that Spirit, and responsible for its transmission. Since Constantine— i.e., since Christianity had become a state religion— the Jews had been excluded, in the name of religion, from any involvement in the affairs of the State. If it were true that their emancipation was desirable in civil society, it was nonetheless *politically dangerous*, as Schopenhauer wrote in 1851. He called for "marriages to be permitted and even encouraged between Jews and Gentiles," explaining it thus:

> Then, in the course of a hundred years, there will be only a very few Jews left and soon the ghost will be exorcized. Ahasuerus will be buried and the chosen people will not know where their abode was. This desirable result, however, will be frustrated if the emancipation of the Jews is carried to the point of their obtaining political rights, and thus an interest in the administra-

tion and government of Christian countries. For then they will be and remain Jews really only *con amore*. Justice demands that they should enjoy with others equal civil rights; but to concede to them a share in the running of the State is absurd. They are and remain a foreign oriental race, and so must always be regarded merely as domiciled foreigners.[35]

This was therefore also the time during which artistic activity was everywhere recognized as an eminently political activity that had to be kept safe from the destructive jealousy of the Jewish God—from what Feuerbach had called "egoism in the form of religion." Still, although the idea of the artless Jew, destroyer of national art and threat to the integrity of the nation state, had been articulated all of a piece and in both aspects by Richard Wagner, time was needed for it to slowly take on its full religious, political, and racial weight before reaching its paroxysm in the 1930s and 1940s.

"This Ugly Little Jew"

The emancipation of the Jews having more or less wiped out those marks of infamy that Christianity had institutionalized, it was now necessary not so much to restore those same marks, but to replace them with ones that would, this time, remain indelible. This was the role taken on by the racial doctrines that claimed to establish scientifically, on the basis of natural and immutable facts, what the Church and the State had previously constructed solely upon canon and secular law, i.e., through theological and political decisions.[36] Two steps were needed before it would become possible to prove that the artistic incapacity of the Jews was primarily natural, and that it was neither the consequence of a mere religious interdiction nor a simple fact of culture. In a Europe that remained thoroughly and profoundly impregnated with Christianity, the first step was to de-Judaize the religion of the State (often this involved dispossessing the Jews of the

discovery of monotheism), and the second step was the biological Aryan-ization of Christ.[37] Finally, therefore, the European peoples would be, body and soul, removed from and purified of any Jewish origins.

It was Émile Burnouf, the great Hellenist and India specialist, who was first to carry out these steps. He did so thirty years before Houston Stewart Chamberlain, who is too easily credited with having been the first to offer a theory of the Aryanization of Christ in his *Die Grundlagen des neunzehnten Jahrhunderts* (Foundations of the Nineteenth Century), a work that was not published until 1899. Burnouf's *The Science of Religions*, pub-lished initially in the form of articles in the *Revue des Deux Mondes* from 1864 to 1868, and almost entirely devoted to the de-Judaizing of Chris-tianity, was based upon a number of sweeping racial differentiations. To begin with, Burnouf claimed (as others had done before him, although this time he had the proofs in hand) that "Christianity as a whole has an Aryan doctrinal tendency, and comparatively little in common with Juda-ism as a religion. It was, in fact, instituted despite and in opposition to the Jews." In fact, he wrote, "we must look for the primordial source of our religion in the hymns of the *Veda*, and not in the Bible," since "the theory of Agni is identical with the theory of Christ." Indeed, he declared himself to be "in a position to identify the different parts played by the different races not alone in the formation, but also in the originating of Christianity."[38] Now, it is true that Ernest Renan's *Life of Jesus*, published shortly beforehand, had opened the way for these ideas. Dividing Judea in two, Renan had proclaimed in peremptory tones the superiority of a free and "revolutionary" Galilee over a Jerusalem delivered unto the Phari-sees: "It was the North alone that created Christianity; Jerusalem, on the other hand, was the true home of the stubborn Judaism which, founded by the Pharisees and fixed by the Talmud, has traversed the Middle Ages and come down to us."[39] But Renan's geographical division was soon to be transformed into a racial division of the Jewish people, amongst whom Burnouf now detected the presence of Aryan elements. Thus Burnouf wrote:

———

the Jewish people consist of two distinct races ... at enmity with each other since the remotest times. The bulk of the Israelite nation was Semitic, and adhered to the worship of Elohim, personified in Abel. The rest, which were always in the minority, were like strangers from Asia, practising the worship of Jehova. They were probably Aryans; their headquarters were taken up north of Jerusalem, in Galilee. The people of that country again form a striking contrast to those of the south; they resemble Poles. It is they who infused, partly at least, into the worship of the Hebrews all that there is of mythology, and into the earlier books of the Bible all there is to be found of a metaphysical nature.[40]

Thus he was able to clearly establish that Jesus the Galilean, even if he did not exactly resemble a Pole, belonged without a trace of a doubt to the superior Jewish minority whose roots were Aryan. This allowed him to explain biologically, in the terms of physical anthropology, the racial "enmity" felt by those worshippers of Elohim, "the bulk of the Israelite nation," toward the superior doctrine of Jesus, which was utterly incomprehensible to them. Burnouf, moreover, included Judaism among the religions that had died out, and he was proud to say that he had discovered the "one law [that] presides over the birth, the growth, and the destruction of all religions." Now this law was not written in the religion of the people, nor was it inscribed in their institutions; it resided, rather, in the "difference of races." Why, Burnouf asked after his expedition to China, did he seek in vain for "a Chinese mathematician in Pekin [sic]"? The reason was that "general notions of an abstract nature are quite foreign to that race of men who lack the requisite part of the brain." In the same vein, he wrote:

A real Semite ... belongs to the occipital races; that is to say, those whose hinder part of the head is more developed than the front. His growth is very rapid, and at fifteen or sixteen it is

over. At that age the divisions of his skull which contained the organs of intelligence are already joined, and in some cases even perfectly welded together. From that period the growth of the brain is arrested.

These physiological limitations entailed, for Burnouf, the evident consequence that the

> cerebral and intellectual development of a Semite ceases before he has reached the age at which man is able to grasp such transcendent speculations. Only an Aryan can attain such understanding, [since] in the Aryan races this phenomenon [arrested intellectual development], or anything like it, never occurs, at any time of life.[41]

Unquestionably, all the way from Hegel's description of the Jews' spiritual emptiness to Burnouf's attribution of arrested physical development, we can see a swerve toward a biological anchoring of a universally accepted inferiority. These two inferiorities, spiritual and physical, converge in their demonstration of the inferiority of the Jews' religious culture. Symmetrically, the superiority of the "Aryan race" was to be justified by its dual biological and cultural preeminence right up through Nazism. Physical anthropology, despite the growing importance that it would take on in various fields of knowledge, was never to go further than the theses developed by Burnouf in the 1860s. Thus race-based anti-Semitism and race-based anti-Judaism, far from having taken the place of the former religious and political motifs, did nothing but co-opt a pseudo-science in order to revive those old motifs, adapting them to new social and political circumstances.

In the same way, Renan went beyond those who, after Friedrich and August Schlegel, were seeking to prove inductively, on the basis of Indo-European languages, the existence of a more or less homogeneous "Aryan"

race. Renan's inductive method led him, like Burnouf, to detect in the Semitic peoples themselves the same stark opposition that he, along with others, had first set up between the polytheistic and creative Aryan and the monotheistic Semite, devoid of art and culture. In 1855, he wrote: "The Semitic race is recognizable solely by negative characteristics: it has neither mythology, epic poetry, science, philosophy, fiction, visual arts, nor any civic engagement."[42] Rejecting, unlike Burnouf, the idea of a primitive polytheism among the Semitic peoples in order to better defend his thesis that they had a "monotheistic instinct," and ignoring his own incoherence, Renan emphasized in 1859 in the *Journal asiatique* that

> a decisive fact traced early on a deep line of separation ... between the various Semitic peoples. I mean here the injunction against painted and sculpted images. A nation that has before its eyes figurative representations inevitably becomes idolatrous. For a naïve people endowed with imagination, any figurative representation will produce in time a legend or a myth. The legislators of Hebrew monotheism understood this very well. In proscribing figurative representations, they laid down for their institutions the great condition of salvation, and so, with much astuteness, they ensured the religious future of their tribe.[43]

Now, we might ask, in what for Renan did this "astuteness" consist? It consisted in the Jewish legislators knowing that this proscription was doubly commanded by nature. Not only, Renan wrote, was the proscription in keeping with "the very laws [of] nomadic life [that] exclude the trappings necessary for an idolatrous cult," but also, and more deeply, it fit the "monotheistic Jews' lack of fecundity in imagination and language." In complete contrast to Kant, who saw the Sublime in the Second Commandment, Renan saw the commandment as having the sole function of justifying, after the fact, an innate incapacity.

In 1862, examining "the role of the Semitic peoples in the history of civilization," Renan had no compunction about saying: "In art and poetry, what do we owe them? Nothing in art. These peoples are scarcely artists; all of our art comes from Greece." Later on, retracing the history of the origins of Christianity, Renan devoted an entire book to the figure of Saint Paul. In this text, Renan imagines Paul's second visit to the city of Athens:

> He saw the only perfect things which have ever existed. ... He saw all that, and his faith was not shaken. He did not startle. The prejudices of the iconoclastic Jew, insensible to plastic beauties, blinded him. He regarded these incomparable images as idols. ... Ah! beautiful and chaste images, true gods and true goddesses, tremble!—here is one who will raise the hammer against you. The fatal word has been pronounced,—ye are idols. The error of this ugly little Jew[44] will prove your death warrant.[45]

Substituted for the Jew's empty mind (mirroring, according to Hegel, the absence of any figured god) we now have the necessary mask of ugliness of the Jew, blind to all beauty and laying waste with his hammer to the beautiful incarnations of Aryan mythology. Under Renan's pen, the ugliness imputed to Paul became the physical proof of the strictly hereditary error of the entire Jewish people—an error that was inseparably religious and aesthetic. Paul, of course, did announce that there would no longer be "Jews and Greeks," but despite his conversion, he was evidently still a Jew and not yet a Greek.

The Jew as "Destroyer of Culture"

In Germany, the emergence of nationalism was very soon to be bound up with anti-Judaism, and this was partly because the emancipation of the Jews was associated with France, and the French armies were occupying

the country at the time. The Jew, therefore, coming from an alien race that was devoid of ideals and, furthermore, complicit with the occupier, could do nothing but hinder the progress toward unity of a nation whose identity remained yet to be constructed.[46] In France, it would not be until the first serious crises of the Third Republic that any real connection would be made between the old Christian and economic anti-Semitism and the new cultural anti-Semitism that was brought about by the emancipation.[47] Édouard Drumont, in *La France juive* (1886), revived Renan's image of the Jews as a "race" that was recognizable "almost exclusively by its negative characteristics," since the Jews had "neither mythology, epic poetry, science, philosophy, fiction, visual arts, nor civic engagement."[48] The former chronicler of art and author of *Mon vieux Paris* (1878) noted in particular that if "a certain style of painting or a certain type of music ... enjoy success with the Jews," it was because "they assimilate much more easily procedures that, by lowering the current level of artistic achievement, emphasize the mode of expression and the exclusively formal aspect over and above the essence of the idea." The Jew, Drumont added, triumphed here even more in that "his hatred for everything beautiful and glorious in our past inspires him in this work of destruction through malicious mockery."[49] Long since present in Wagner, the theme of the Jew as destroyer of the aesthetic Incarnation of the national Spirit thus made its entrance into France, accompanying the very strong Catholic reaction to the secularization that the country was undergoing at the time. Just as it had been for Wagner, the imagined attack coming from the Jews was seen by Drumont as so much the more dangerous because it was being carried out on a body politic that was already sick and suffering.

The theme of the Jew as destroyer of culture, eclipsed for a time by the violence of the Dreyfus affair, would not attain its widest influence until immediately after the First World War, when a number of Jewish artists proudly offered their aesthetic contribution to "Eternal France." Moving thus from the military to the cultural sphere, the accusation of treachery held against the Jews was particularly virulent in the debates carried on

in the École de Paris around 1925.[50] At that time, it was argued that the Jews could stake their claim on art only because of the prior dissolution of the *natural national* boundaries of art: "Local feeling, local spirit, and local color will undergo an unavoidable decadence as soon as the vague possibility of an international art appears. For then, painting as a career will start to become open to the Jews."[51] Worse still, not satisfied with ruining the national artistic tradition, the Jews were then going to go as far as to profiteer from the sale of its ruins. Although one could find in the Louvre "no significant works of art signed by Jews," one suddenly saw "innumerable Israelite painters hanging their paintings in our contemporary exhibition halls. But this is mere illusion. There is no Jewish art. This is so much the more evident in that the Jews are great and avid collectors. They are the masters of the art market. But they have never created a single work of art."[52] Four years later, denouncing "kosher painting" and "those Polacks who pronounce Giotto like Ghetto," Camille Mauclair, a former Dreyfusard who had become a Catholic, wove ever tighter and made more explicit the links uniting the denial of and the profiteering from the incarnated spirit:

> But after all, it is clear and well-accepted that the Jews have never excelled in the visual arts. One can point to no Jewish genius in painting or sculpture (nor in music). How can we not be outraged at the fact that the current art market is in the hands of the Jews of France and Middle Europe, and that the merchants, the critic-sellers, the Jewish painters who are so numerous in so-called "living art" all conspire to attack the Latin tradition and to follow the spirit of negative criticism, division and the disruption of values that is the Bolshevik bedrock of their race?[53]

Essentially, then, was it not entirely within the logic of their race that the Jews, who were once capable of betraying Christ for thirty pieces of silver

before crucifying Him and then profaning the Host and making money out of it, were now seeking to draw maximum profit from the ruins of a national art that they had themselves just destroyed?

Nowhere, of course, was there a more efficient machine than Nazi Germany when it came to amalgamating all of these themes. According to Nazi propaganda, the Jews were the anti-people or the anti-race; they were a people devoid of art, and physically ill-formed, coming to wreak havoc with their blood and their jealous God on the creative genius of the Aryan, and finally preventing the racial and national ideal from taking on its true form in art. Like many others before him, Hitler justified the superiority of the "Germano-Nordic race" by a single idea: throughout all of history, the Aryans were the sole "creators of culture" or *Kulturbegründer*, eternally in conflict with the Jews, the *Kulturzerstörer*, the "destroyers of culture."

Christianity, as we know, had divided the Jewish God in two: an object of fear and an object of love.[54] The invisible critical agency was separated from Christ as intercessor, capable of realizing human desires in the visible world, i.e., performing miracles. On the basis of this division, Hitler was able to qualify conscience (the critical) as a "Jewish invention,"[55] and Nazism was to forbid all criticism of "German Art" because such criticism was seen as a result of the "dissolving power" of the Jewish mind on the Incarnation of the Spirit of the People, or of the race. Thus Goebbels's banning of all art criticism in 1936, and his insistence on its replacement by simple "reporting,"[56] seemed to the Nazis to be necessary to the very survival of the incarnated national Idea—the German God become "Form." Any criticism was liable to shake the confidence the people had in themselves, and risked threatening the redemptive love that the German people devoted to their own image, i.e., to the Führer and his art. The "struggle for art (*Kampf um die Kunst*)" undertaken by the Nazis, Hitler explained as early as 1922, was in reality the continuation of the struggle against the "ideas of 1789." It was "a battle which began nearly 120 years ago, at the moment when the Jew was granted citizens' rights in the European States.

———

142

The political emancipation of the Jews was the beginning of an attack of delirium." An attack, Hitler continued, led by

> a people of robbers. He [the Jew] has never founded any *Kul-tur*, though he has destroyed civilizations by the hundred. He possesses nothing of his own creation to which he can point. Everything that he has is stolen. Foreign peoples, foreign work-men build him his temples. ... He has no art of his own: bit by bit he has stolen it all from the other peoples or has watched them at work and then made his copy. He does not even know how merely to preserve the precious things which others have created: as he turns the treasures over in his hand they are trans-formed into dirt and dung.[57]

On 20 April 1923, in a speech entitled *Politics and Race: Why are we Anti-Semites?*, Hitler attacked the invisible threat of corrosion posed by the spe-cifically Jewish lack of *visible* God, territory, and State to the Nation States. The Jews, he declared, sought to "spread their invisible State as a supreme tyranny over all other States in the world." National Socialism, he contin-ued, associating the "visible" figure of the German State to the figure of Christ, wanted to "prevent our Germany from suffering, as Another did, the death upon the Cross."[58] But it was not until *Mein Kampf* that we see Hitler, already promoted to the rank of "German Christ"[59] and soon "Art-ist of Germany," associate explicitly the Jews' destruction of German art with their destruction of Christ as an image of the Spirit of the German people. It was precisely in *Mein Kampf* that he drew this striking portrait of the iconoclastic Jews: "Their whole existence is an embodied protest against the aesthetics of the Lord's image."[60]

The same "national-Christian"[61] mythology animated Alfred Rosen-berg's supposedly anti-Christian *The Myth of the XXth Century*. But whereas Hitler, in *Mein Kampf*, had branded the Jew, as Luther had done, the "evil demon" of the German people, Alfred Rosenberg sought to identify the

"evil demon of Jewry" itself. Like Renan, Burnouf, Chamberlain, and many others before him, he thought he could isolate the evil better by splitting the figure into two. In order to better stigmatize the accursed part in the Jew, the one that prevented the Jew from ever being a *Kulturbegründer*, Rosenberg chose to cite as witness the "half Jew" Oscar Schmitz:

> The evil demon of Jewry is ... Phariseeism. It is certainly the bearer of the hope of the Messiah, but simultaneously is the guardian which prevents any Messiah from arriving. ... That is the specific, most dangerous form of Jewish denial of the world. ... The Pharisee actively denies the world. He ensures that, where possible, nothing takes shape (*Gestalt*), and in so doing he is driven by a demonic emotion. [The Pharisees are] the spirit which always denies, and with an ecstatic affirmation of a Utopian existence which can never be, conceal the arrival of the Messiah.[62]

This quotation from Oscar Schmitz, however, actually came from his contribution to a special issue of the journal *Der Jude* that had been entirely devoted to anti-Semitism, and Schmitz was clearly really denouncing here the old Christian anti-Semitism.[63] Rosenberg, in ironic contrast, becomes the champion of Christian anti-Semitism, fully accepting the description of the Jew as the eternal denier of the Salvation that had been brought about by the Incarnation, and also the denier, in the name of an absolutely unrealizable utopia, of a Redemption that had already happened and was already visible. The "Wandering Jew" (*der ewige Jude*) was "always the same," breaking all idols and holding up the text of his Law against the redemptive image. The Synagogue was always blind. Just as they were incapable of seeing the Messiah in Christ, the Jews were incapable of seeing their Savior in Hitler or finding their redemption in German art. Nazi anti-Semitism can be properly understood only from this historical perspective—i.e., the incarnated God superseding the invisible God,

and the subsequent transformation of that supersession into the opposition between the redemptive agency and the critical agency that it needed to abolish. Furthermore, this anti-Semitism took on meaning only through the identification of the redemptive agency with an "art" that was understood as the production of the self by the self, i.e., the self-production of the Body of the people, purified by the Spirit of the people.

A DESERT RACE

One of the most remarkable aspects of the theme of the artless Jew was its persistence up to and even beyond the middle of the twentieth century. It persisted despite the accumulation of contrary proofs supplied by scholarly works on the Jewish illustrated manuscripts of Paris, Hamburg, or Oxford, and by the existence of the numerous collections of Jewish artworks in Strasbourg, Frankfurt, Vienna, Prague, London, Paris, Warsaw, and Danzig. It persisted also in spite of successive archaeological discoveries, the most spectacular of which was the discovery by a French-American team, in 1932, of the frescoes in the synagogue at the small Syrian town of Dura-Europos, known already for its pagan and Christian works. Margaret Olin has shown how the discovery of these figurative and often narrative frescoes, dating from before the middle of the third century, suddenly upset the commonly accepted idea of the fundamental and unchanging aniconism of the Jews—the very basis of the idea of the artless Jew.[64] Initially, the reports and descriptions of this discovery generated a fierce resistance among archaeologists who had been convinced for so long that the Jewish people were "the least artistic of the great peoples of the ancient world."[65]

The discovery of figurative mosaics in the synagogue at Beth Alpha in 1929 had dealt a first blow to the myth of the artless Jew, a myth that was based, as we have seen, upon an interpretation of the Second Commandment as strict and absolutely unchanging. As Clark Hopkins and Robert du Mesnil du Buisson, both part of the archaeological team at Dura-Europos,

pointed out: "Following recent discoveries in Palestine of synagogues from the fourth and fifth centuries where the floors are decorated with figurative mosaics, we had already reached the conclusion that the rule forbidding representations in synagogues was not observed in the first centuries of our era." One of their conclusions turned out to be particularly unacceptable. They claimed that the paintings at Dura, "a substantial series of scenes from the Old Testament interpreted by the Jews themselves," were not just "analogous" in style, composition, and subject matter to Christian paintings, nor did they just show strong links with the frescoes of the catacombs, but that what distinguished them from the pagan frescoes at Dura was an element that "was essentially Christian ... the direct representation of the plot of the story." They concluded: "*We can assert that the Christians borrowed this method from the Jews, and so it was in the East rather than in Rome that the characteristic Christian style was first formed.*"[66] Gabriel Millet, the Byzantinist who was responsible for the introduction to France of the works of the Austrian Josef Strzygowski,[67] whose anti-Semitism bordered at that time on delirium, immediately declared there was nothing surprising in this, since these paintings did nothing but confirm the Eastern origins of Christianity and its art:

> The new paintings at Dura will help us to better define the character of Byzantine art. Looking at them closely, the informed Byzantinist will experience no surprise; he will see already realized, in the third century, what Byzantium produced in the tenth, eleventh, and twelfth centuries; namely, this strange combination of illusionism and the icon.[68]

Millet passed in utter silence over the significant fact that a Jewish figurative art had in fact been discovered.[69] As Margaret Olin has correctly pointed out, this silence was still there at the very end of the twentieth century in the great surveys whose singular taxonomies would classify the paintings of the synagogue at Dura as "Roman art" or "Early Christian art," and thus

support the view of the Jewish religion as immutable and serving no other purpose but to prepare the way for Christianity, a view that was "ahistorically Christian or teleologically Hegelian."[70] In reality, this ahistorical view had always been present behind the thesis of the "Wandering Jew," identifying the contemporary Jew with the Jew of antiquity. There was little doubt about the idea that the ban raised by the Second Commandment might have been interpreted in various ways by rabbis throughout history, but in 1925 Pierre Jaccard, echoing others and taking advantage in order to better hammer in the nail of atavistic incapacity, rejected outright the idea that it might, at least at certain times in history, have applied only to graven images made for the purpose of idolatry, and not to the creation of any image. Jaccard argued that "The second commandment ... in no way explains the absence of engraving, painting, and sculpture in Israel," since the ban came into existence only a long time after Moses:

> *far from being a law imposed upon nature, the second commandment of the Decalogue appears, to the contrary, to be the legalized expression of a deep incapacity that the Hebrew nature has for the representation of forms and colors.* ... The Hebrew legislators erected as a moral and religious duty *a natural and spontaneous tendency* of the Semitic mentality.[71]

Herbert Read, writing in 1932, adopted the desert argument that Renan had put forward a century earlier. In *The Anatomy of Art* Read argued: "Relatively speaking, there is no Jewish art. By origin the Jews are a desert race, nomadic, quickly reacting to physical experience. But the plastic arts belong to sedentary peoples, to those who settle in cities and form a stable civilization, an atmosphere of refinement."[72] Bernard Berenson,[73] in his *Aesthetics and History*, went so far as to classify the Dura frescoes as "provincialized and distorted late Hellenistic." Convinced that there "existed no Jewish art" (if one were to discount the bad artistic imitations made by Jews dispersed in the midst of other peoples), Berenson had no doubt that this

was due to the "fanatical hatred of the anti-Hellenic Jew against everything that might entice him away from his bleak abstractions and the passionately fervid, aggressive, and exasperated affirmation of his monotheism."[74]

It is a remarkable fact that the emergence and development of the theme of the artless Jew, onto which was grafted, at least up until the Second World War, that of the Jew as denier of the national spirit incarnated in art, coincided with the hundred-year period 1850–1950, during which each of the European nations erected its national art as a national idol, as a veritable cult through which it claimed to honor both the Spirit of its people and the land from which it had arisen. So if the Spirit of a people could become art, just as the Word became flesh, it was always the case that the legitimacy of this art ultimately derived from the land, the rightful possession of the people. Two examples will suffice. Herbert Read, the celebrated English art historian whom I have already cited, explained in *The Meaning of Art* (1931, revised by the author in 1968) that "The Jewish race ... has now found a 'national home' in Palestine (Israel)." This race, "still dispersed and in a sense nomadic," had created a "distinctive art" only in its later years, and this art, for Read, did not have "the same respect for form as Aryan art."[75] As a second example, I cite the art historian Werner Haftmann's remarkable comments in 1972 on Mark Rothko's "abstract" paintings. For Haftmann, Rothko's work constituted a fortuitous compromise between the proscription against representation and the artistic expression of the spirit of the Jewish people:

> In analyzing these paintings, the historian ought to be convinced of a striking fact: Judaism, having remained without images over the course of more than two thousand years, has found its own pictorial expression and now has its own art thanks to the process of meditation developed by modern art. All of this has happened just at the time when Israel has become a refound land.[76]

Thus was the Jew no longer always the same, as he had been through eternity; ceasing to wander as a stranger among nations that he clumsily tried to imitate, he could finally raise himself to the dignity of art. He had his own art because he had his own land. With Herbert Read and Werner Haftmann, we see the messianism of art joining that of the land—the two secular messianisms that nineteenth-century racial nationalism had long since tied together.

Since the eighteenth century, just as Herder had thought of peoples and races as plants rooted in a particular soil,[77] Europe had understood the fine arts, in Sulzer's widely accepted phrase, as "indigenous plants" (*einheimische Pflanzen*).[78] Accordingly, Herder had declared: "The people of God [the Jews], whose country was once given them by Heaven itself, have been for thousands of years, nay almost from their beginning, parasitical plants on the trunks of other nations."[79] But with the founding of the State of Israel, the old metaphor that saw in the Jew a parasitic plant choking the native, good plants of the European nations suddenly lost an important part of its *raison d'être*. As we have seen, one hundred and fifty years earlier, the rehabilitation of the barbarians had brought about a significant change in how they were viewed. Their invasions, once seen as destructive, were now good and valuable migrations coming both to regenerate exhausted peoples and to found modern Europe. Formerly outsiders, the barbarians were now insiders, absorbed and integrated to the point where, losing their barbaric identity, they became themselves "indigenous plants." Contrariwise, it was only when the Jews were given a land outside of Europe that their legendary wanderings ceased to be seen as evil and dangerous migrations.

Barbarian Blood: Heredity and Style

In his lectures during the winter of 1822–1823, Hegel taught his students that the forefront of world history passed through one people after another, and that no single people was ever able to lend its name to more than one epoch. After the Eastern world had been supplanted by the Greek world, he declared, the latter was in turn replaced by the Roman world, with its principle of abstract Universality. The Roman world—in which, he claimed, "Free individuals are sacrificed to the severe demands of the National objects, to which they must surrender themselves in this service of abstract generalization"—was replaced, in its turn, by the principle of "subjective self-consciousness" incarnated in the Germans. Out of the transition or struggle between these two principles, Hegel argued, there arose a fourth order: the order of their reconciliation that culminated in the Christianity of the Germans. In this way, therefore, he taught: "The destiny of the German peoples is to be the bearers of the Christian principle," in such a way that "The German Spirit is the Spirit of the New World" (*der germanische Geist ist der Geist der neuen Welt*).[1] Hegel claimed to have little to say about the first period of this world order, the time of the "great invasions" or "migrations of peoples," except that the primeval forests from which these peoples were supposed to have come failed to arouse his curiosity.

Unlike Fichte or Friedrich Schlegel, Hegel did not consider the Germans of the nineteenth century to be the direct heirs of the ancient Germanic peoples who had once conquered Rome. However, since he did consider that, after the reign of the Father and that of the Son, it was with the Germans, and thanks to them, that the reign of the Spirit, i.e., of Christianity, had come into the world, he had no qualms about saying that the spirit of the "Germanic world" was identical with the Christian spirit of the modern world.

RACIAL AND LINGUISTIC MIXING

For Hegel, the contrast between the conquering barbarians and the cultivated but vanquished inhabitants of the Roman Empire was eventually resolved in the "hybrid character of the new nations that were now formed." Indeed, not all of the European nations possessed this "hybrid character," as could be seen clearly from their languages. It was easy to distinguish the pure German language from those languages with which it had been mixed. In effect, Hegel categorized those peoples as *Latin (romanische)* whose languages he described as "an intermixture of the ancient Roman— already united with the vernacular—and the German." Thus Italy, Spain, Portugal, and France were states that exhibited "a divided aspect ... [with] in their inmost being ... characteristics that point to an alien origin." Against these Latin or "Romanized" peoples stood three nations, "more or less *German-speaking*" and "which have maintained a consistent tone of uninterrupted fidelity to native character (*ungebrochene Innigkeit*)." These three nations were Germany itself, Scandinavia, and England, the latter two having been, like Germany, affected by Roman culture only around their borders before being Germanized again by the Angles and Saxons. But "*Germany proper*," Hegel added, "kept itself pure from any admixture" (*Das eigentliche Deutschland erhielt sich rein von aller Vermischung*).[2] In this historical fiction, designed to consolidate "*Germany proper*," the theme of German ethnic purity came down in a direct line from section IV of Tacitus's

Germania, a text that had been rediscovered during the Renaissance and had very quickly become the modern Germans' certificate of identity and authenticity.[3] But it was really August Wilhelm Schlegel, in his *Lectures on Dramatic Art and Literature*, who provided Hegel with the idea of a parallel between the mixture of languages and the mixture of peoples. Schlegel wrote:

> The whole play of vital motion hinges on harmony and contrast. Why, then, should not this phenomenon recur on a grander scale in the history of man? In this idea we have perhaps discovered the true key to the ancient and modern history of poetry and the fine arts. Those who adopted it gave to the peculiar spirit of *modern* art, as contrasted with *antique* or *classical*, the name *romantic*. The term is certainly not inappropriate; the word is derived from romance—the name originally given to the languages which were formed from the mixture of the Latin and the old Teutonic dialects, in the same manner as modern civilization (*Bildung* of Europe) is the fruit of the heterogeneous union of the peculiarities of the northern nations and the fragments of antiquity.[4]

The idea that there was a rigorous equivalence between the mixture of the Latin and Germanic languages and the mixture of races was so widely distributed in Europe, at least up until the 1860s,[5] that it was effectively taken for granted. In 1829, for example, Simonde de Sismondi wrote: "those languages which usually receive the designation of the Romance languages, are all derived from the mixture of the Latin with the Teutonic, of the people who were accounted Romans, with the barbarous nations which overthrew the Empire of Rome."[6]

However, Hegel and August Schlegel did not draw exactly the same conclusions from this "mixture." Hegel was mainly concerned to establish a stark opposition, on the basis of the dichotomy between the pure language

of the Germans and the mixed languages of the Latin peoples, between the "divided aspect" of the former and the "uninterrupted fidelity to native character" of the latter. He was soon to attribute to the Germans an enduring transhistorical character, and thus to establish a bridge between the Germans of the very first centuries of the Christian era and those of the sixteenth century. Speaking of Luther and the Reformation, the revolution against the "externality" of the Catholic Church that had become odious, Hegel invoked the "time-honored and cherished sincerity of the German people (*die alte und durch und durch bewahrte Innigkeit des deutschen Volks*) ... destined to effect this revolution out of the honest truth and simplicity of its heart." This famous "infinite subjectivity," one of the most basic elements of the Germanic spirit (so much bound up with the spirit of Christianity that it was completely identified with it), was ultimately opposed just as much to the formal and abstract interiority of the Catholic Church as it was to that of the Roman Law. The very same division continued through to Hegel's own time, the period of Enlightenment and Revolution: "As it was the purely German nations among whom the principle of *Spirit* first manifested itself, so it was by the Romanic nations that the *abstract idea* was first comprehended."[7] Essentially, the entire history of Christianity—i.e., the history of the Spirit—came down to the confrontation between Germanic spirituality and Latin abstraction.

For more than a century all of the European contributions to the history of art took as their model this conflict between these two ethnic or racial "characters." Karl Schnaase, for example, was to reiterate Hegel's distinction between the pure Germanic nations and the "hybrid nations" of Europe:

> while Germany was a single nation because of its ethnic origin (*Abstammung*) and its destiny, in the Latin countries there lived together several races (*Stämme*) in a multicolored mixture of the original inhabitants and Germans of diverse origins, differing amongst themselves by language, law, and customs.[8]

August Schlegel, on the other hand, was concerned with a different question. For Schlegel, as we have seen, it was important to legitimize the use of the term *romantic* in order to define the spirit of modern art, and thus to contrast it with art that was "antique or classical." *Romantic* seemed to him to be a particularly fortunate term with which to characterize modern art because, according to him, it derived from the term used to designate the mixture of Latin with the ancient Germanic dialects in exactly the same way that the new *Bildung* (of Europe) had been formed by "the union of the peculiarities of the northern nations and the fragments of antiquity; whereas the civilization (*Bildung*) of the ancients was much more of a piece." In this linguistic, ethnic, and religious taking hold and redirecting of a splintered antiquity, Schlegel saw the vast and powerful movement of History. The fragments of Latin had melted into the Germanic dialects, the fragments of the ancient populations had been absorbed by the now dominant Germanic elements, and Christianity had assimilated the fragments of paganism. Furthermore, Schlegel added, "After Christianity, the character of Europe has, since the beginning of the Middle Ages, been chiefly influenced by the Germanic race of northern conquerors, who infused new life and vigor into a degenerated people."[9] Schlegel's vision of history was to become yet more radical in his *Lectures on the Theory and History of the Fine Arts* in Berlin in 1827. Again, and more forcibly, he was to say that the Germanic races, "with their love of freedom and with the freshness of their new ideas," had rejuvenated the ancient world and subjugated the entire Western Empire. The barbarians of the North were thus in all truth "the ancestors of all of the peoples of Europe."[10]

EVOLUTION: FROM THE ANCIENT SOUTHERN TACTILITY TO THE MODERN
NORTHERN OPTICALITY

As soon as he had posited the stark contrast between the romantic and the classical, August Schlegel went about extending it systematically from literature to the whole of the fine arts. He took a comment by Hemsterhuis

implying that modern sculptors were "too much in the way of painters" while, to all appearances at least, the painters of the ancient world were "too much like sculptors," and applied it to a much wider context. The spirit inhabiting *all* of the artistic works of the ancients, he argued, was *sculptural* (*plastisch*), whereas the spirit of the moderns was *painterly* (*pittoresk*). Now, this idea of there being a division between the sculptural and the painterly styles was not new, neither was its insertion into history. Herder, for example, anticipating Ernst Haeckel's theory of recapitulation (*Ontogenese rekapituliert Phylogenese*) developed a century later, had formulated the hypothesis that the entire history of humanity was repeated in each individual in the evolution from touching to seeing. In the child, he wrote, "his eyes see as his hands feel. Nature proceeds with each individual person in the same way as it does with the race as a whole: it moves from feeling to seeing, from the plastic to the painterly."[11] Furthermore, in accordance with his cultural and political primitivism, Herder had denounced the painterly quality and the "shadows" of the moderns in order to better extoll the virtues of touch that characterized the ancient world: "How far we stand behind them may be judged by a later age."[12] In contrast to Herder, Schlegel considered the painterly style to be clearly superior. In this, he followed the traditional Aristotelian hierarchy of the senses, and by emphasizing the importance of the "Germanic" element in the moderns he gave to the role of the arts in history a "racial" dimension that was not at all present in Herder. Closer to Herder in this respect, Schiller did think that the ancients were superior to the moderns in the field of sculpture because, as he put it, "the strength of the ancient artist ... subsists in finitude," whilst it was the moderns who excelled in everything "infinite."[13] Still, it is quite clear that Schiller, like Herder, in no way sought to associate the characteristics that he identified in the ancients and the moderns with any sort of ethnic or racial origin.

Such, however, was to be exactly the task assigned to the history of art first by Alois Riegl, then by Heinrich Wölfflin, both of them equally convinced of the truth of the thoroughly Hegelian idea that each people or

each race was destined to play its assigned cultural and artistic part in history according to a law prescribed to it by a force that both inhabited it and was greater than it.[14] As we have already seen, at the very beginning of the twentieth century, Riegl's racial evolutionism claimed for the "Indo-Germanic peoples" a crucial role in the transition from the *nahsichtig* (near-seeing) to the *fernsichtig* (far-seeing), and from the tactility of the ancients to the opticality of the moderns—two "artistic directions" with two "contrasting origins." For Riegl, near-seeing (sculptural and tending to isolate forms) originated with the "Orientals," whereas far-seeing (optical and tending to connect forms together) originated with the "Indo-Germanic peoples." Riegl said of these two forces: "Throughout all time, the latter tendency has been the driving one, and the former tendency has been conservative." Thus, he argued, one could see in modern art the same distribution of roles as had existed in the Late Roman world between the Latin (Orientalized) peoples and the Germanic peoples: "In a one-sided preference the former pursue the tactile, and the latter the optical problem."[15]

Heinrich Wölfflin was soon to put forward an evolutionist argument very similar to Riegl's, and (a fact that is often ignored) Wölfflin's *Principles of Art History* (1915) was actually subtitled *The Problem of the Development of Style in Early Modern Art*. In this work, Wölfflin sought to set out and classify historically the stylistic "values" that he saw as paramount in a given country, a nation, or a race (individuals interested him only insofar as they belonged to one or another of these collectivities). The development of modern art, he argued, had to be seen in terms of the movement from one term to another in each of the five pairs of categories for which his work is now famous: linear and painterly, planar and recessional, closed form and open form, multiplicity and unity, absolute clarity and relative clarity. The first pair of terms, linear and painterly, was not really new, since, as has already been noted, the contrast between the sculptural and the painterly had been commonplace and presented in many different ways since the end of the eighteenth century. As Wölfflin described it, the movement from the linear style to the painterly was the move from a style that, "being

———

objectively inclined, grasps things according to their palpable condition" to a style where the "drawing and modeling no longer coincide geometrically with the plastic basis of the form; they merely give the optical appearance of the thing." Wölfflin's categories were essentially an extension of Riegl's basic contrast, and Wölfflin's pairs of formal categories did little more than lay out the consequences of the first pair of categories. More interesting, however, is the fact that, in the historical transition from the tactile to the optical, Wölfflin drew the parallel between ontogenesis and phylogenesis that Riegl had already formulated. In fact, in the Preface to the *Principles*, Wölfflin praised Riegl highly, pointing in particular to the latter's articulation, on the basis of Wickhoff's thoughts on the painterly (*Malerisch*), of the terms *optic* (visual) and *haptic* (tactile)—"conceptual tools" designed to define visual and tactile values.[16] This is Wölfflin's elaboration of the distinction:

> The delineation of a figure with a consistently defined line still has something corporeal about the way it grasps things. The operation performed by the eye is comparable to the operation of the hand feeling its way around a solid, and where the modeling reproduces reality in gradations of light, this likewise appeals to the sense of touch. By contrast, a painterly depiction in mere patches precludes this analogy. It issues from the eye alone and appeals only to the eye, and just as a child gets out of the habit of touching things in order to "grasp" them, so man has grown out of the habit of examining works of art in terms of their tangibility.[17]

Much more was involved here, therefore, in this transition from one term to another than just a paradigm shift in the visual arts corresponding only to the "forms" or "schemata of seeing." This transition from one stage to another was nothing less than the forward development of the whole of humanity from the infantile stage to a more mature and adult stage.

Furthermore, Wölfflin associated these two stages not just with specific visual "schemata" but with distinct peoples: the Latin and Germanic races, which were specifically represented in his account by the Italians and the Germans. Thus, he wrote, "one cannot get around the fact that every people will have art- historical epochs that appear as the more characteristic revelation of national virtues than others. In Italy it was the sixteenth century (classical) ... for the Germanic north it was the age of the baroque." Wölfflin was confident that he had proved that in the evolution of Western art, "the focal point would have had to shift according to the particular talents of specific peoples." It had shifted, therefore, from the South to the North—the home of the Germanic race that "always had the essence of the painterly in its blood."[18] Riegl and Wölfflin's aesthetic and historical ideas, like those of so many of their followers, were fully in the theoretical line of romanticism. It was the romantics who had first postulated that Western art had evolved from a reputedly ancient and entirely Mediterranean tactile materiality toward the spiritual opticality that they believed was a characteristic unique to the "modern" Germanic peoples. Riegl and Wölfflin's theories repeated all the romantic prejudices, and they prolonged and multiplied their consequences through the use of what was to become an illusory but persistent scholarly apparatus. The ultimate source for the "ethnic" classification and interpretation of works of art that still today dominates an important part of art and art-historical discourse, and often underpins the exhibition of works of art according to "national schools," can be found, therefore, in precisely that cluster of romantic luminaries among whom shone most brightly, almost two hundred years ago, Hegel, Germaine de Stäel, and the Schlegel brothers.

BARBARIAN BLOOD AND THE ORIGINS OF GOTHIC ART

Until at least the 1960s, most art historians consciously set themselves the task of trying to understand how artistic forms came into being, and how they were transmitted. Indeed, this endeavor was seen as one of the most

important in the discipline. Since it was the case that, since the middle of the nineteenth century, art historians had thought of artistic forms and their resulting "styles" as living organisms, it should not surprise us that they looked for answers to their questions in the realm of biology. The "life" of artistic forms was therefore, for them, not only intimately linked with the life of human groups (also conceived of as organic wholes), but these art historians also thought of artistic forms as being born and growing up in exactly the same fashion as humans, i.e., through couplings, crossings, and mixings. Evidence for this parallel can be seen clearly in the famous debates about the origin of Gothic art that split scholarly opinion across Europe for almost one hundred and fifty years.

A few months before his death in June 1968, Sir Herbert Read, the great English art historian who had defended the German avant-garde artists when they were under attack from the Nazis, revised and corrected a new edition of his book *The Meaning of Art*. This work had originally been published in 1938 as a series of articles in the famous weekly *The Listener*.[19] "It may be old-fashioned," Read argued, "to believe in the racial factor in art, or in anything else but politics, but though art in a very real sense is universal ... certain types of art have characterized certain types of people."[20] Following Riegl and Worringer, who had consistently contrasted the *spirit* of the peoples of the North with the classicism of those of the South, Read emphasized the distinction between the Aryan and Semitic races, speaking of the "marked difference in their modes of aesthetic expression," and he cited Picasso as further evidence of the importance that he felt should be given to the "racial factor." Although Picasso had settled in Paris as early as 1903, Read argued, he had never allowed himself to be assimilated into France, and he had always preserved the integrity of his Spanish origins. In support of his thesis, Read cited Wilhelm Uhde's observation to the effect that Picasso's "native integrity" was "more Germanic than French." Since it might seem strange to characterize Picasso as "Germanic," Read recalled that Uhde saw "an underlying similarity in the Greek, Spanish and German genius," all three of them having a "common tendency to express a

longing for the infinite." Read cited directly Uhde's description of Picasso's manner as "somber ... tormented ... vertical in its tendency, romantic in its tonality," and "embodying in its totality the Gothic or Germanic spirit." If anyone were to object that Picasso was above all an individualist, Read glossed, "Mr. Uhde would perhaps reply that there is no such thing as an individualist; we all express the complex organizations into which we are born as a dependent unit."[21] But was this, in fact, what Uhde actually thought?

The particular work of Wilhelm Uhde that Herbert Read mentioned was *Picasso and the French Tradition: Notes on Contemporary Painting*, published in Paris in 1928.[22] In this text, Udhe contrasted Matisse's "intelligence" with Picasso's "love." In both prewar and postwar Paris, Uhde suggested, there was always a choice to be made between "the great mainstream of the French tradition" that passed through Cézanne and Picasso, and the "charming, easy current" represented by Renoir, Matisse, and Bonnard, and an artist had to choose between "the positive, affirming present" and the "vanishing past." Despite the painterly aspect of Picasso's art that fit well with the French tradition, for Uhde, there was nothing "Romanesque" about it, and the young artists from the Germanic countries who had come to learn from Matisse should have understood that. Furthermore, the mystical and ineffable art of Spain had always been closer to Germanic art, as could be seen, Uhde argued, in the case of El Greco, who was scarcely more of a rationalist than Rembrandt. However, Uhde continued, there was something else at work in Picasso:

> thanks to the responses of his spirit to the French tradition, there appeared a great Gothic art, just as long ago Gothic architecture came to birth following the invasion of the Ile-de-France by the Franks and their contact with a population which was largely Roman. The young Germans and Scandinavians remained in ignorance of this fact of capital importance ... and their lack of intuition prevented them from perceiving this

sympathy, just as they could not understand that the Cubism of Picasso was the second great manifestation of Gothic feeling on French soil.[23]

Wielding once again, like a sledgehammer, after Riegl, Wölfflin, and Worringer, the great romantic and Hegelian oppositions, Uhde distinguished between two opposing souls. The Franco-Roman soul, clear and joyful, was to be found embodied in an art that was classical and impressionist, i.e., *receptive*; its dominant tendency was horizontal, and its medium was the surface of the painting. In contrast, the push toward *transcendence* that characterized both the Greek and the Germanic soul was embodied in an art that was "Greco-German" and romantic. The latter could not be contained within the flat plane of the painting. It could be expressed only by forms that aspired to a nostalgia-filled spatial elevation (*Sehnsucht*), i.e., by sculpture and architecture, and also by music and speculative philosophy. Picasso, therefore, embodied fully "the Gothic and Germanic spirit." Even though Uhde did not deem it necessary to go into the causes of this, he accepted nonetheless that it was "always possible to plow up the question of race and to find traces of Goth migrations in Spain,"[24] and he insisted that with Picasso: "For the second time in the history of peoples, the Gothic ideal is realized in contact with Roman soil." The significance of this, therefore, went well beyond a simple question of painterly technique: "The Greek spirit, romantic, German and Gothic, has been revived in new forms, and stands beside the Latin, classic and French spirit."[25] Uhde's ideas, however, were not always consistent. Sometimes the Gothic spirit took its place quietly alongside its classical neighbor; sometimes, as if awakening suddenly from a long sleep, it sprang forth in order to become as one with classicism and to impregnate it with its own blood. On Braque and the origin of cubism, Uhde wrote: "for the second time, springing from foreign stock in this same land, Gothic feeling unites itself in Georges Braque's work with Latin genius."[26] Uhde appealed to the theory of the importation and blending of a foreign temperament constantly

throughout his work: "the Gothic mentality ... is, beyond doubt, essentially Germanic and was carried to the Ile-de-France by the German tribe known as the Franks."[27]

Uhde's work caused such a sensation that in the following year the journal *Formes*, edited by the critic and art historian Waldemar-George, launched on its basis a wide inquiry into "the origins of Gothic art." This was a problem, the journal claimed, "of burning relevance today" (even though, we should note, archaeology had actually solved the problem as early as 1841). In a bid for impartiality, Waldemar-George summoned four French- and four German-speaking art historians.[28] After summarizing Uhde's ideas on Picasso and the French tradition, Waldemar-George asked these eminent historians two short questions:

1. Is Gothic art a sculptural and architectural style that is limited to one era (a historical period), or is it the manifestation of a state of mind (a psychological concept)?

2. To what extent did the Gallo-Romans and the Germans contribute to the birth and development of Gothic art?

Formulated thus, these questions did at least have the merit of setting up history and psychology as mutually exclusive, and they succeeded in reviving once again the age-old debate about the "ethnic," national, or racial origins of architectural styles.

It is well worth looking at the answers to these questions provided by the art historians Henri Focillon, Élie Faure, and Albert Erich Brinckmann. Focillon, for example, suggested that Gothic art was "a single point in Western history." It was no doubt also "the expression of a type of thinking," but it was a type that had "nothing of the purported German mysticism." Focillon wondered: if, as Wilhelm Uhde claimed, the Gothic "feeling" had been specifically Germanic, why did it appear so late "in Germania?" Furthermore, he asked: "why did the Romanesque, i.e. the Mediterranean, tradition subsist there longer than it did elsewhere?" Focillon's remarks, which were about temporal asynchrony, sketched out the

ideas concerning manifold and stratified time that he was in the process of developing, which were soon to be an essential part of his substantial and systematic work on the topic. It was, in fact, on the basis of the argument from chronological discordance that Focillon refuted the thesis that it was the Germans who had impregnated Gothic art: "At the time when the first systematic experiments on the ogival arch were being carried out in France, and when a distinct style became apparent, the 'tribe of the Franks' had long since disappeared as both an ethnic group and a historical force. It is in the sixth century, and not in the twelfth century, that we find Gallo-Romans and Germans."

But Focillon's words, commonsensical to begin with, suddenly swerved toward total paradox as he wrote: "Within the superior peoples, history works with races in order to wipe out races." For Focillon, therefore, clearly there were superior peoples. By privileging the inequality of "peoples" against that of "races," Focillon espoused, almost without knowing it, the very theses that he thought he was attacking, and he ended his piece with a return to the most thoroughgoing nationalistic historiography: "Gothic art is neither German, nor Latin, nor 'Gothic.' It is the French art of the crown lands from the second half of the twelfth century."[29] National claims such as this, it is true, had been evenly distributed throughout the nineteenth century among the Germans, French, and English. Here, however, Focillon was taking such thinking into the twentieth century, just as he had already done in 1919 in a highly patriotic and eloquently titled work, *Les Pierres de France*:

> We call this surprising way of building Gothic art. We should call it French art. There is nothing more French in its origins and in its development. It is a magnificent expression of the human soul, conceived by our forefathers and possessing a universal meaning; it was born in a canton whose borders can be easily delimited and that can be traveled in a day.[30]

Élie Faure responded to Waldemar-George's questions by sending in a few extracts of his own already published works. No doubt he was concerned to show that he had already thought through these questions and that, well before Wilhelm Uhde, he had resolved the issue with an equally racialist but much more concisely worded account of the birth of Gothic art: "Thus one sees Christian art emerging from French soil because the armed Franks violently mixed themselves in with the Celtic peoples who had long been in contact with the southern races." This striking formulation, lifted word for word from Faure's own *The Spirit of the Forms* (1927), was a perfect synthesis of historical ideas inspired in him by his reading of Gobineau: namely, that there was no history other than the history of races and interracial mixing; or, more exactly, "History begins with the mixing of blood." After reading Gobineau's *An Essay on the Inequality of Human Races*, Faure had been convinced that history was nothing but "one long biological drama," since "in man's arteries there whirled a vortex of mixed blood containing the skills that he had inherited from all of his ancestors either swirling in conflict one with one another or dissolving into themselves."[31] But what was truly unique about Faure was his conviction that art itself could have arisen only as a result of the intermixing of races. He maintained, along with Gobineau: "The white species remains powerless to develop a plastic genius ... if its black strain is not sufficiently pronounced for the sense of rhythm that characterized the black to be fused in some way with the sense of abstract order that characterizes the white."[32] Given that interracial mixing was, for Faure, the sole precondition for the appearance of works of art, the history and development of art ultimately came down to the history of interracial mixing. Accordingly, he accounted for the appearance of Dutch painting by the "black share infused by the Spanish into the veins of the Dutch," an interracial mixing that also made sense of Rembrandt's mysterious yet undisputable kinship with Vélazquez and Goya.[33]

Finally, Albert Brinckmann, professor at the University of Cologne and a disciple of Wölfflin, sent in a long and detailed response. First of all, he noted that Carl Friedrich von Rumohr had maintained, a full century

earlier, that since the Gothic style had been conceived in the lands that were "impregnated with Germanism," it should be called the "Germanic" style. Brinckmann then went on to "assert with certainty" that this style could have become rooted only in a country that was either purely Germanic, or had a population that had been mixed with "a Germanic tribe," such as, for example, in Northern Italy, i.e., the land of the Lombards, or Northern Spain, where there were "small Germanic enclaves," or, of course, in France, where there had been the settlement of the Franks, from whom moreover the country derived its own name. The closing lines of Brinckmann's essay were no less Gobineauan than Faure's contribution. Brinckmann concluded:

> For a long time now, the study of the races has shown clearly that, in the field of the arts and sciences, remarkable gifts are invariably the result of a fortunate mixture of races. People of pure blood, such as the Scandinavians, have made scant contribution to European activity over the past thousand years. It is, in contrast, Northern France that provides the greatest support to the thesis of interracial mixing. It is not by its form, but rather by the content of its argument that Wilhelm Uhde's thesis corroborates scientific investigation.[34]

Focillon believed that he could disprove the thesis of the racial determination of art by arguing that because of the historically long interbreeding of races, "Nowhere in the universe are there conservatories in which pure races may be found to flower."[35] But since this argument was based on the erroneous idea that racism necessarily involved a faith in racial purity, it was of absolutely no use against those, such as Uhde and Brinckmann, who believed in the positive value of the "mixing" of races. Although for the latter, to be precise, what counted above all in such mixing was the obvious and unassailable supremacy of German "blood." Occasionally implicitly, but most often very explicitly stated in their works, the superiority

of German blood over the blood of the Latin races was seen as a form of domination that was at once political, cultural, and gendered. The ideology of the "Frankish conquest" was not limited to the Germanic tribes' transformation into a hereditary aristocracy. With no fear of contradiction, the purveyors of this ideology saw the Germanic tribes as the ever-living source of the rejuvenation of the exhausted Latin races—a rejuvenation that was carried out, according to Ernest Renan, at the behest of Providence. The regeneration of the peoples of the South through the blood of those of the North was always understood as an impregnation that was inextricably cultural and biological. Was it not true that in uniting themselves with the Latin races, the Germans had given birth to Gothic art? The Latin races were never thought to have impregnated the Germans—the sexual metaphor, seemingly dictated as much by nature as by history, was never reversed.

Ten years before Gobineau was to maintain that interracial mixing was both the reason for the decline of the white race and the source of all artistic culture, Gustav Klemm had already divided the whole of humanity into "two parts each necessary to the other." He drew a distinction between "members of the active [and] members of the passive race," and it was "by this marriage of peoples ... that humanity is completed ... and brings forth the flowers of culture."[36] Always, this distinction involved a relationship of domination. We can see this, for example, in Gustave d'Eichthal's very Saint-Simonian statement: "The Black seems to me to be the 'female race' in the human family, as the White is the 'male race.'"[37] Just as Thomas Carlyle had opposed the "masculine principle" of the Germans to the "feminine principle" of the Latins,[38] Gobineau also divided the peoples of the earth into "males" and "females." He was distressed by the idea that the better part of the Germanic tribes, who had become strengthened by spending longer in the North, had allowed their strength to be dissipated as they moved toward the South, where the male influences, always less strong, had all but disappeared before the triumph of the feminine principle. But there were nonetheless exceptions to the rule that Northern masculinity

167

was always subsumed by Southern femininity. The Piedmont region of Italy and the North of Spain, for example, had escaped this fate because of the long presence of Germanic tribes—i.e., the Lombards and the Visigoths respectively—in those regions after the fifth century.[39] Bismarck—who, of course, aligned the Germans with masculine peoples—was by no means alone in internalizing Gobineau's teaching. From the end of the nineteenth century and right up through the 1930s at least,[40] it became utterly commonplace on both sides of the Rhine to describe the Latin peoples as "feminine."

It is very likely that Wilhelm Uhde drew the main inspiration for his ideas from Wilhelm Worringer, whose 1911 work on Gothic art was widely read at the time. Worringer wrote: "a disposition to Gothic is only found where Germanic blood has mingled with that of the other races." Here, therefore, the reference to the time of the Germanic invasions or *Völkerwanderungszeit* was quite explicit. Claiming to be interested only in the "Northern and Central European conglomerate of nations, the real breeding ground of the Gothic style," he assured his readers that he was not seeking to uphold "any spirit of race-romanticism such as that of Houston Stewart Chamberlain." Still, this did not prevent him from saying that if the Germans were not "its sole creators," they were at least "the *conditio sine qua non* for Gothic."[41] Yet the appeal to the Germanic invasions as an explanation for Gothic art did not begin with Worringer—its roots went right back to the early nineteenth century.

In 1823, in a work on Cologne Cathedral, Sulpiz Boisserée was the first to appeal to the intermixing of races (*Stammesvermischung*) in the establishment of what was to be the enduring theory of the exclusively German origin of Gothic art: "It was really the Germans and their neighbors, the English and the Northern French, related to the Germans by an ancient racial mix, that first practiced most and perfected this architecture."[42] Since all of the neighboring peoples of the Germans had thus been Germanized, it was useless to retort that Cologne Cathedral had been modeled upon

the cathedral at Amiens—the fact of its Germanic origin was unassailable. Moreover, Boisserée added, everyone knew that art always bore the imprint of the spirit of the nation that gave it birth. The "vegetal character" of Gothic architecture, he argued, derived from "The Germans' predilection for Spring [and] the deep feeling for the beauties of Nature that [had] always characterized the Germanic peoples." When the great art historian Franz Kugler noted, in 1842, that the origins of the "Germanic style" were to be found in France,[43] and when, in the following year, the architect Franz Mertens singled out Saint-Denis as the first building constructed in the Gothic style,[44] the theory of "racial mixing" played a vital part in preserving the Germanic origin of the Gothic style. The same argument was used by August Reichensperger: "People go to great lengths to deprive Germany of the honor of having invented the Gothic style, and they make a pretense of forgetting that at the time of its first appearance, the part of France which saw the first buildings of this type was under the control of the Germanic race."[45] The Belgian Louis Pfau went so far as to say that the Gothic style had sprung up "in every land that was either under the direct domination of the Germanic race, or where the latter had interbred with the indigenous population." He continued: "where the Germanic blood ends, there Ogival architecture ceases to exist." Gothic architecture had, therefore, never crossed the border from Lombardy (home of the Lombards, who were of Germanic blood, like the Normans) into central Italy, and it had never made an appearance in countries that were "purely Latin." In order to understand the real origins of Gothic art, Pfau stressed, one had to consider not "the geographical divisions of today [1862], but the distribution of races that alone matters."[46] As Paul Frankl pointed out in 1960, the idea that it was the Franks, descendants of the Germans, who were the true creators of Gothic architecture was to persist at least up until the time of the historian Georg Dehio, who died in 1932; and, in fact, thanks to National Socialism, through to the years immediately following the Second World War.[47]

Formulated thus, the argument always assumed the absolute primacy of
Germanic blood over the blood of all of those peoples with whom the Ger-
mans had interbred. Since the fifth-century conquerors had been far less
numerous than the populations they conquered, it was clear that this was
a matter of quality, not quantity. Artistic quality followed naturally from
quality of blood. Finally, Viollet-le-Duc made this law of the primacy of
"Aryan blood" part of his teaching at the Sorbonne: "When this superior
race comes in more or less thick layers (excuse this expression borrowed
from the physical sciences) across another race, it also dominates it. Since
the very beginning of history, there has been no exception to this rule."[48]
Handed down and repeated by innumerable German art historians from
Franz Kugler to Wilhelm Worringer and beyond, here was the reason why
the Gothic style, despite the fact that it had first appeared on French soil,
had really been born of a German father, and had found its true and most
perfect expression only in Germany.

As we have seen, in the last years of the nineteenth century, Louis Courajod
had vigorously promoted the idea that the Gothic style could have arisen
only after "a long and obscure barbarian incubation." Courajod was con-
cerned above all to show that there had been "communication, inoculation,
transfusion of new blood, barbarian blood," and simultaneously "trans-
fusion, injection of a new intellectual principle." But the barbarian inva-
sions, Courajod insisted, taking further the ideas of Viollet-le-Duc, had
really only awakened "the old Gaulish spirit" that had been dormant under
the Roman domination. By destroying the old ruling classes—i.e., those
who had collaborated with the occupying Romans, and had imposed upon
Gaulish democracy an art that was foreign, and therefore artificial—the
industrious Germanic invaders had liberated "the old instincts of the Celtic
race." The "barbarian temperament, the Aryan, Indo-Germanic element,"
expressed through decorative art, was thus "mixed with the old Celtic style

of ornamentation that derived from the same oriental origins." Courajod's vision, therefore, involved two modes of existence for this authentic and popular "national" art in the territory of France. He saw alternating periods of wakefulness and dormancy depending upon whether the barbarians—i.e., the indigenous Celts or the invading Germans—were either dominant or dominated. Roman civilization, therefore, had "murdered Gaul and temporarily buried the Celtic soul"; but barbarian civilization, in contrast, had "made France and had defined the personality of her art." In this way, for Courajod, it was uniquely the art of the Middle Ages that should be seen as "the true expression of the temperament of the homeland after the intermixing of races."[49]

Courajod maintained that during the seventeenth century it was not just in France but across all of Europe that one could see this split in the life of the peoples between the artificiality of surface and the authenticity of atavistic impulses. What had until the sixteenth century been the true expression of popular feeling and the "faithful mirror of the thought of each nation" had thus ceased to be "the common possession of the entire ethnographic family" when it was taken over by a caste of Romanists. In rejecting "any suggestion of atavism," and having broken with "all of the traditions of the primitive workmanship of the race transmitted by blood," he said, the art of the seventeenth and eighteenth centuries was free only "in the reputedly benign handling of ornament." Just as Versailles presented a faux natural world, with faux rivers and faux canals, the academic institutions succeeded in quashing the spirit of the people by concocting "a faux public mindset, a faux national language, a faux homeland, a faux France, a faux French art." All of these Academicians, he argued, were convinced that "the rational and absolute scientific *a priori*" could, in matters of art, "legitimately take the place of the feeling of the race, of inherited instincts, and of the traditional and unconscious play of History enacted by successive individuals inspired by a single atavistically predestined line of thought." But happily, Courajod insisted, a quiet resistance persisted—under the Roman yoke at first, and then later under the domination of

the Romanists (i.e., of the illegitimate Renaissance and the "wicked Italian stepmother"). This was the quiet, latent, and "often unconscious" resistance against Latin classicism carried on by Northern art—the true reflection of the character of the racial roots of the country.[50] It was in the decorative arts, where the repressive control of Romanism and of the Academy was less vigilant, that one could see evidence everywhere of barbarian atavism. As Courajod put it, this ornamental art, coming from the Scandinavians and Germans from whom, he wrote, "we" descend, is "a racial art, issuing from national principles, fixed in the blood, tied to the temperament of the people." For this reason, he claimed, *ornament does not lie*, declaring: "We can always have confidence in the ornament of a people. It is an unreflective gesture, a product of the unconscious hand, a nervous impulse, a form of writing that betrays the feelings of the soul and that cannot lie."[51] For Giovanni Morelli, as we have seen, it was the painter's unconscious tracing of an anatomical detail that allowed for the connection to be made between the work and the painter, and it was *physiognomy* that was always the clue to race. For Courajod, interested only in artistic matters on a *collective* scale, it was through ornament, the product of the "unconscious hand," that a whole people betrayed their racial identity. As with Morelli, Courajod's ideas involved a doubling of conscious and unconscious processes, and thus, also as with Morelli, they apparently owed much to the many new theories of the divided subject that were coming to the fore in psychology at the time. But unlike Morelli's vision, Courajod's hypothesis of the divided life of art involved the conflict between two antagonistic races and civilizations. For Courajod, the unconscious and almost irrepressible forces were always the expression of an Aryan or Indo-Germanic race standing up to the power of a cosmopolitan Rome (ancient and modern) that consciously exerted its normative and repressive power. As Pierre Francastel has pointed out, it is easy to see why this idea was so well received by the German historians of the following century.[52] Aside from a few details, Courajod's vision was the same as the one that had been framed seventy-five years earlier by Madame de Staël and the Schlegel brothers when they

imagined romanticism as the revolt of Tacitus's cherished "Germanic freedoms" against the oppression of the classicism of the Latins.

Toward the end of the nineteenth century, the new theories of the unconscious were grafted onto this basic model in such a way that the division of the races came to be thought of as a conflict between two psychic states. Essentially, this was what Hegel had suggested when he contrasted the "internal division" of the *hybrid* (part Latin and part Germanic) nations with the "undivided interiority" of the exclusively Germanic nations. In the new history of the art and culture of Europe that was beginning to be written, it was the Northern races that embodied the forces of the unconscious and the power of subjectivity, while the Latin races were depicted as beings "objectively" without depth and, at best, psychically divided. Most art historians came to use the opposition between the *conscious* and the *unconscious*, sometimes transposed to a contrast between the *patent* and the *latent*, as an easy key allowing them to construct, despite the apparent succession of "styles," the fiction of an absolute continuity in the art of a people or race.

We can see this fiction at work, for example, in the way German-speaking art historians set up the baroque as "proof" of what was, in fact, a delusional and purely imaginary Germanic continuity. Georg Dehio had unabashedly written that the Germans had "entered history as a race without art"[53] (an admission that would appear to have some merit, given the numerous works that were being written at the time in an attempt to unearth a primitive or archaic German art); however, this admission also showed that Dehio did really believe that there existed a racial identity uniting the Germans of the great invasions with those of the Germany of Kaiser Wilhelm II. This is why, around 1900, Dehio wondered how to determine the "border between the Renaissance and the Gothic" in the Germanic countries, i.e., how the transition from the Gothic style to the style of the Renaissance, and finally to the baroque, had come about. For Dehio, these apparently purely stylistic questions entailed serious racial consequences.[54] It was a question of showing that the ethnic or racial border

between the North and the South had been safely guarded throughout the centuries because the essence of Germanic art, symbolized by the Gothic, had remained untouched by the Italians and their Renaissance: "The path of evolution went in a straight line from the Late Gothic (*Spätgotik*) to the Baroque, [a path] often disturbed, but never destroyed by the lateral attacks (*Flankenangriffe*) from the Renaissance." From this, Dehio deduced the existence of a "Gothicizing Baroque" (*gotisierendes Barock*) allowing him, on the one hand, to construct an utterly fictive "Germanic" continuity, and, on the other, to make the baroque style an act of resistance on the part of the peoples of the North to the classical imperialism of the South. He went so far as to claim that the "historical relationship" between the baroque and the Renaissance was not one of succession but, rather, one of contiguity: *nicht ein Nacheinander; sondern ein Nebeneinander.* Dehio could not have made it more obvious that, for him, national and racial differences were more crucial than historical differences. He reiterated it nine years later, once again removing the baroque from its usual historical position in order the better to affirm the paramount influence of purely ethnic or racial factors in its development:

> In my opinion, the Renaissance and the Baroque do not succeed one another, they proceed side by side from the beginning, and they divide the art world that followed the Middle Ages in this way: the Renaissance is the style of the Italians, in conjunction with the civilization that bears its name; the Baroque, in Modern Times, is the spontaneous product of the same Northern peoples who had created the Romanesque and Gothic styles. In the same way that the Italian Late Gothic is a latent Renaissance, the Late Gothic of the Germans is a latent Baroque.[55]

At almost exactly the same time, Wilhelm Worringer, a follower of Alois Riegl[56] and Heinrich Wölfflin, also set about disconnecting artistic styles from historical moorings in order to see them as the atemporal expressions

of particular races. Worringer gave the generic name *Gothic* to all manifestations of anticlassicism. The Gothic style, he argued, was

> a phenomenon not bound to any single period of style, but revealing itself continuously through all the centuries in ever new disguises; a phenomenon not belonging to any age but rather in its deepest foundations an ageless racial phenomenon, deeply rooted in the innermost constitution of Northern man, and, for this reason, not to be uprooted by the leveling action of the European Renaissance.[57]

His concern was not to construct a history of the Gothic *stricto sensu*, but rather to develop a "psychology of style" capable of uncovering the "latent Gothic" as it had existed before its actual appearance in history, and everywhere it had been repressed and oppressed—from the time of the culture of Hallstadt and La Tène, from the beginnings of the evolution of a Northern world most likely located in "Germanic Scandinavia," and right through to his own time. In spite of its stubborn insistence, the classicism of the South had never succeeded in completely extinguishing the "Gothic will" of the Aryan peoples. Whenever this will found itself "obstructed by more powerful external conditions," it took on "a foreign disguise." Thus the baroque of the North was "a flaring up again in a strange garb of the suppressed Gothic will to form."[58]

Nevertheless, the rhetoric of reawakening was not intended—any more than was the rhetoric of incubation it came to complete—merely to describe a single line of history punctuated with periods of dormancy and wakefulness. On the contrary, this rhetoric furnished art historians with one of the most effective metaphors enabling them to depict, beneath all apparent breaks in history, the continuous, unconscious life of an organic body of people. During the years prior to the Second World War, Albert Brinckmann, presenting himself in France as a disciple of Louis Courajod,

was to develop further the theme of the "long and obscure barbarian incubation" formulated by his master at the end of the nineteenth century.

Brinckmann argued that the struggles and tensions out of which Western European art emerged could be explained only by the "facts of racial biology." In effect, it was the "racial structure" (*der rassenmäßige Aufbau*) of the various centers of artistic creation that determined the particular form of an artistic style, its technique, essence, and evolution. It was not possible, he argued, to isolate a style of art from its context, as the formalist Wölfflin had sought to do, even though Wölfflin himself had pointed to racial differences between Italian and German art, even though he had called them "differences of vision." Like Dehio before him, Brinckmann felt that the image of the cultivated ancient German that archaeologists were trying to promote effectively diminished "the grandiose character of the creation *ex nihilo* that was medieval artistic civilization," which was wholly attributable to the Germans. It was easy to prove the creative power of the Germans, since all the regions of the Roman countries into which they had not penetrated and mixed with the indigenous population had remained sterile. Such was the case, for example, with the South of Italy and Sicily, and with Provence and Brittany in France. At this point, Brinckmann introduced the theory of the "barbarian incubation," stressing that interracial mixing

> could have no productive results before the elapse of a certain amount of time during which the races interpenetrate and become assimilated one to another. The precise amount of time differs in each case and appears to be a function of the degree of kinship that exists between the two mixed elements. In the case of France, we can say that there was a creative renewal and an artistic flowering in the Languedoc around 1100, some six centuries after the settlement of the Visigoths and the invasion of the Franks. The same development can be seen in Burgundy shortly after 1100, i.e., some six centuries after the establish-

ment of the Burgundians, and five and a half centuries after the arrival en masse of the Franks. In the North of Italy, the phenomenon takes place in the eleventh century, *grosso modo* five centuries after the establishment there of the Lombards.[59]

So we can now see the true meaning of the title, "The Spirit of the Nations," that Brinckmann gave to his work. This "Spirit" was the racial spirit supposedly common to all European peoples—the spirit of the Germanic race distributed throughout by the good "Aryan blood." And this, moreover, was the very clear implication of the map of the Germanic invasions that illustrated Brinckmann's 1938 publication (figure 5.1).

In 1949, after the Second World War and the millions of deaths that resulted from this vision of race as the only real motivating force of history, UNESCO launched a massive educational campaign concerning the concept of race. A pamphlet published in 1952 included a map of the "Melting Pot of Peoples in Europe before the Twelfth Century" (figure 5.2).[60] Its conclusion was that the results of the early migrations of peoples made "peoples in the Caucasoid group extremely difficult to classify into races." The map had an advantage, at least, over the Jacob-Friesen map (included in Brinckmann's book) in that the population movements added to the movements of the sole "Germanic tribes" made it unreadable. Still, the 1952 UNESCO pamphlet nonetheless continued to fully maintain the concept of "race," albeit without providing any specific racial categories. Today, as we know, modern genetics rejects the validity of all such categories with regard to the human species.

"National Sense of Form" and the Racial Body

Worringer and Brinckmann were not, of course, the first to develop a psychology of style on the basis of a psychology of race. Alois Riegl's concept of the *Kunstwollen* (the will to art) remains one of the most well-known examples of those "psychologies of art" that postulate the autonomous

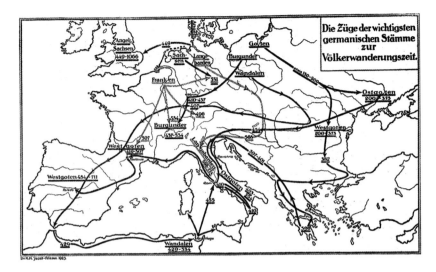

5.1 Jacob-Friesen, 1923: "The Paths of the Main German Races at the Time of the Migrations of Peoples," in Albert E. Brinckmann, *Geist der Nationen*, 1938.

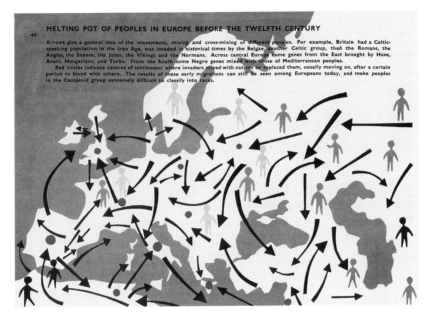

5.2 UNESCO, 1952: Map of the "Melting Pot of Peoples in Europe before the Twelfth Century."

nature of artistic production with respect to any sort of historical determi-
nation, and thus aim to connect the production of art objects directly with
the supposedly unchanging psyche of a people or race. Heinrich Wölfflin
is today the figure who best represents the twentieth century's attempt to
ground art history in the psychology of art. He was close to Riegl[61] in many
ways, and he is perhaps more interesting because of his contradictions and
recantations. What best defines his thought is a national and racial psy-
chological essentialism, and he articulated this essentialism quite clearly:
"What most concerns us [the Germanic peoples] is to understand clearly
our own essence (*unsere eigene Art*)."[62] He was interested in the physical and
tangible manifestations of this "Art." Rejecting, as merely a crude version
of materialism, Semper's theory that accounted for the history of forms
by the constraints of materials, climate, and functions, Wölfflin opted, as
early as his *Prolegomena to a Psychology of Architecture* (1886), to study first the
"proportions" of buildings, convinced as he was that those proportions are
"what every nation contributes as its very own." His thinking was very
much in line with what I have called the "physiognomical principle," as
we can see from the question with which Wölfflin begins the *Prolegomena*:
"How is it possible that architectural forms are able to express an emotion
or a mood (*Stimmung*)?"[63]

Influenced by the emerging theories of empathy,[64] Wölfflin argued that
we "sense a similar formative force in every architectural creation, only it
comes from within rather than without, like a creative will that fashions its
own body." Quite remarkably, he rebuked Robert Vischer, the "origina-
tor" of the concept, for not having understood that empathy (*Einfühlung*)
was a process that involved the entire human body, not just the imagina-
tion. But in fact, this was precisely Vischer's view of things. Wölfflin,
therefore, in his *Prolegomena* was appropriating Vischer's ideas in apparent
ignorance of the distinction made by Vischer between an empathy that
was "physiognomic" and without movement (but full of *Stimmung*) and an
empathy that was "mimetic," active, charged with affect, which he called
motor empathy (*motorische Einfühlung*).[65] In fact, Wölfflin never used the

term *Einfühlung*, although all his work was clearly thoroughly infused with the theory of empathy; Wölfflin's own term for the concept, *Formgefühl* (sense of form), was more nebulous.

In addition to this physiognomical vision, Wölfflin's psychology of architecture involved a completely untheorized leap from the individual to the *collective* body. Basing his argument upon analogies between architecture and the human "physical existence," he wrote: "Our own bodily organization is the form through which we apprehend everything physical." Every physical body, therefore, had its own "expression" that each person could feel, exactly like any human expression that could be felt through our capacity for *Nacherleben* or *reliving*. Thus, for example, "As soon as one imitates the expression of an emotion, one will immediately begin to experience that emotion."[66] In the European artistic tradition, these very old ideas went back notably to Horace's famous principle to which painters had adhered from the sixteenth to the eighteenth centuries: *si vis me flere dolendum est primum ipsi tibi* (if you want me to weep, you yourself must first feel grief). However, when these ideas were taken up again at the end of the nineteenth century—either by the mimetic theories of English or French psychology, or by theories of the *Einfühlung* in Germany—they were applied only to the particular experiences affecting the bodies of individual subjects. Wölfflin's muscular move, in his 1886 text, was to go directly and *without any theoretical explanation* from what he called the "sense of form" or *Formgefühl* (involving a form that was both produced and felt by the individual body) to the "sense of the people" (*Volksgefühl*), which he was later to call a "national sense of form" (*national Formgefühl*). He was assuming, therefore, the existence of national or racial bodies capable of collectively producing forms to which those same bodies would react in an equally collective manner.

For Wölfflin, therefore, the "formative force" was never about the will of a particular individual; it was always about the collective will of a people or race. Like the majority of his contemporaries, Wölfflin used the terms *race*, *nation*, and *people* interchangeably; however, when he did choose to use

race, it was nearly always as part of an insistence on the physical and biological nature of a collectivity, and on the hereditary transmission of certain stylistic "characteristics." What, he was to ask, lay behind the material manifestation of a work of art? In the introduction to his *Principles of Art History*, he gave his answer: it was "temperament" that formed individual style, the spirit of the time formed the style of historical periods, and it was "racial character" (*Rassencharakter*) that formed the style of a people. No more so than with the "formative force," the psychology of art that interested Wölfflin did not focus solely upon the individual and on an individual "temperament"; the focus was always, rather, on the collectivity and the racial character (*Rassencharakter*) that determined that collectivity. As Wölfflin developed, following so many others, the *topos* of the assumed division between the Latin and Germanic peoples, he was convinced that the "contrast between the Southern and Northern feelings toward life is expressed in the contrast between reclining and standing proportions. The feeling in the South is one of restful being, in the North one of restless pressing forward." These contrasting proportions, albeit so crudely formulated, were for Wölfflin sufficient evidence of the "physiognomy" of works of art, and he believed that these categories were capable of revealing the inner life of the peoples to whom he attributed the origins of the works. Thus he defined the idea of a psychology of art as "one that infers from the impressions we receive the popular sentiments (*Volksgefühl*) that generated these forms and proportions," and he added: "It is too well known to require comment that styles are not created at will by individuals but grow out of popular sentiments and that individuals can create successfully only by immersing themselves in the universal and by representing perfectly the character of the nation and the time," concluding abruptly with: "What a nation has to say, it always says."[67]

Initially based upon "proportions," his national and racial psychology of art was to find a yet more thorough and systematic formulation in his *Principles of Art History* (1915), before culminating in 1931 with *The Sense*

of Form in Art, in which the theory of "constants" was to reach its most extreme expression.

Wölfflin was, of course, highly attentive to formal changes and to the "evolution" of styles; however, he paid increasingly greater attention to factors that he saw as permanent and arising from the supposedly fixed characteristics of a people or race. As early as 1899, he argued that the "classic art" of the Renaissance in Italy owed nothing to the ancient model, and that it was a "purely national feature" and "nothing more than the natural continuation of the Quattrocento, and a completely spontaneous expression of the Italian people."[68] This national and racial essentialism was to become more explicit in 1931, when he was to fiercely rebuke any history of art based upon succession of discrete styles:

> only brief reflection is needed to realize that the various styles
> of a country do contain a common element that stems from the
> soil, from the race. Thus the Italian Baroque, for example, not
> only differs from the Italian Renaissance but also resembles it,
> since behind both styles stands the Italian man as a racial type;
> and racial types change only slowly.[69]

But by this time Wölfflin had long understood "evolution in art" as a law immanent to the *Volk* or race. Back in 1914, emphasizing how much the permanent characteristics making up a national imagination persisted and prevailed over stylistic changes in a given country, he declared that it was now high time to consider "that which persists through change" in order to finally "uncover the great national types of the history of art." Again, in 1936, he wrote: "each people assuredly have their own sense of form, and this form remains more or less constant and asserts itself more or less clearly in all styles."[70]

In *Renaissance and Baroque* (1888), Wölfflin had offered up a few simple formal categories, establishing a contrast between the classicism of the Renaissance and the "painterly" baroque style, in order to define an

internal break in the history of style in Italy. In *Principles of Art History*, these same categories were no longer applied to moments in history; they established, rather, a geographical division between the races of the North and the South, each one with its own "national sense of form." Wölfflin stressed the "linearity" of the Latin race precisely in order to set it in opposition against "the Germanic race [that] has always had the essence of the painterly in its blood." It was in the countries of the North, he insisted, that the "painterly sensibility seems *rooted in the soil*." Accordingly, Italy had "always been possessed of a stronger instinct for the plane than the Germanic North, which in its turn has the agitation of depth in its blood."[71] We should note here the famous phrase from his introduction: "Seeing as such has its own history, and uncovering these 'optical strata' has to be considered the most elementary task of art history."[72] In 1933, he stressed again that this history of seeing derived from processes that were "always governed by the exigencies of time and race." Throughout his career, Wölfflin was always a complex, contradictory, and ambiguous figure. He was torn between his work as an art historian concerned with change and his deep fascination for permanent factors he thought he could extract from the contingencies of history. Martin Warnke has noted, in a very cautious article,[73] that since Wölfflin is now an established historical figure, it would be futile for us to seek to deem him right or wrong, instead of trying to understand why, while his contemporaries gave various reasons for the change of style, Wölfflin himself gave none. But since Warnke considers that, for Wölfflin, the national-racial determination of forms was a mere "concession ... to the spirit of the times," he is unable to see that, since *Renaissance and Baroque*, Wölfflin had really abandoned all attempts to *explain* stylistic transformation, and that he was already fully convinced that it was the particular *Rassencharakter* that determined each "style" and each succession of styles. Quite paradoxically, as time went on, Wölfflin insisted more and more on the necessity of developing a *history* of art based on the "permanencies" and continuities of national and racial characters. His "concession ... to the spirit of the times" was, in

fact, so deep and radical that it swept along with it his entire theoretical apparatus.

In 1931, for example, Wölfflin claimed that if the sculpture of the Italian Renaissance possessed the characteristic of clarity, this had nothing to do with any "systematic athletic training" but derived ultimately from "a racially different bodily organization." Further on in the same text, he noted that it was thanks to line that we could speak of "the indestructible character of the Italian concept of form." But why? Above all, because of "the Italians' innate sense of the body and of movement," since even "the way a man leans against the door jamb of a house; the way a woman lifts a jug from a well—these things look different in the South than in the North."[74] Such observations concerning physical bodies and physical behaviors—behaviors that we consider today to be obviously social and cultural habitus, i.e., codes readily subject to change—seemed to Wölfflin, equally obviously, to refer directly to racial and national permanencies written into the biological memory of human bodies.

"Rediscovering the Ancient Peoples in the Moderns": Constants in Art and the Persistence of Races

With his characteristic astuteness, the American art historian Meyer Schapiro referred in 1936 to the links that racial theories had made with the monuments of the past and with the discipline of art history:

> The racial theories of fascism call constantly on the traditions of art. ... Where else but in the historic remains of the arts does the nationalist find the evidence of his fixed racial character? His own experience is limited to one or two generations; only the artistic monuments of his country assure him that his ancestors were like himself, and that his own character is an unchangeable heritage rooted in his blood and native soil. For a

whole century already the study of the history of art has been
exploited for these conclusions.[75]

In truth, we could add almost a century to Schapiro's reckoning because,
as we have seen, it was with Winckelmann that the history of art began to
look seriously at the physical resemblance between the works of art of the
past and the peoples who were living in a given art historian's own day.
Winckelmann, however, was circumspect. Obsessed as he was by what he
saw as the physical degeneration undergone since the high period of Greek
art, if he wrote that the "appearance of today's Egyptians should still be
discernible in the figures of their earlier art" it was only to follow it up
with "but the similarity between nature and its image is no longer what
it was." The same degeneration, he claimed, had affected the bodies of the
Egyptians—according to certain reports, they had become "stout and fat."
The sky above Egypt was still the same, but its contemporary inhabitants
were henceforth "of a foreign stock," with a language, religion, form of
government, and general ways of living quite the opposite to those of the
past. Once sober and hardworking, they were now slumped into sloth, the
cause of their excessive corpulence. Winckelmann stressed that things were
very different with the Greeks of his day. Despite all the interracial mixing
and race dilution, "the present-day Greek race is still noted for its beauty,"
to the extent that in Naples, so close to Greece, one could even find many
faces "that could serve as models for a beautiful ideal and which ... appear
to be created for sculpture, as it were."[76]

Underpinning Winckelmann's vision was a subtle framework involving
divergences and similarities in the relations between the physical bodies of
his contemporaries and the artistic works of the past. Sometimes time was
expanded, as for example when modern corpulence obscured any possible
similarity to the elegance of ancient paintings or sculpture. Sometimes
time was contracted, as when the faces of his own contemporaries called
up immediately for him the memory of ancient sculptures. On the one
hand, his eye was dulled by the opacity of modern bodies that occluded

the images of ancient Egypt; on the other, the almost Greek bodies of the Neapolitans were nearly transparent, allowing him to see directly the pure masterpieces of ancient Greece. The similarity or divergence between the bodies of his contemporaries and the ancient forms thus became an indubitable sign of a respective continuity or discontinuity of blood.

Elsewhere, attempting to characterize the successive styles of the ancient Etruscans, Winckelmann noted that the "characteristics" of the second style, of which he said that it "tends towards trifles," were still "characteristic of this nation." He was convinced that there existed a "national" and biological continuity uniting ancient Etruscans and modern Tuscans, and he was equally convinced about the stylistic continuity that appeared to derive from the former: "The style of their ancient artists can still be seen in works of their descendants, and the impartial and discerning eye will find it in the drawing of Michelangelo ... Daniele da Volterra, Pietro da Cortona, and others."[77] Continuity of blood and stylistic continuity were thus perfect mirrors one of the other.

It would not be until the following century, however, that people began to look more systematically at ancient monuments for tangible proof of the immutable characteristics—physical and moral—of peoples, i.e., what historians and anthropologists were soon to call the *permanence* or *persistence of races*. This began quietly enough with travelers to certain parts of Egypt or Greece finding themselves struck by a sense of *déjà vu*. Vivant Denon, for example, believed that he could see in the modern Coptic people "the ancient Egyptian stock, a species of dark-skinned Nubian, such as we can see in the forms of the ancient sculptures," with their flattened foreheads and wooly hair.[78] In Morea, the diplomat François Pouqueville saw everywhere "the models that inspired Apelles and Phidias." For Pouqueville, the mountain girls of Taygetus had the "attitude and bearing of Pallas," and when the girls of Messenia walked through the fields in their delicate bare feet, they could be "Flora in the middle of flower-bedecked meadows."[79] In 1873, as Théodore Ribot sought to understand the laws of "psychological heredity," he recalled that Pouqueville had not just described the physical

resemblance between contemporary Greeks and the ancient sculptures, but had also "affirmed the transmission of the principal character traits and customs." Thus the Arcadians still carried on a pastoral way of life, while their neighbors in Sparta still possessed the passion for fighting and an irritable temperament.[80] But a second approach was to follow this first quasi-hallucinatory stage of simple association: it became henceforth of crucial importance to seek proofs in the ancient monuments themselves for the hypotheses that had recently been put forward concerning the descent of peoples.

The archaeologist and cartographer Edme-François Jomard, who had been part of Napoleon Bonaparte's 1798 expedition along with Vivant Denon, later ridiculed those writers who had believed that the contemporary Coptic people were representatives of the ancient Egyptians. Those writers had never studied, he said, "the type found imprinted on the monuments." How, he asked, could one confuse the low forehead and snub nose of the Copts with the wide and elevated forehead, and the aquiline nose, of the ancient Egyptians? And how could one believe, like Winckelmann, that the latter could be identified "by the African form of their physiognomies?"[81] Jomard argued, in contrast, that "looking at the men of the regions of Esné, Ombos, Edfu, or the area around Selseleh, it would seem as if ... the figures from the monuments at Latopolis, Ombos, or Apollinopolis Magna had come down from the walls and were walking in the countryside." Far from being fixed in stone, this very ancient past was still living, therefore, in the present, since the same type, the same physiognomy, characterized the Fellahin of the Nile valley as much as it had the ancient inhabitants of Egypt. Had the latter not "transmitted their history by means of the arts, in the monuments that cover the banks of the Nile?" Any number of paintings and bas-reliefs depicted Egyptians alongside foreigners, and it was very easy to distinguish the former from the Ethiopians, Persians, Negroes, and other distant peoples.[82] As early as 1794, the founder of racial anthropology Johann Friedrich Blumenbach had noted, when comparing the paintings found on several Egyptian mummies in London with various

other monuments, that it was not possible to attribute to the ancient Egyptians "one common character of national physiognomy" in the way that Winckelmann, Corneille de Pauw, or Pierre d'Hancarville had done. Supplying drawings to prove his case, Blumenbach identified three distinct physiognomies: one the "Ethiopian cast," another "approaching to the Hindoo," and finally a *"mixed"* physiognomy that included elements from the other two (figure 5.3).[83]

Now these simple remarks from the monogenist Blumenbach, soon to be reiterated in his major work *On the Natural Varieties of Mankind*, were to furnish arguments over the course of the following century and a half to the most resolute polygenists, allowing them to find in the ancient monuments proofs of the continuity of races. The idea soon became widespread that artistic monuments could compensate for the lack of written evidence when it came to establishing relations of descent between contemporary peoples and the peoples of antiquity. The anthropologist Antoine Desmoulins, one of Cuvier's students, also thought that "everywhere man creates gods in his own image." He considered this to be an important "physiological phenomenon," the significance of which had not yet been realized:

> This constant correspondence of ideas of beauty and sentiments of taste in all peoples, each with their own particular organization, and this conformity between their imitative arts with those ideas and that taste [gives] to artistic monuments *a genealogical significance that can fill the silence of traditions and history.*

This was because, as Desmoulins continued, a species or a race might well change its language, and it could express the same needs, the same ideas and feelings, whatever its language—*"but one cannot change one's face, one's brain, one's whole organization."*[84] As Claude Blanckaert has indicated, language lost its former function as a marker of identity, the function it had had for Volney and August Schlegel, which Paul Topinard summed up with these words: "Same language, same people, same race was the basic

5.3 Johann Friederich Blumenbach, 1794: Three distinct physionomies in ancient Egypt.

key that could unlock everything."[85] But as early as 1826 with Antoine Desmoulins in France, and then in the 1840s with Samuel Morton in the United States, it was no longer languages but physical characteristics that permitted a return back through time to bring about the reconstruction of the descent of peoples and races. A new ethnology was in the process of being created, and it reversed the old convictions: languages, once seen as permanent and unchanging, were now unstable; the historical and climatic variability of "physiognomies" gave way to the dogma of the persistence through all contingencies of distinctive racial characteristics.

In the first half of the nineteenth century, therefore, a genuinely new interest arose in the human figures found in the artistic monuments of the past. In 1829, in a widely read essay, the doctor William Frédéric Edwards, the founder, some ten years later, of the Paris Anthropological Society, drew systematically upon the supposedly irrefutable evidence provided by these figures. Responding to Amédée Thierry's *Histoire des Gaulois*, in which Thierry had established, based on a reading of texts, a division within the "Gaulish race" between two distinct races, Edwards chose to look closely at the physical bodies of his contemporaries in order to "rediscover the ancient peoples in the moderns."[86] For if, as he reasoned, modern linguistic idioms betrayed their ancient origins, could we not say the same of bodily forms? "Would they be less persistent? Have we preserved none of the characteristics of our ancestors?" But since it was the ancient monuments that provided him with the "characteristic types of the ancient peoples," Edwards could rediscover in modern people only the "types" of the ancient works of art. To begin with, as a good polygenist, he used the example of the Jews to show that the transmission of racial types was not adversely affected by climate:

> It does not follow from the fact that they all resemble each oth-
> er today that they were this way in the ancient past. However,
> if you will consent to look at the last three hundred years, I can
> give you an unassailable example. In Milan, I saw Leonardo da

Vinci's *The Last Supper*. It is sadly altered by the injuries of time and the neglect of the inhabitants, yet we can see quite clearly all of the figures in the painting. We find among them the exact features of the Jews of today. ... But if you ask for more proof, and if you were to ask what were the features of the Jews of the more distant past, I can tell you what they were like more than three thousand years ago.

Now, the ethnologist James Cowles Prichard had cited a Greek author to the effect that the Egyptians were black and curly-haired, and so Edwards, finding himself in London in the company of his friends Dr. Hodgkin and Dr. Knox, decided to double-check this—not by looking again at the text, but rather by scrutinizing a monument that was being exhibited in London at the time: "The Tomb of the King of Egypt." Standing before the life-size painted figures, Edwards was convinced that he could identify those belonging to a people that were certainly dark-skinned, but "had neither the color nor the tightly curled hair of the Negroes." He noted also "two other small groups from foreign nations. In one of them we saw most strikingly the Jewish nation. The day before this, I had myself seen Jews walking in the streets of London. Now I was sure I was seeing their very portraits."

Traveling throughout Italy, Edwards again sought out confirmation that the descendants of those who had built all the great monuments that lay about him in ruins were still alive, and were "offering up the image of their ancestors." In Florence, where the Grand Ducal Gallery allowed him the opportunity to study the "Roman type," he preferred the busts of the early emperors who were not, unlike so many of their successors, of foreign stock. He was at this point struck by the idea that, far from being "universal" within a given people, physical traits were always found with counter-traits following the model, proposed by Amédée Thierry, of the Gaulish "family" that was divided into two races: the Galls and the Kymry. Italy was no exception here, since there was a Gallish type clearly identifiable in

the Tuscan—i.e., Etruscan—busts and statues, whilst another more Northern type was witness to the living presence of the descendants of the Gaulish Kymry race. Everywhere—in Greece as in Egypt, and in Italy as in France—Edwards's close examination of the paintings and the "inspection of the monuments" confirmed him in his belief that these artistic fictions had perpetuated themselves in the living flesh of his contemporaries—a phenomenon that he called, as so many were to repeat after him, *racial persistence*.[87] The Italian architect and critic Giuseppe Pensabene was to say, more than a century later, upon leaving the museums of Chiusi, Volterra, and Tarquinia, where he had made drawings of the Etruscan marbles: "I see these men alive once again. I see this race walking before me in flesh and blood." And again: "I have only to mingle with the people who are out walking in the church squares or sitting in the local taverns to discover these same Etruscans, living and speaking right in front of me."[88]

In the meantime, ethnology and the history of art had many times fed one upon another in order to base the persistence of races on the works of art of the past, and to base stylistic constants upon racial constants. Paul Broca, one of the most famous French anthropologists of the nineteenth century, would have been unable to maintain his racist and polygenist arguments had he not been able to find support for them in the interpretations of ancient Egyptian artworks. Even the most inflexible theologians (he asserted, against all the facts) would admit henceforth that men were originally "divided into several perfectly distinct races whose types have persisted without alteration right down to our own day." For those who were unconvinced by the written documents, or still doubted the "identity of the ancient types with certain modern types," the drawings and sculptures of ancient Egypt, found in monuments going back to the most distant antiquity, were enough to remove any hesitations. He referred his readers to Samuel Morton, whose *Crania Aegyptica* (1844) presented cropped versions of the drawings in Champollion's *Monuments de l'Égypte*, in order to show that black people always figured in the ancient monuments as "a scorned and servile race." In the eternal war of races, it was the same

conquering peoples who always triumphed over the same conquered races. Thus, in the Nubian temple of Beit el-Wali there was a depiction of the face of Ramesses II that stood out, according to Broca, "in starkest contrast to those of the vanquished, one could believe that one was seeing a modern Greek in the midst of the inhabitants of the Congo."[89] Almost a half-century later, his student Ernest Hamy, the founder of the Trocadéro Ethnographic Museum, sought once again to "discover in contemporary races such as the Kurds, Tartars, Aissori, etc., the very recognizable survivals of the conventional types found thus depicted in the most ancient Chaldean monuments" (figure 5.4).[90]

Louis Courajod was stirred by the statues of the *Wise and Foolish Virgins* on the west façade of the cathedral of Strasbourg, seeing them as "national figures" sculpted in the pink sandstone of the Vosges:

> The material comes from the ground, as the expression comes from the soul of Alsace. ... The models that the sixteenth-century Alsatian artists used have not changed since then. We can still find them in the nineteenth century, in the paintings of Jundt, Brion, Marchal, and Pabst. It is the same nature.[91]

Anthropologists looked for survivals of ancient artistic types in the physical bodies of the modern "races," while art historians were wonderstruck by the survivals of ancient bodies in the works of modern art; they all, therefore, appeared to find confirmation for the ideas of Antoine Desmoulins. When the historical record was silent, the artistic monuments took on an irreplaceable genealogical function. Was not the resemblance between the living people and the figures of the works of art proof enough that a single genealogical chain bound them together? Was not the transmission of similar physical characteristics inextricably grounded in both the social and biological memory of a given race? Did not the same laws that governed genetic reproduction also regulate the production of artifacts imitating nature? Whether in response to the laws of natural heredity or of artistic

5.4 E. T. Hamy, 1907: Comparing the profile of a twentieth-century Kurd from "high Mesopotamia" with a profile of the Ur-Nina dynasty from a Chaldean tablet, *ca.* 2500 BCE.

mimesis, men were essentially bound to copy nature and to transmit clusters of resemblances. Furthermore, the idea that artists made their works in the same way that people made children had never ceased to circulate since the time of classical antiquity.[92] The modern age, in transferring onto national or racial collectivities those properties that had previously been attributed to individual subjects, had made possible the chiasmus formed by the dogma of the permanence of races and that of artistic constants: the hypothesis of stylistic constants in works of art made no sense unless one accepted the hypothesis of the persistence of races, and that, in its turn, depended upon evidence provided by works of art. Taken together, this could only revive Winckelmann's syndrome in which all distinctions between artistic figures and living figures, between past and present, were blurred. As both Courajod and Ernest Hamy were proposing doctrines that betrayed an obsession with a delusional genealogy of identity, Marcel Proust was to compose the most astute description of the hallucinatory quality attaching to the subjective experience of the sudden appearance of something one had believed to be relegated to the distant past:

> But in any case to speak of racial persistence is to convey inaccurately the impression we receive from the Jews, the Greeks, the Persians, all those peoples whose variety is worth preserving. We know from classical paintings the faces of the ancient Greeks, we have seen Assyrians on the walls of a palace at Susa. And so we feel, on encountering in a Paris drawing-room Orientals belonging to such and such a group, that we are in the presence of supernatural creatures whom the forces of necromancy must have called into being. Hitherto we had only a superficial image; suddenly it has acquired depth, it extends into three dimensions, it moves.[93]

Just a few years after this, the director Sergei Eisenstein chose to depict in film the permanence of the eternal Mexican people; always identical

5.5 Sergei Eisenstein, two movie stills from *¡Que Viva México!*, 1931.

to themselves in facial and bodily features, they had survived the collapse of their ancient culture from the time of Spanish rule right on through to the dictatorship of Porfirio Díaz. At the beginning of the film, as images of living people alternate with those of the ancient sculptures, and as the camera shows, sometimes in the same shot, the inhabitants of the Yucatan and the Mayan sculptures (figure 5.5), the audience hears in voice-over:

> Time in the prologue is eternity
>> It might be today.
>> It might as well be twenty years ago.
>> Might be a thousand.
>> For the dwellers of Yucatan, land of ruins and huge pyramids, have still conserved, in feature and forms, the character of their ancestors, the great race of the ancient Mayas.
>> Stones—
>> Gods—
>> Men—
>>
>> ...
>> The people bear resemblance to the stone images, for those images represent the faces of their ancestors.[94]

As we shall now see, the conviction that art bears witness to the continuity of people or race had by no means been effectively anaesthetized in the aftermath of the Second World War. Indeed, it has found new life through the ongoing ethnicization of art that has been under way since the 1950s.

The Ethnicization of Contemporary Art

Originally the doctrine of "man determined by culture" was a
reaction against racial theories. ... Instead of race we have now
culture, but most anthropologists fail to see *mankind* and fail to
see the *individual*.

Geza Roheim, Psychoanalysis and Anthropology, *1950*

During the twenty or thirty years after the Second World War, one might
have thought that it would have become increasingly difficult to argue that
artistic production was determined by the racial origin of artists. Surely, a
person would have thought, such ideas must have been put to rest, scarcely
mentionable after the disastrous consequences of racial theories in the colo-
nial world and in the heart of the old Europe. The truth, however, is that
the deeply essentialist belief in the absolute and long-lasting continuity of
distinct peoples and their cultures has persisted with tenacity.

 In 1947, for example, a work entitled *Les Origines de l'art français* main-
tained that the Roman conquest (in reality no more than a brief episode in
the history of Gaul) had proven itself incapable of "stifling the old Celtic
spirit." The reader was told that, since "the ancient indigenous foundation"

remained an inexhaustible source of inspiration, Celtic art had continued to exist throughout "French" history. Artistic styles such as Flamboyant Gothic art, the Baroque, the Rococo, Art Nouveau, *Art nègre* (African Art), Cubism, Futurism, and Surrealism were, according to this book, evidence of so many resurgences of the "old anticlassical principles" that were profoundly rooted in European art and, in particular, in the French soil.[1] In 1955, an exhibition called *Pérennité de l'art gaulois* was designed to inform the French public about an original but forgotten civilization, characterized in the exhibition catalog as one "of which we are yet the inheritors and that we continue to carry into the future."[2] The famous critic Charles Estienne extolled the "heretical line" that ran uninterrupted from the forms of Gaulish coinage right through to the most recent works of the École de Paris, and a figure such as André Breton, pointing to Apollinaire's anticlassicism, saw Gaulish art as both the victim of "an exceptionally resolute repression" and the instrument of a thousand-year-old struggle against "the Greco-Latin contagion." Why, Breton asked, should we look for the antidote to the poison of classicism in the art of "the ancient Mayans or the contemporary Australian Aborigines," who were inescapably foreign to us, when this antidote was right there before us in the Gaulish medallions dug up, he said, from "the very ground that one walks on?" Jean Babelon, director of the Cabinet des Médailles, was equally convinced that Celtic art, with its "surrealist magic, was a reaction against that Mediterranean reason as a model to which it had been forced to subject itself."[3]

Apart from a few differences in the details, these were the very same ideas about the awakening of the old Gaulish spirit by the barbarians of the North and their descendants resurfacing perfectly intact seventy or ninety years after they were first set down, and promulgated by Viollet-le-Duc and Louis Courajod. It is true that they had been kept alive in France during the 1930s by historians such as René Huyghe, for whom twentieth-century art was neatly divided by "the rivalry between the Latin races and the Germanic races." When Huyghe analyzed the relations that French

art maintained with the "Indo-Germanic races," he was in no doubt that, in a Europe divided between "Latin-Mediterranean art" and "Germano-Nordic art," the cultural indicator had moved further away from the Mediterranean world during his own century: "The civilization that had been progressively established over the whole of Europe by the Latin classical spirit appears shaken by an abrupt reawakening of the forces that it had stifled."[4]

Once again, therefore, we can see the reappearance of the same national, ethnic, and racial essentialism that had led to the idea that cultures were singular and impermeable entities. A Spanish scholar maintained that no outside influence had ever had any corrupting effect upon the unbroken purity of Spanish national architecture,[5] and Nikolaus Pevsner struggled clumsily in his *The Englishness of English Art* (1956) to distance himself from Nazi thinking. He noted, for example, that two distinct racial types had existed in England right up to his own day. One of these types was "tall with long head and long features, little facial display and little gesticulation," while the other was "round-faced, more agile, and more active." While the Celts, he claimed, "had a special delight in the spiral curve and the tight intertwining of such curves," the artistic works produced by the Angles, Saxons, and Normans (all of "Germanic" descent) were evidence of their innate love of freedom.[6] Sir Herbert Read, as we have seen, was still stressing in 1968 the higher value of Aryan art in comparison with a Jewish art which, he claimed, was entirely lacking in "respect for form."

In the United States, the great art historian Robert Rosenblum claimed to have reconstructed the "Northern Romantic Tradition," a tradition that was radically anticlassical and anti-Mediterranean.[7] He hoped that this "unorthodox" view would succeed in overthrowing what he saw as the imperialistic Parisian hold on the interpretation of modernity. Defined therefore by an American, this Nordic genealogy that went from "Caspar David Friedrich to Mark Rothko" offered the great advantage of including America in the age-old conflict dividing Europe between North and

South. In a similar fashion, in the 1980s, the American art historian Svet-
lana Alpers claimed to have isolated the notion of the non-Albertian pic-
turing found in Kepler's optics. The existence of this "mode of picturing,"
refined in the Northern artists' studios, was allegedly proof enough for
her to say: "Northern art came of age, came into a new age, by staying
close to its roots." This thoroughly fictitious non-Albertian mode of depic-
tion was naturally just as transhistorical as its countermodel, the Southern
"Albertian mode," based on the optics of Brunelleschi, that had supposedly
exerted its imperialist power both on European art up to the nineteenth
century and on art history and criticism right through to the end of the
twentieth.[8]

In this way, the postures and strategies of the victimized became
increasingly effective as, within the space and history of Europe and the
West, they were pitted (following a single pattern that ran from Herder to
Breton) against the normative superpower of a "Latin classicism" accused
of having crushed and repressed everything that was unique and indig-
enous. Since the end of the Enlightenment, therefore, the roles seemingly
remained the same: classicism was always the instrument of *Roman* impe-
rial and colonial universalism (Breton referred to it thus in 1954 in order
to better distinguish the "invaders of 50 BCE" from those of 1940), and all
of the insurrections carried out by its victims were not only legitimate but
highly desired.

In 1951, Jean Dubuffet called for "Honneur aux valeurs sauvages,"[9] con-
vinced, as he was, that "this force of blood, that this intensity of vital fluid
is ... more passionate in Occidental Man than in any other race." This inten-
sity, he claimed, appeared in Europe and in America more powerfully than
anywhere else. This was because, as he put it, the "man of the European
race, who is a savage and tempestuous man, does not express himself at all
in our classical art, borrowed from the Greeks, who themselves borrowed
from Egyptian sources," adding that classical art was "a borrowed art and
foreign to our race." Anyone who wished to discover "authentic and liv-
ing European art" could find it only in "art brut" that had above all to be

kept pure and free from any contamination by "CULTURAL ART" and its marketing apparatus. A number of these ideas had long been put into circulation by his friend Louis-Ferdinand Céline.

As Daniel J. Sherman has noted,[10] it was no accident that Dubuffet's incorporation of the primitive into "civilization" coincided with his travels in colonial Algeria, where he went to "cleanse" himself in order the better to regenerate what he saw as European art in a state of decline. In claiming that the "primal values" of Europe were more powerful than those of the colonized countries, Dubuffet was not engaging in a critique of colonial violence, neither was he engaging in a critique of the racial violence that, coming out of Europe, had just torn the whole world apart for five years. What Dubuffet was undertaking was more like a second symbolic conquest that was intended to divest the colonized peoples of the very negative characteristics that "civilization" had first conferred upon them. This act of appropriation (or reappropriation) instantly reversed the values of these characteristics. What had once appeared negative was suddenly transformed into something entirely positive. Furthermore, by treating European art as a whole, as a single entity beyond the conflict between Latin and Germanic races, Dubuffet changed the focus of the racialization of art.

From one perspective, Dubuffet's incorporating of the "savage" was just the latest expression of that long-standing anticlassical tradition glorifying the barbarians, whose wild and primitive energy had remained perfectly intact, and who had once succeeded in regenerating the sickened West. This is surely the meaning contained in Dubuffet's letter from El Golea in 1947:

> We did everything we could to immerse ourselves in Arabic. We were almost always solely in the company of natives, and that served us very well because we came back thoroughly cleansed, refreshed and renewed.[11]

If Dubuffet initially saw the colonized peoples as noble savages offering Europeans a reinvigorating bath in the fountain of youth, they were not to keep that quality for long. Once the benefits of his cleansing were thoroughly established, the discourse of colonialism resurfaced in all its crudeness and violence: "When you get down to it, I do not quite know what to think of these people, and I tend to think the worst. Their arses rarely leave the ground."[12] And again:

> He's not so bad, the plucky Aryan. He's good to be around. I'm not unhappy to be back again with him. I'm going to stop studying Arabic. Just seeing a bit of Arabic script now gives me a headache; it turns my stomach and makes my teeth chatter.[13]

Looking at things from another perspective, however, if we follow Aimé Césaire in seeing "the savaging of the continent" that took place during the Second World War as both the prolongation of colonial brutality and the backlash of that same brutality onto Europe, then we can understand that many of the cultural constructs produced in Europe at that time had the effect of silencing or obfuscating the fact that they were based upon the very same racial thinking that had legitimized colonialism. Paradoxically, then, to praise "savage values," in the name of the superiority of a "European race" whose values were understood as fundamentally quite foreign to those of classicism, was tantamount to minimizing (if not exactly justifying) both the crimes committed during the war and the crimes perpetrated through colonialism. It was to shout out once again that culture was primarily a matter of race; and it was to claim once again that the European race was superior to all others—superior even in terms of savagery. With this remarkable ideological sleight of hand, the European imaginary switched the places occupied up to then by the savage and the barbarian; and at the same time, it reversed the meanings that those terms carried.

Europeans had first seen *Art nègre* in strictly Gobineauan terms: it was "the life-giving sperm of the spiritual twentieth century." In the words

of Paul Guillaume, "the savage who incised into the enormous sequoia an effigy of an Ancestor ... wasn't worrying about art; he was accomplishing a hieratic sexual act."[14] But now a Europe that was barbaric in all reality could both take on the mask of the noble savage and, in the same move, redefine the savage as a barbarian by removing him from the primitivism that had formerly placed him in a happy state of primordial nature. *Art nègre* was no longer a Gobineauan leavening agent of "melanism," working to rejuvenate old Europe. Europeans now chose to see the success of *Art nègre* thirty years previously as a deadly assault carried out against the values of classicism, and thus as the foreshadowing of a "slipping back to puerile and barbarous preferences."[15] While the West had never acknowledged primitive peoples as its contemporaries, effectively expelling them from history,[16] it now made the figure of this new barbarian into an ever-present threat. With the collapse of the colonial empires, primitivism and its happy primordial nature were soon to disappear in the face of fear of the barbarian—now a synonym for all human conflicts. Initially expelled from history, the colonized noble savage made his return in the disturbing guise of a new aggressive and dangerous barbarian, provoking new race wars.

Since the Second World War, the ethnicization or racialization of art (the term *ethnic* being generally merely a fig leaf for *racial*), far from being the prerogative solely of the West, has become—or become once again—an increasingly ordinary and generalized practice. Since the 1970s, cultures on all continents have gradually appropriated the European model, contrasting reputedly indigenous artistic forms with a supposedly normative and controlling—i.e., imperialistic—"classical" art. It was very much the case, therefore, that the imputation of cultural imperialism (a charge that was largely false and delusional coming from the mouths of the blandishers of barbarian or Northern culture) became perfectly justified when it was seen to be coming from the former colonies now subjected to "modernity." But we know that colonialism has ended up going so far as to extend the Western concept of modernity in such a way as to make of it a psychological

category beyond its temporal and geographical dimensions. Ashis Nandy defines this as a "second form of colonization":

> This [second] colonialism colonizes minds in addition to bodies and it releases forces within the colonized societies to alter their cultural priorities once for all. In the process, it helps generalize the concept of the modern West from a geographical and temporal entity to a psychological category. The West is now everywhere, within the West and outside; in structures and in minds.[17]

One of the most remarkable instances of this "second form of colonization" is certainly the establishment by white people of the category of *Inuit art*. In 1948, as he was visiting an Inuit community (at the time called Eskimos) at Hudson Bay, the Canadian artist James Houston discovered the *pinguak* sculptures. These were small toys, a few centimeters in size, carved in ivory and generally representing animals.[18] The small collection of objects Houston purchased at that time was put on show at the Montreal Handicraft Guild. These objects were highly admired. Houston was asked by this organization, and by the Canadian government, to return the following year to the Canadian Arctic in order to encourage the Inuit to produce more. The idea was that the sale of such objects could help to offset the significant cost of maintaining a people living in difficult economic conditions, just as the sale of their craft objects had done prior to the war. This project was hugely successful, and the production of objects primarily for sale spread to a great number of Inuit villages. When the annual value of production rose to a million Canadian dollars, the Hudson's Bay Company, originally founded in the seventeenth century as a fur-trading enterprise, sent representatives to the villages in order to encourage the Inuit to produce even more of these objects, and to sell them to the Company. As a result, cooperatives were set up in parts of the Canadian territory, sometimes managed by the Inuit themselves, for

purchase and sale, with profits going directly to the producers. This cooperative model would be imported into Australia by the Australian government in order to encourage and commercialize the production of artifacts by the Aboriginal people. Around 1958–1959, James Houston had the idea of initiating the Inuit into the art of printmaking. This endeavor was enormously successful, and has continued to be so right up to the present day. Indeed, in the 1970s, convinced that their identity in the world was bound up with their identity as artists, the Inuit created their own economic, social, and political institutions. These institutions allowed them to construct for themselves a genuine autonomy that, owing nothing to the traditions of their ancestors, enabled the development of their "modern consciousness."[19]

Each region of the Inuit territory (known as Nunavut) had its own recognizable style. This was partly the result of the color and density of the stone found in a region, and partly the result of the fact that the Inuit sculptors tended to copy the style of the most famous sculptors of their own region. The more technological modernity established itself in the Inuit territory and culture, the more the white market required the Inuit to produce exclusively work that was typically Inuit, at least in the eyes of the white purchasers. Furthermore, the dimensions of these sculptures underwent a significant transformation. The *pinguak* toys and the first commercially produced copies that measured only a few centimeters twenty-five or thirty years earlier were soon replaced by sculptures weighing more than fifty kilos and measuring more than a meter in height. Today, the price of certain pieces can go as high as C$300,000. Thus a growing demand for authenticity— i.e., for the immediate identification of the "ethnic" origin of the objects—has had the effect of creating production, on a massive scale (in both senses of the term), of evocations of ways of life that have long since disappeared. And yet, even in 1989, Ignacio Ramonet, a famous French scholar of the Third World, was wonderstruck to discover that it was still possible to "sculpt Inuit identity," and that authentic artists could "recount traditional life, precisely the life that modernity was

threatening with total destruction." He was delighted to see that there still existed "authentic regional characteristics," and that the sculptors used the traditional tools handed down from generation to generation, not electrical or power tools. He was, however, sad to see that "certain less than conscientious artists add a wax coating in order to artificially enhance the brilliance of the piece." Despite this, he concluded that the artistic work of the Inuit gave a deep cultural meaning to their search for political autonomy, and that it would allow them one day, "when all of them will have been thoroughly Americanized, to recall for themselves what was, for each of them, their profound Inuit identity."[20]

The West has long been haunted by the thought of "primitive" peoples entering into contact with "modernity," a modern world that was destined to destroy, inexorably and pitilessly, their pure and authentic ethnicity. Victor Segalen, for example, at the beginning of the twentieth century, bemoaned the death of the "pale and slender Marquesan people," walking slowly toward their eventual total exhaustion before "this scourge: contact with the 'civilized'." In twenty years' time, they will no longer be "savages," "they will have forever ceased to be."[21] Yet we know that, well before Victor Segalen and Ignacio Ramonet, the idea had been tirelessly repeated that the peoples we now call "indigenous"[22] could only either remain true to their essential identity or die. It was absolutely incumbent upon them to show the signs of their belonging to an immemorial tradition—i.e., to exhibit the signs of their ahistoricity—lest they should disappear forever.

The example of the Inuit, and also of the Aboriginal people of Australia,[23] demonstrates how the West's age-old yearning to fix other peoples within a racial and ethnic identity that it, the West, had already assigned to them, has been echoed since the 1990s by the increasingly strong desire on the part of these same "indigenous peoples" to have this identity universally recognized. Now, one of the most reliable ways of achieving this universal recognition is to produce artifacts supposedly coming out of their own "tradition," and also to produce objects to which the market accords

the status of works of art. The paradox is that these same objects which, for some observers, testify to the anchoring of a people in their immemorial tradition, and constitute the indisputable signs of their racial and ethnic identity, are for other observers the very instruments of that same people's entry into the modern commercial market and, by virtue of that very fact, into the most technologically advanced parts of the modern world. The display of ethnic and racial provenance once they enter the market has therefore come to endow these objects with a clear surplus-value.[24]

This surplus-value attaching to the ethnic sign, however, can vary enormously depending upon the markets in which the objects are put up for sale. Today there exists, alongside the contemporary art market, a market of the noncontemporary, i.e., the market of objects that are still close to craftwork and to *tourist art*, and the boundaries between these markets are disappearing on all continents. In other words, this is the market of the "primitive," where objects display the signs of their ethnic provenance— signs that simultaneously, therefore, place them outside of history. Thus Sotheby's has a department of "Ancient and Ethnographic Arts," while contemporary Australian art is classified in the "Paintings, Drawings and Sculpture" section. Along with this ahistoricity of ethnographic, "indigenous," "tribal," or "native" art comes its anonymity. It is always produced by a "people" or an "ethnic group," while contemporary art is never anonymous—it is always the work of an "individual."[25]

It is not hard to see that the growing search for authenticity in ethnographic art has led everywhere to such great commercial pressures that the sought-for authentic quality finds itself increasingly diluted by the huge scale of production. However, there are at least two ways of looking at this phenomenon. The first, coming from an essentialist conception of culture and identity, bemoans the loss of ways of life, and the disappearance of techniques and beliefs that are supposedly "authentic," i.e., have always been free from contact with other cultures. Those who share this vision deplore the homogenization of the peoples of the world. A second vision, accepting the always more or less unstable and dynamic nature of

all culture, would value and underscore, like Caylus three centuries ago, the "mixture of national tastes" that results from their exchanges and their conflicts.

At the same time, the signs of an immemorial ethnicity (the very *raison d'être* of the "noncontemporary" art market) have now encroached upon the objects put up for sale in the contemporary art market. Through a remarkable contamination that has come, no doubt, from the world of tourist art, dealers, collectors, and art lovers have sought out, often with great enthusiasm, ethnic signs inscribed in "contemporary" works of art. Now, it may sometimes happen that the desire to make known an ethnic origin is unfairly attributed to an artist, and this is the surely case with Basquiat, whose work some commentators are quick to see as the product of a biological process: "This son of a Haitian father and a Puerto Rican mother knows that the 'primitive' forms are written into his genes."[26] But when an artist who was born in Manchester, England, and is a former student of the Royal College of Art in London, decides to use elephant feces to attach to his works his own African (Nigerian)[27] origins, this display must surely be seen as part of a deliberate commercial strategy. The artist must, of course, know that the signs of belonging to a non-Western racial and ethnic group (signs that have been and still are a source of stigma in most social situations in the West) have equally become a source of profit both in the contemporary art world and in the contemporary world of culture as a whole.

The fact that the display of racial and ethnic signs in artistic works is now guaranteed to bring a substantial surplus-value to a work of art is quite evident today in the United States in the growing number of art shows in which the "ethnic" or "racial" quality of the works exhibited simply goes without saying. It is as if an artist or a work of art can be, before everything else, "Black," "African-American," "Latino," or "Native American," and that the artist or the work can be addressed necessarily and exclusively to the members of his or her or its "community."[28] At the same time, in the global contemporary art market, we can see the increasing presence (in

particular since the 1990s) of both a "Contemporary African Art" whose principal producers often live outside of the African continent yet make strong claim to their "traditions," and a "Contemporary Islamic Art" whose principal producers are not Muslims.[29] In each case, the extreme fluidity of identities is deliberately occluded in order to foreground categories that are meant to show, once again, that art and culture are primarily a matter of *race*. If everyone involved in the world of art and culture were convinced that art and culture were essentially a matter of race, then the global art market could well become a permanent exhibition of a powerful and dangerous competition between the "races"—the very same competition between races that drove the first art historians to found the discipline.

Notes

Introduction

The first English translation of this chapter, by Nicholas Huckle, was published in *October* 161(Summer 2017), 11–22.

1. "There may have been fogs for centuries in London. ... But no one saw them, and so we do not know anything about them. They did not exist till Art had invented them." Oscar Wilde, "The Decay of Lying" (1889), in *The Artist as Critic: Critical Writings of Oscar Wilde*, ed. Richard Ellmann (Chicago: University of Chicago Press, 1982), 312.

2. Hannah Arendt, "Lying in Politics: Reflections on the Pentagon Papers," in Arendt, *Crises of the Republic* (San Diego: Harcourt Brace, 1972), 5.

3. Joseph von Goerres, *Germany and the Revolution*, trans. John Black (London: Longman, Hurst, Rees, Orme, and Brown, 1820), 199.

4. Pierre Jacques Changeux, *Traité des extrêmes ou éléments de la science de la réalité* (Amsterdam: Darkstée & Merkus, 1767), vol. I, 375–376.

5. Patrick J. Geary, *The Myth of Nations: The Medieval Origins of Europe* (Princeton, NJ: Princeton University Press, 2002), 49.

6. André Piganiol, *L'Empire Chrétien (325–395)* (Paris: Presses universitaires de France, 1947), 422.

7. Lawrence Nees, ed., "Approaches to Early-Medieval Art," *Speculum* 72, no. 4 (October 1997), 960.

8. Walter Goffart, "None of Them Were Germans: Northern Barbarians in Late Antiquity," in Goffart, *Barbarian Tides: The Migration Age and the Later Roman Empire* (University of Philadelphia Press, 2006), 187–229.

9. Tacitus, *Germania*, ca. 98; Jordanes, *Getica*, 551; Paul the Deacon, *Historia Langobardorum*, ca. 788; Beatus Rhenanus (1485–1547), *Rerum Germanicarum libri tres* (Basel, 1531). Cf. Goffart, *Barbarian Tides*; Klaus von See, "Der Germane als Barbar," and "Vom 'Elden Wilden' zum 'Volk der Dichter und Denker'. Die Anfänge der Germanen-Ideologie,"in *Barbar, Germane, Arier. Die Suche nach der Identität der Deutschen* (Heidelberg: Winter, 1994), 31–82.

10. Henry Bogdan, *Histoire de l'Allemagne de la Germanie à nos jours* (Paris: Perrin, 2003).

11. J.-G. Herder, *Philosophical Writings* (1774), trans. and ed. Michael N. Forster (Cambridge: Cambridge University Press, 2002), 300–301.

12. Comte de Hertzberg, "Dissertation aiming to explain the causes and the superiority of the Germans over the Romans & to prove that the North of Germania or Teutonia between the Rhine & the Vistula, & principally the present Prussian Monarchy, is the original land of these heroic nations, who in the celebrated migration of peoples destroyed the Roman Empire, & who founded & peopled the principal monarchies of Europe," in Hertzberg, *Huit dissertations ...* (Berlin: Decker & Fils, 1787), 28–29.

13. Thus the historian Gervinus saw in the Reformation "the renewal of the opposition of the Latin and Germanic races," still visible in the division between a "Germanic" North America and a "Latin" South America. Georg Gottfried Gervinus, *Introduction à l'histoire du XIX^e siècle*, trans. F. van Meenen (Brussels and Leipzig: Flatau, 1858), 39.

14. Goffart, *Barbarian Tides*, 13.

15. Viollet-le-Duc, *Entretiens sur l'architecture, vol. I* (Paris: Morel et Cie, 1863), 205.

16. Numa Denis Fustel de Coulanges, *L'Invasion germanique et la fin de l'Empire* (1891; Paris: Hachette, 1904), 552.

17. Geary, *The Myth of Nations*, 155–156.

18. Fustel de Coulanges, *L'Invasion germanique et la fin de l'Empire*, xii.

19. Michel Baridon and A. O. Lovejoy, *Le Gothique des Lumières* (Paris: G. Monfort, 1993).

20. See, for example, "German Architecture," the famous text that Goethe wrote in 1772 on the cathedral of Strasbourg against the "good taste" of the Italians and the French.

21. See *Correspondance 4: Civilisations. Orient-Occident, Génie du Nord-Latinité. Lettres de Henri Focillon, Gilbert Murray, Josef Strzygowski, Rabindranath Tagore* (Paris: Société des Nations, Institut international de coopération intellectuelle, 1935).

22. Leibniz had, from 1691, called upon his compatriots to explore the soil "in order to re-establish the ancient history of Germania": Alain Schnapp, *The Discovery of the Past*, trans. Ian Kinnes and Gillian Varndell (New York: Harry N. Abrams, 1996), 206.

23. Comte du Buat-Nançay, *Histoire ancienne des peuples de l'Europe* (Paris: Desaint, 1772), vol. I, vi–xv.

24. J. W. Goethe, quoted by Erich Auerbach, *Mimesis: The Representation of Reality in Western Literature*, trans. W. R. Trask (Princeton, NJ: Princeton University Press, 1953), 330–331. ("Aber uns Nordländer kann man auf jene Muster nicht ausschließlich hinweisen: *wir haben uns anderer Voreltern zu rühmen und haben manch anderes Vorbild im Auge.*" "Geschmack," remarks following Goethe's translation of *Rameau's Neffe*, in *Goethe's Werke*, vol. 36 [Cotta, Stuttgart, and Tübingen, 1830], 170; emphasis added.)

25. Montesquieu, *The Spirit of Laws* (1748), trans. Thomas Nugent (1752) (Kitchener: Batoche, 2001), vol. I, book VI, ch. XVIII, p. 108; book X, ch. III, p. 157.

26. Online: http://www.rae.es/diccionario-de-la-lengua-espanola/la-23a-edicion-2014. See the classic work by Léon Poliakov on which I am drawing here: *The Aryan Myth: A History of Racist and Nationalist Ideas in Europe*, trans. Edmund Howard (New York: Basic Books, 1974).

27. Lega Nord, or Northern League, is a right-wing regionalist party formed in 1991.

28. This did not prevent a great number of Germans in the nineteenth and twentieth centuries from deducing, to the contrary, from all of these barbarian migrations the "Germanic" character of the art and culture of Europe as a whole, including Italy.

29. Gottfried Wilhelm von Leibniz, *New Essays on Human Understanding*, trans. A. G. Langley (Chicago: Open Court, 1916), 297. On the history of the myth of the Indo-Europeans, see the recent work by Jean-Paul Demoule, *Mais où sont passés les Indo-Européens? Le mythe d'origine de l'Occident* (Paris: Seuil, 2014).

30. Pierre Leroux, "De l'influence philosophique des études orientales," *Revue encyclopédique* (1832), 69–82 (here 75).

31. *Aux sources de l'ethnologie française. L'académie celtique*, ed. and intro. Nicole Belmont (Paris: CTHS, 1995).

32. There are two notable exceptions: Louis Courajod, a Germanophile, defended, at the end of the nineteenth century, the idea of a close barbarian kinship between the Celts and the Germans; Henri Focillon, a Germanophobe, sought for "the genius of the race" in *Les Pierres de France* (1919), from the "Celtic landscapes" to the railroad stations of Paris, and often signed his letters: "The old Celt." See "Lettres de Henri Focillon à Georges Opresco," ed. Radu Ionesco, *Revue roumaine d'histoire de l'art* (Bucharest) 29 (1992).

33. Ernest Renan, *Essais de morale et de critique* (Paris: M. Lévy Frères, 1861), 59.

34. Abbé [Jean Benoît Désiré] Cochet, *La Normandie souterraine, ou notices sur des cimetières romains et des cimetières francs, explorés en Normandie*, 2nd ed. (Paris: Derache, 1855), 4.

35. V. Tahon, *Compte-rendu des travaux du congrès de Charleroi*, Société paléontologique et archéologique de Charleroi (Brussels: Deprez, 1889), 85–87 and 120–125. See Hubert Fehr, *Germanen und Barbaren im Merowingerreich* (Berlin: De Gruyter, 2010), 243, who associates this passage with an identical remark of Fustel in *La Monarchie franque* (1888), 296: "The rule that scholars have established for distinguishing between the races in the grave is highly arbitrary."

36. Hippolyte Taine, "Études de psychologie. I: Th. Ribot, l'Hérédité" (1873), in *Derniers Essais de critique et d'histoire*, 7th ed. (Paris: Hachette, 1923), 185–193 (here 188–189).

37. Zeev Sternhell, *The Anti-Enlightenment Tradition*, trans. David Maisel (New Haven: Yale University Press, 2006). See also *Histoire et Lumières. Changer le monde par la raison. Entretiens avec Nicolas Weill* (Paris: Albin Michel, 2014).

38. Stuart Hall, "Race, the Floating Signifier," Media Education Foundation, 1997, www.mediaed.org.

39. Maurice Barrès, *Le Voyage de Sparte* (Paris: Plon, 1906), 49.

40. Hall, "Race, the Floating Signifier."

Chapter 1

1. Roger de Piles, *Abrégé de la vie des peintres ...* , 2nd ed. (Paris: Estienne, 1715), 538–545; Roger de Piles, *The Art of Painting, and The Lives of the Painters* (London: J. Nutt, 1706), 398–480.

2. Giovanni Pietro Bellori, *The Lives of the Modern Painters, Sculptors and Architects* (1672), trans. Alice Sedgwick Wohl (Cambridge: Cambridge University Press, 2005), 252. The fragment is included in the "Life of Domenico Zampieri." Bellori dedicated his work to Colbert.

3. Cited by René Bray, *La Formation de la doctrine classique en France* (1926) (Paris: Nizet, 1963), 128.

4. *Encyclopédie ou dictionnaire raisonné des sciences, des arts et des métiers*, art. "Goût" (final section composed by Paul Landois, 1757).

5. Johann Georg Sulzer, *Allgemeine Theorie der Schönen Künste* (Leipzig, 1771), vol. I, 445, cited by Werner Oechslin (who seems strangely unaware of De Piles's text on the taste of the nations), "Le goût et les nations: débats, polémiques et jalousies au moment de la création des musées au XVIIIe siècle," in Édouard Pommier, ed., *Les Musées en Europe à la veille*

de l'ouverture du Louvre (Paris: Klincksieck / Musée du Louvre, 1995), 365–414, see p. 402. Paillot de Montabert, *Traité complet de la peinture* (Paris: Delion, 1829–1851), vol. III, 344.

6. Antoine Joseph Dezallier d'Argenville, *Abrégé de la vie des plus fameux peintres* (Paris: De Bure l'Aîné, 1742), Part One, "Avertissement," x, and "Discours sur la connoissance des desseins et des tableaux," xxvi. The *Encyclopédie* confirmed this usage: "Manner, *in Painting*, is the particular way that each painter has in drawing, composing, expressing, and coloring."

7. De Piles, *The Art of Painting*, 392.

8. Ibid., 393.

9. Ibid., 393–397.

10. Ibid., 395.

11. Jean-Baptiste Dubos, *Réflexions critiques sur la poésie et la peinture* (1719; Paris: Mariette, 1733), vol. II, 267.

12. Pierre Jean Mariette, *Recueil Crozat*, vol. I, 1729, iii (preface). *Recueil d'estampes d'après les plus beaux tableaux et d'après les plus beaux desseins qui sont en France, Dans le Cabinet du Roy, dans celuy de Monseigneur le Duc d'Orléans, & dans d'autres Cabinets. Divisé suivant les differentes écoles; avec Un abbregé de la Vie des Peintres, & une Description Historique de chaque Tableau*, Tome Premier: *Contenant l'Ecole Romaine* (Paris: Imprimerie Royale, 1729).

13. Antoine Joseph Dezallier d'Argenville, *Abrégé de la vie des plus fameux peintres*, new ed. (1745–1752; Paris: De Bure l'Aîné, 1762), vol. III, 288.

14. Ibid., vol. I, li.

15. Ibid., vol. I, x, xxi.

16. De Piles, *The Art of Painting*, 397.

17. Antoine Joseph Pernety, "Ecole Françoise," in *Dictionnaire portatif de peinture, sculpture et gravure* ... (Paris: Bauche, 1757), 250.

18. David Hume, "Of National Characters" (1748), in *Essays, Literary, Moral, and Political* (London: Ward, Lock, 1898), 122.

19. François Ignace Espiard de La Borde, *Essais sur le Génie et le Caractère des Nations* (The Hague: Nicolas van Daalen, 1751, vol. I), 54.

20. Jacques Barzun, *Race: A Study in Superstition*, 2nd ed. (1937; New York: Harper & Row, 1965), 79–80.

21. D'Alembert, "School: in the Fine Arts," an addition to the article "School (Painting)" by Chevalier de Jaucourt for the *Encyclopédie*. Jaucourt's discussion of the principal schools begins with these words: "This term is ordinarily used to mean the class, or the series of

painters who have become famous in a country, and who have followed its taste; however, one sometimes uses the term school to designate the students of a great painter, or those who have worked in his manner. Hence, with this latter meaning, one says: the school of Raphael, of the Carracci, of Rubens, etc. But taking the word school in its widest sense, we count eight schools in Europe: the Roman school, the Florentine school, the Lombard school, the Venetian school, the German school, the Flemish school, the Dutch school, and the French school."

22. Cited by Oechslin, "Le goût et les nations," 387.

23. De Piles, *The Art of Painting*, 398–480.

24. The entry "Kunstgeschichte" in the *Allgemeine deutsche Real-Encyklopädie für die gebildeten Stände*, vol. 8 (Leipzig: Brockhaus, 1845), 435–436; see Heinrich Dilly, *Kunstgeschichte als Institution. Studien zur Geschichte einer Disziplin* (Frankfurt: Suhrkamp, 1979), 86.

25. See Bray, *La Formation de la doctrine classique en France*; Ingrid Kreuzer, *Studien zu Winckelmanns Aesthetik. Normativität und historisches Bewußtsein* (Berlin: Akademie Verlag, 1959), in particular 16–31 ("II. Stil und Geschmack").

26. Johann Joachim Winckelmann, *Reflections on the Imitation of Greek Works in Painting and Sculpture* (1755), trans. Elfriede Heyer and Roger C. Norton (La Salle, IL: Open Court, 1987), 3.

27. Johann Joachim Winckelmann, *Briefe*, ed. Walther Rehm, vol. 1 (Berlin: Walter de Gruyter, 1952), 394.

28. Anne-Claude-Philippe, Comte de Caylus, *Recueil d'Antiquités égyptiennes, étrusques, grecques, romaines et gauloises*, vol. III (Paris: Desaint and Saillant, 1759), preface, xx, and vol. IV (Paris: N. M. Tilliard, 1761), 76.

29. Caylus, *Recueil d'Antiquités*, vol. III, preface, xxi–xxiii. See also De Piles.

30. Marcel Mauss "Les techniques du corps," *Journal de Psychologie* 32, no. 3–4 (15 March–15 April 1936).

31. Pierre Bourdieu, *Practical Reason: On the Theory of Action*, trans. Gisèle Sapiro (Stanford: Stanford University Press, 1998), 8.

32. Dezallier d'Argenville, *Abrégé de la vie des plus fameux peintres*, l.

33. Caylus, *Recueil d'Antiquités*, vol. II (Paris: Duchesne, 1756), 23–24.

34. Ibid., vol. V (Paris: Tilliard, 1762), 325. The evolution of "tastes" or "styles" was therefore not, according to Caylus, a purely linear and progressive phenomenon, as has often been claimed. Caylus anticipated, rather, Waldemar Deonna, *L'Archéologie, sa valeur, ses méthodes*, vol. III: *Les rythmes artistiques* (Paris: Laurens, 1912), 32–33. Deonna cites Charles Lalo, for whom early art often resembles the art of "highly civilized periods," and

she refers to phenomena of psychic regression (old age returns to childhood) as discussed by Théodule Ribot with regard to language and memory.

35. Caylus, *Recueil d'Antiquités*, vol. III, 316.

36. Hume, "Of National Characters," 119.

37. Caylus, *Recueil d'Antiquités*, vol. IV (Paris, 1761), 106.

38. Ibid., vol. I (Paris, 1752), 117–118.

39. Caylus, *Recueil d'Antiquités*, vol. III, x–xi. Thus we have here a portrait of Caylus that is far removed from the cruel epitaph composed for him by Diderot: "Ci-gît un antiquaire acariâtre et brusque / Oh ! qu'il est bien logé dans cette cruche étrusque," cited by Thomas Crow, *Painters and Public Life in Eighteenth-Century Paris* (New Haven: Yale University Press, 1985), 268.

40. Francis Haskell, *History and Its Images: Art and the Interpretation of the Past* (New Haven: Yale University Press, 1993), 180.

41. On the relations between Caylus and Winckelmann, see in particular Samuel Rocheblave, *Essai sur le comte de Caylus. L'homme—L'artiste—L'antiquaire* (Paris: Hachette, 1889), 328–366; Kreuzer, *Studien zu Winckelmanns Aesthetik*; Markus Käfer, *Winckelmanns hermeneutische Prinzipien* (Heidelberg: Winter, 1986), 23–32; Haskell, *History and Its Images*, 180–186; Alex Potts, *Flesh and the Ideal: Winckelmann and the Origins of Art History* (New Haven: Yale University Press, 1994), 76–81; Élisabeth Décultot, "Anthropologie et ethnologie de l'histoire de l'art au XVIIIe siècle. Winckelmann et le tableau des peuples antiques," *Études germaniques* (2009, no. 4), 821–840; Élisabeth Décultot, "Winckelmann et Caylus. Enquête sur les rapports de l'histoire de l'art au savoir antiquaire," in Nicholas Cronk and Kris Peeters, eds., *Le Comte de Caylus, les arts et les lettres* (Amsterdam: Rodopi, 2004), 59–78.

42. Johann Joachim Winckelmann, *History of the Art of Antiquity*, trans. Harry Francis Mallgrave (Los Angeles: Getty, 2006), 71; compare Winckelmann, *Geschichte der Kunst des Alterthums* (Dresden: Waltherischen Hof-Buchhandlung, 1764), ix.

43. Winckelmann, *History of the Art of Antiquity*, 112 (*Geschichte der Kunst des Alterthums*, 4–6). The consequences of this thesis will become clear in chapter 2.

44. Johann Gottfried Herder, *Denkmal Johann Winckelmanns* (Kassel: Kay, 1882), 48. It is worth noting that Antoine-Yves Goguet, to whom Herder refers, is the author of *De l'origine des Loix, des Arts et des Sciences et de leurs Progrès chez les Anciens Peuples* (Paris: Dessaint & Saillant, 1758), the three volumes of which were very quickly translated into German, English, Italian, and Spanish.

45. Herder, *Denkmal Johann Winckelmanns*, 46, 44. See Hubert Locher, "Stilgeschichte und die Frage der 'nationalen Konstante,'" *Zeitschrift für schweizerische Archäologie und Kunstgeschichte* 53, no. 4 (1996), 285–293 (in particular 287).

46. See Potts, *Flesh and the Ideal*, 79, for a good account of the oposition between Caylus's "diffusionist aproach" and Winckelmann's attempt to represent the autonomous development of Greek art.

47. Comte de Caylus, "Réflexions sur quelques chapitres du XXXVe Livre de Pline," *Mémoires de l'Académie des Inscriptions et Belles-Lettres* 25 (1759), 149–214; see 191.

48. Hippolyte Fortoul, "Peinture," in Pierre Leroux and Jean Reynaud, eds., *Encyclopédie nouvelle ou Dictionnaire philosophique, scientifique, littéraire et industriel, offrant le tableau des connaissances humaines au xixe siècle*, vols. V–VII (1841), 374 (emphasis added). This essay was taken up again with the title "Essai sur la Peinture," and included in a volume later published by Fortoul, *Études d'archéologie et d'histoire* (Paris: Firmin Didot Frères, 1854), vol. I, [XIII. Des Écoles]).

49. *Lettre de M. le Chevalier de Tincourt à Madame la Marquise de *** sur les Tableaux et Dessins du Cabinet du Roi* (Paris, 1751), 20, cited by Andrew McClellan, "Rapports entre la théorie de l'art et la disposition des tableaux au XVIIIe siècle," in Édouard Pommier, ed., *Les Musées en Europe à la veille de l'ouverture du Louvre* (Paris: Klincksieck / Musée du Louvre, 1995), 565–582 (see especially 577).

50. Debora J. Meijers, "La classification comme principe: la transformation de la Galerie impériale de Vienne en 'histoire visible de l'art,'" in Pommier, *Les Musées en Europe à la veille de l'ouverture du Louvre*, 591–606.

51. Nicolas de Pigage, *La Galerie électorale, de Dusseldorff, ou Catalogue raisonné de ses tableaux ...* (Brussels: J. B. Jorez, 1781), preface, vi–viii (German edition in 1778). Two other rooms, showing paintings from a mixture of several schools, but principally works by Gerard Dow and Van der Werff, had been named after those two artists. The "Rubens Room," however, held only "major works" of the great master. See Meijers, "La classification comme principe."

52. Chrétien de Mechel (Christian von Mechel), *Catalogue des Tableaux de la Galerie impériale et royale de Vienne* (Basel: Chez l'Auteur, 1784), preface, xiv–xv (German edition in 1781). See Meijers, "La classification comme principe."

53. Alexandre Tuetey and Jean Guiffrey, *La Commission du Muséum et la création du musée du Louvre, 1792–1793* (Paris, 1910), 178–189 (see 187).

54. Jean-Baptiste-Pierre Le Brun, *Réflexions sur le Muséum national* (14 January1793). See this text and a very important afterword by Édouard Pommier (Paris: Réunion des Musées Nationaux, 1992), 9.

55. Fortoul, "Peinture," 374 (emphasis added).

56. Hippolyte Fortoul, "Idée d'une formule générale de l'architecture," *Revue indépendante* 1 (1841), 237–247. Essay taken up again with the title "Du principe de l'art allemand ... ," in Hippolyte Fortoul, *De l'Art en Allemagne* (Paris: Labitte, vol. II, 1842), 311ff.

———

57. Fortoul, "Idée d'une formule générale de l'architecture," 238–239.

58. Sulpiz Boisserée, *Geschichte und Beschreibung des Doms von Köln* (1823), 2nd ed. (Munich: Literarisch-artistische Anstalt, 1842), 70–71; Karl Schnaase, *Niederländische Briefe* (Stuttgart and Tübingen: Cotta, 1834), 474. I discuss these points in more detail in chapter 4.

59. Friedrich Ludwig Jahn, *Essai historique sur les mœurs, la littérature, et la nationalité des peuples de l'Allemagne …* , trad. P. Lortet (Paris, Doyen, 1832), §XLIV, 426.

60. Immanuel Kant, "Determination of the Concept of a Human Race (1785)," trans. Holly Wilson and Günter Zöller, in Kant, *Anthropology, History, and Education*, ed. Günter Zöller and Robert B. Loudon (Cambridge: Cambridge University Press, 2007), 145–159.

61. Notably those of Alexander Bain, Herbert Spencer, Wilhelm Wundt, and Hippolyte Taine.

62. Théodule Ribot, *L'Hérédité. Étude psychologique sur ses phénomènes, ses lois, ses causes, ses conséquences* (Paris: Ladrange, 1873), 379.

63. Carole Reynaud-Paligot, *La République raciale, 1860–1930* (Paris: Presses universitaires de France, 2006), 155–162.

64. See Jean-François Gossiaux, "Ethnie, ethnologie, ethnicité," *Ethnologie française*, n.s. 27, no. 3 "Quelles ethnologies? France Europe 1971–1997" (July–September 1997), 329–334.

65. Claude Lévi-Strauss, "Race and Culture," in Lévi-Strauss, *The View from Afar*, trans. Joachim Neugroschel and Phoebe Hoss (New York: Basic Books, 1985), 14. See also Wiktor Stoczkowski, *Anthropologies rédemptrices. Le monde selon Lévi-Strauss* (Paris: Hermann, 2008).

66. Charles Darwin, *The Descent of Man* (Princeton, NJ: Princeton University Press, 1981), 354.

67. Timotheums Merzahn von Klingstädt (or Klingstöd), *Mémoire sur les Samojedes et les Lapons* (Copenhagen: Philibert, 1766), 8. See also Michèle Duchet, *Anthropologie et histoire au siècle des Lumières* (1971), Postface by Claude Blanckaert (Paris: Albin Michel, 1995), 295–298.

68. Buffon [Georges-Louis Leclerc, Comte de Buffon], *Œuvres complètes*, édition Lacépède, vol. V (Paris: Rapet et Cie, 1818), an addition to the section "Variétés dans l'espèce humaine" in l'*Histoire naturelle de l'homme*, 295. Cf. Nicholas Hudson, "From 'Nation' to 'Race': The Origin of Racial Classification in Eighteenth-Century Thought," *Eighteenth-Century Studies* 29, no. 3 (Spring 1996), 254.

69. Buffon, *Œuvres complètes*, 247. Cf. Claude Blanckaert, "Les conditions d'émergence de la science des races au début du XIXe siècle," in Sarga Moussa, ed., *L'Idée de "race" dans les sciences humaines et la littérature (XVIIIe et XIXe siècles)* (Paris: L'Harmattan, 2003), 135–137.

70. Britta Rupp-Eisenreich, ed., *Histoires de l'Anthropologie, XVIe–XIXe siècles* (Paris: Klincksieck, 1984), 240.

71. François Guizot, *Du gouvernement de la France depuis la Restauration, et du ministère actuel* (Paris: Ladvocat, 1820), 1–2.

72. Jean Charles Léonard Simonde de Sismondi, *Études sur les constitutions des peuples libres* (Paris: Treuttel et Würtz, 1836), 89.

73. Britta Rup-Eisenreich, "Critiques allemandes de la notion de race," *Gradhiva*, no. 19 (1996), 3–23 (see 10).

74. Johann Friedrich Blumenbach, *On the Natural Varieties of Mankind*, trans. Thomas Bendyshe (New York: Bergman, 1969), 227–243 (Latin edition 1795, German edition 1798, first English edition 1865).

75. Isidore Geoffroy Saint-Hilaire, *Histoire naturelle générale des règnes organiques*, vol. II (Paris: Masson, 1859), 334–335.

76. Giovanni Morelli, *Italian Painters: Critical Studies of Their Works*, vol. 1, trans. Constance Jocelyn Ffoulkes (London: John Murray, 1892), 75.

77. Edgar Wind, "Critique of Connoisseurship," in Wind, *Art and Anarchy* (London: Faber & Faber, 1963); Jack Spector, "The Method of Morelli and its Relation to Freudian Psychoanalysis," *Diogenes* 66 (1969), 63–83; Hubert Damisch, "La partie et le tout," *Revue d'esthétique* 23 (1970), 168–188; Enrico Castelnuovo, "Attribution," *Encyclopaedia Universalis*, vol. II (Paris, 1970), 780–789; Richard Wollheim, "Giovanni Morelli and the Origins of Scientific Connoisseurship," in Wollheim, *On Art and the Mind: Essays and Lectures* (London: Allen Lane, 1973), 177–201; Giovanni Previtali, "À propos de Morelli," *Revue de l'art*, no. 42 (1978), 27–31; Henri Zerner, "Morelli et la science de l'art" (1978), in *Écrire l'histoire de l'art. Figures d'une discipline* (Paris: Gallimard, 1997).

78. Carlo Ginzburg, "Clues: Roots of an Evidential Paradigm," *Theory and Society* 7, no. 3 (May 1979), 273–288.

79. Carol Gibson-Wood points with great astuteness to this essential aspect of Morelli's thought in her thesis *Studies in the Theory of Connoisseurship from Vasari to Morelli* (New York: Garland, 1988), 211–222. See also Daniela Bohde, *Kunstgeschichte als physiognomische Wissenschaft. Kritik einer Denkfigur der 1920er bis 1940er Jahre* (Berlin: Akademie Verlag, 2012), 54.

80. Giovanni Morelli, *Italian Painters: Critical Studies of Their Works*, vol. 2, trans. Constance Jocelyn Ffoulkes (London: John Murray, 1893), 125.

81. Giovanni Morelli, *Italian Masters in German Galleries: A Critical Essay on the Italian Pictures in the Galleries of Munich-Dresden-Berlin*, trans. Louise M. Richter (London: George Bell & Sons, 1883), 3. I would like to thank Michela Passini for drawing my attention to this point.

82. Ibid. Winckelmann had already established this organic link between the characteristic forms of an art, "facial features," and a people's dialect (*History of the Art of Antiquity*, 118; *Geschichte der Kunst des Alterthums*, 19).

83. Morelli, *Italian Painters: Critical Studies of Their Works*, vol. 2, 127.

84. Ibid., 125.

85. Morelli, *Italian Masters in German Galleries*, 231–232.

86. Gibson-Wood, *Studies in the Theory of Connoisseurship from Vasari to Morelli*, 214.

CHAPTER 2

1. Johann Joachim Winckelmann, *Reflections on the Imitation of Greek Works in Painting and Sculpture* (1755), trans. Elfriede Heyer and Roger C. Norton (La Salle, IL: Open Court, 1987), 5.

2. On Winckelmann's anti-French sentiment, see Carl Justi, *Winckelmann, sein Leben, seine Werke und seine Zeitgenossen*, vol. 2, t. II (*Winckelmann in Italien*) (Leipzig: Vogel, 1872), 40–48; Kurt Karl Eberlein, "Winckelmann und Frankreich. Zur Geschichte des deutschen Kultureinflusses im französischen Klassizismus," *Deutsche Vierteljahrsschrift für Literaturwissenschaft und Geistesgeschichte* 11 (1933), 592–595; Martin Fontius, *Winckelmann und die französische Aufklärung* (Berlin: Akademie Verlag, Sitzungsberichte der deutschen Akademie der Wissenschaften zu Berlin, Klasse für Sprache, Literatur und Kunst, 1968), no. 1; Steffi Röttgen, "Winckelmann, Mengs und die deutsche Kunst," in Thomas W. Gaehtgens, ed., *Johann Joachim Winckelmann* (Hamburg: Felix Meiner, 1986), 175–176.

3. *Demosthenis erste philippische Rede. Im Auszug übersetzt von B. G. Niebuhr, Neuer Abdruck, mit einem Vorwort* (Hamburg: Friedrich Perthes, 1831), 6. Drawn from the final sentence of the foreword, the formula "Griechenland ist das Deutschland des Alterthums" became in Germany, after 1853, a dissertation topic; the Hellenist Christian Muff was soon to invert the phrase and to reveal its implicit meaning: "Deutschland ist das Griechenland der Neuzeit." Muff, *Antik und Modern. Ein Vortrag* (Halle: Mühlmann, 1879), 47.

4. Gustav Friedrich Waagen, *Handbook of Painting* (1862), trans. J. A. Crowe (London: Murray, 1879), 50.

5. Written and published in Latin in 1655 by the doctor Claude Quillet (1602–1661), *Callipaedia, or, the art of getting pretty children* was a great success for two centuries, translated into many languages, and with no fewer than nine French editions by the middle of the nineteenth century.

6. Winckelmann, *Reflections on the Imitation of Greek Works in Painting and Sculpture*, 11.

7. Ibid., 21.

8. Ibid., 15.

9. Vasari was content to note that one could recognize Greek statues by "the fashion of the head, the arrangement of the hair, and from the nose, which from its juncture with the eyebrows down to the nostril is somewhat square." Giorgio Vasari, *Vasari on Technique*, ed. G. Baldwin Brown, trans. Louisa S. Maclehose (London: J. M. Dent, 1907), 44–45.

10. Letter to Count Bünau from Rome, 7 July 1756, in Johann Joachim Winckelmann, *Briefe*, ed. Walther Rehm, vol. 1 (Berlin: Walter de Gruyter, 1952), 232.

11. Montesquieu, "Pensées" (ca. 1730), in *Œuvres complètes*, ed. R. Caillois (Paris: Gallimard, 1949), vol. I, 1349. Cf. http://www.unicaen.fr/services/puc/sources/Montesquieu/index.php?oeuvre=pensees&texte=87.

12. Ibid.

13. "The closer that nature draws to the Greek climate, the more beautiful, lofty, and powerful in appearance are her human creations. Thus in the most beautiful parts of Italy ...". Johann Joachim Winckelmann, *History of the Art of Antiquity*, trans. Harry Francis Mallgrave (Los Angeles: Getty, 2006), 119.

14. Letter to Genzmer from Rome, 20 November 1757, in Winckelmann, *Briefe*, vol. 1, 312.

15. Winckelmann, *History of the Art of Antiquity*, 210 (*Geschichte der Kunst des Alterthums*, 177).

16. Winckelmann, *History of the Art of Antiquity*, 133 (*Geschichte der Kunst des Alterthums*, 42).

17. Curiously, our own contemporaries are often less attentive readers, attributing here to Winckelmann a strictly "idealist" and never "biological" point of view. Thus Thomas Franke writes that the "Greek nose" was for Winckelmann only "one artistic experiment among others": Franke, *Ideale Natur aus kontingenter Erfahrung. J.J. Winckelmanns normative Kunstlehre und die empirische Naturwissenschaft* (Würzburg: Königshausen & Neumann, 2006), 64. The excellent David Bindman chooses to ignore the text entirely, declaring that according to Winckelmann the ideal profile "could not be observed in real life"; Bindman, *Ape to Apollo: Aesthetics and the Idea of Race in the 18th Century* (Ithaca: Cornell University Press, 2002), 90.

18. Jean-Baptiste-René Robinet, *Vue philosophique de la gradation naturelle des formes de l'être* ... (1768), 189.

19. Winckelmann, *History of the Art of Antiquity*, 118 (*Geschichte der Kunst des Alterthums*, 20): "die Gesichts-Bildund ihrer Nation."

20. Johann Gottfried von Herder, *Sculpture* (1778), ed. and trans. Jason Gaiger (Chicago: University of Chicago Press, 2002), 71.

21. Toussaint-Bernard Émeric-David, *Recherches sur l'art statuaire, considéré chez les Anciens et chez les Modernes* (Paris: Veuve Nyon Aîné, an XIII [1805]), 361.

22. Antoine L. Castellan, *Lettres sur la Morée et les îles de Cérigo, Hydra et Zante* (Paris: Agasse, 1808, vol. II), 112–113 (emphasis added). The motto "Et in Arcadia ego!" is to be found on the title page.

23. Nicolas Ponce, "Dissertation sur le beau idéal considéré sous le rapport des arts du dessin, lue dans la séance de la quatrième classe de l'Institut, le samedi 26 avril 1806," *Nouvelles des arts* (Paris: Imprimerie des Annales du Musée, 1805 (1806), vol. V), 281–282.

24. Karl Otfried Müller, *Handbuch der Archäologie der Kunst* (Breslau: J. Mar, 1830), 405; *Nouveau manuel d'archéologie*, trans. P. Nicard (Paris: Manuels Roret, 1841), vol. II, 1, 139.

25. Johann Caspar Lavater, *Essai sur la Physiognomonie ...* (1783), cited by Jean-Claude Lebensztejn in *L'Art de la tache. Introduction à la Nouvelle méthode d'Alexander Cozens* (n.p.: Éditions du Limon, 1990), 242–243.

26. Claude Blanckaert, "Les vicissitudes de l'angle facial et les débuts de la craniométrie (1765–1875)", *Revue de synthèse*, 4th ser., no. 3–4 (July–December 1987), 417–453.

27. Petrus Camper, "A Treatise on the Natural Difference of Features in Persons of Different Countries and Periods of Life; and on Beauty," in *The Works of the Late Professor Camper on the Connexion between The Science of Anatomy and the Arts of Drawing, Painting, Statuary*, ed. T. Cogan (London: J. Hearne, 1821), 9.

28. Ibid., 42 (translation slightly modified).

29. Ibid., 99. See Blanckaert, "Les vicissitudes de l'angle facial," and Miriam Claude Meijer, *Race and Aesthetics in the Anthropology of Petrus Camper* (Amsterdam: Rodopi, 1999), *passim*.

30. Concerning "all the causes alleged by ancient and modern writers of the diversities of make observable in the human countenance," Camper wrote: "we shall not be surprised that a similar diversity should be found in the human species dispersed over different parts of the globe." A monogenist, he stressed that "Black, tawny, and white men are simply varieties; they do not constitute essential differences" (Camper, "A Treatise on the Natural Difference of Features," 59, 28).

31. Denis Diderot, "Voyage dans quelques villes de la Hollande" (first published in *Correspondance littéraire*, 1780–1782), in *Œuvres complètes*, ed. J. Assézat & M. Tourneux (Paris: Garnier, 1876, vol. XVII), 447.

32. Camper, "A Treatise on the Natural Difference of Features," 32.

33. Winckelmann, *History of the Art of Antiquity*, 194 (*Geschichte der Kunst des Alterthums*, 146).

34. Georges Cuvier, *The Animal Kingdom Arranged in Conformity with its Organization*, trans. H. M'Murtrie (New York: G. & C. & H. Carvill, 1839), 52

35. Georges Cuvier, "Note instructive sur les recherches à faire relativement aux différences anatomiques des diverses races d'hommes" (1800), *Revue anthropologique* 20 (September 1910), 303–306, introduction by Georges Hervé, 289–302.

36. Adolphe Bloch, "Essai sur les lèvres au point de vue anthropologique," *Bulletins de la Société d'anthropologie de Paris* 9, no. 9 (1898), 297.

37. Georg Wilhelm Friedrich Hegel, *Aesthetics: Lectures on Fine Art*, vol. 2, trans. T. M. Knox (Oxford: Clarendon, 1975), 730. On Hegel and the Greek profile, see also Steven Decaroli, "The Greek Profile, Hegel's Aesthetics and the Implications of a Pseudo-Science," *Philosophical Forum* 37, no. 2 (June 2006), 113–151.

38. See Bruce Baum, *The Caucasian Race: A Political History of Racial Identity* (New York: NYU Press, 2006), 58–94.

39. François Bernier, "Nouvelle division de la terre par les différentes Espèces ou Races d'hommes, envoyée par un fameux Voyageur à M. l'Abbé de la ★★★★★ à peu près en ces termes," *Journal des Sçavans*, 24 April 1684, 133–140. See Siep Stuurman, "François Bernier and the Invention of Racial Classification," *History Workshop Journal* 50 (2000), 1–21; Pierre H. Boulle, "François Bernier and the Origins of the Modern Concept of Race," in Sue Peabody and Tyler Stovall, eds., *The Color of Liberty: Histories of Race in France* (Durham: Duke University Press, 2003), 11–27.

40. Silvia Sebastiani, "François Bernier (1620–1688)," in Pierre-André Taguieff, ed., *Dictionnaire historique et critique du racisme* (Paris: Presses universitaires de France, 2013).

41. The *Venus* in the Farnese collection (first century of our era) is to be found today in the National Museum of Archaeology in Naples with the name *Venus Callipyge*.

42. David Brion Davis, "Slavery—White, Black, Muslim, Christian," *New York Review of Books* 48 (5 July 2001), 51, cited by Baum, *The Caucasian Race*, 2.

43. Johann Friedrich Blumenbach (1752–1840), *The Anthropological Treatises of Johann Friedrich Blumenbach*, ed. and trans. Thomas Bendyshe (London: Longman, 1865).

44. Ibid., 307.

45. Ibid., 107.

46. Ibid., 269.

47. Christoph Meiners, *Grundriß der Geschichte der Menschheit* (Lemgo: Meyers, 1785). See Britta Rupp-Eisenreich, "Christoph Meiners et Joseph-Marie de Gérando: un chapitre du comparatisme anthropologique," in Daniel Droixhe and Pol Pierre Gossiaux, eds., *L'Homme des Lumières et la découverte de l'autre* (Brussels: Éditions de l'Université de Bruxelles, 1985), 21–47; Friedrich Lotter, "Christoph Meiners und die Lehre von der unter-

schiedlichen Wertigkeit der Menschenrassen," in Hartmut Boockmann and Hermann Wellenreuther, eds., *Geschichtswissenschaft in Göttingen. Eine Vorlesungsreihe* (Göttingen: Vandenhoeck & Ruprecht, 1987), 30–75.

48. Meiners, *Grundriß der Geschichte der Menschheit*, §16, pp. 43–44.

49. Cuvier, *The Animal Kingdom*, 52–53.

50. See chapter 4 below.

51. Julien-Joseph Virey, *Histoire naturelle du genre humain*, 2nd ed. (Paris: Crochard, 1824), vol. II, 31.

52. Waldemar Deonna, *L'Archéologie, sa valeur, ses méthodes*, vol. II: *Les lois de l'art* (Paris: Renouard & Laurens, 1912), 172, 178–179.

53. See in particular Carl Justi, *Winckelmann. Sein Leben, seine Werke und seine Zeitgenossen* (Leipzig: Vogel, 1866–1872); Ingrid Kreuzer, *Studien zu Winckelmanns Aesthetik. Normativität und historisches Bewusstsein* (Berlin: Akademie Verlag, 1959); Richard Woodfield, "Winckelmann and the Abbé Du Bos," *British Journal of Aesthetics* 13, no. 3 (Summer 1973), 271–275.

54. Jean-Baptiste Dubos, *Réflexions critiques sur la poésie et la peinture* (1719; Paris: Mariette, 1733), vol. II, 150: "The Arts have not flourished beyond the 52nd degree of northern latitude, and neither have they flourished closer to the equator than the 25th degree. ... The Arts spring up according to their own climate."

55. Thus Michael Huber, the second French translator (ed. 1789) of Winckelmann's *History*, could justifiably add this sentence: "It is equally true that it is due to the same influence of climate that we should attribute the air of goodness, the gentleness of character, and the serenity of soul of the Greeks. All of these qualities contribute no less to the creation of beautiful images than nature herself does to the generation of beautiful forms" (vol. II, 6).

56. Winckelmann, *History of the Art of Antiquity*, 194 (*Geschichte der Kunst des Alterthums*, 147). See Franke, *Ideale Natur aus kontingenter Erfahrung*, 113. According to Franke (172, note 85), the cited poet is Richard Blackmore who, in *The Nature of Man. Poem. In Three Books* (London, 1711), wrote: "These stupid Nations, this degenerate Race, / Can scarce the Being of their Maker trace, / Tho' Marks of Pow'r Divine shine bright on Nature's Face."

57. Winckelmann, *History of the Art of Antiquity*, 194 (*Geschichte der Kunst des Alterthums*, 147).

58. Winckelmann, *History of the Art of Antiquity*, 195 (*Geschichte der Kunst des Alterthums*, 149). See Alex Potts, *Flesh and the Ideal: Winckelmann and the Origins of Art History* (New

Haven: Yale University Press, 1994), 164–170, and Franke, *Ideale Natur aus kontingenter Erfahrung*, 15–19.

59. Mario Praz, *Le Goût néoclassique* (Paris: Le Promeneur, 1989), 74.

60. Winckelmann, *History of the Art of Antiquity*, 196 (*Geschichte der Kunst des Alterthums*, 150–151).

61. Winckelmann, *History of the Art of Antiquity*, 118 (*Geschichte der Kunst des Alterthums*, 20).

62. See G. S. Kirk and J. E. Raven, *The Presocratic Philosophers* (Cambridge: Cambridge University Press, 1957), 169.

63. Aristotle, *Politics*, trans. Trevor J. Saunders (Oxford: Clarendon Press, 1995), 3 (Book 1, chap. 1).

64. Montaigne, *The Complete Essays of Montaigne*, trans. Donald M. Frame (Stanford: Stanford University Press, 1965) Book II, chap. XII, 397: "Wherefore Xenophanes used to say wittily that if the animals make gods for themselves, as it is likely they do, they certainly make them like themselves are, and glorify themselves as we do."

65. Spinoza, Letter 56 to Hugo Boxel, in Spinoza, *The Ethics: Treatise on the Emendation of the Intellect & Selected Letters*, ed. Symour Feldman, trans. Samuel Shirley (Indianapolis: Hackett, 1992), 283.

66. Montesquieu, *Lettres persanes* (1721), letter LIX.

67. Pierre Camper, "Du Beau physique, ou De la Beauté des formes" (Discours lu à l'Académie de dessin d'Amsterdam en 1782), in *Œuvres de Pierre Camper qui ont pour objet l'histoire naturelle, la physiologie et l'anatomie comparée* (Paris, Jansen, an XI [1803]), vol. III, 409.

68. Winckelmann, *History of the Art of Antiquity*, 111 (*Geschichte der Kunst des Alterthums*, 4).

69. Winckelmann, *History of the Art of Antiquity*, 112 (*Geschichte der Kunst des Alterthums*, 5–7).

70. Antoine François Prévost, *Histoire générale des voyages*, new ed., vol. XXV (Amsterdam: Harrevelt & Chaguion, 1780), 61.

71. Johann Joachim Winckelmann, *Anmerkungen über die Geschichte der Kunst des Alterthums* (Dresden: Waltherischen Hof-Buchhandlung, 1767), 23.

72. Winckelmann, *History of the Art of Antiquity*, 128 (*Geschichte der Kunst des Alterthums*, 32). The opposition between the beauty of the Greeks and the ugliness of the Egyptians would become a classical *topos*; see for example C. S. Sonnini, *Voyage en Grèce et en Turquie*, vol. I (Paris: Buisson, an IX [1801]), 22–26. It is therefore not possible to say, as does David Bindman, arguing against Martin Bernal's position in the latter's *Black Athena* (London,

1991), vol. I, 212–213, that Winckelmann had never assumed that the art of the Egyptians was "inherently defective"; Bindman, *Ape to Apollo*, 91.

73. The expression is Jackie Pigeaud's, "*Torniamo a Roma*: vers quelle Antiquité?," in *Winckelmann et le retour à l'antique. Entretiens de La Garenne Lemot* (Nantes, 1995), 53.

74. Françoise Frontisi-Ducroux, "Les limites de l'anthropomorphisme. Hermès et Dyonisos," in Charles Malamoud and Jean-Pierre Vernant, eds., *Le Temps de la réflexion*, VII, "Corps des dieux" (Paris: Gallimard, 1986), 193–211 (see 195–197).

75. Winckelmann, *History of the Art of Antiquity*, 196 (*Geschichte der Kunst des Alterthums*, 151–152).

76. Hippolyte Taine, *Art in Greece*, trans. J. Durand (New York: Holt & Williams, 1871), 119.

77. Hippolyte Taine, *Lectures on Art*, trans. J. Durand (New York: Henry Holt & Company, 1875), 303 (translation slightly modified).

78. Daniel Arasse, "Ogni dipintore dipinge se," *Le Sujet dans le tableau. Essai d'iconographie analytique* (Paris: Flammarion, 1997), 7–15. See also Frank Zöllner, "'Ogni pittore dipinge sè'. Leonardo da Vinci and 'automimesis'," in Matthias Winner, ed., *Der Künstler über sich in seinem Werk. Internationales Symposium der Bibliotheca Hertziana* (Rome, 1989; Weinheim: VCH, 1992), 137–160. See also more recently Philip Lindsay Sohm, *The Artist Grows Old: The Aging of Art and Artists in Italy, 1500–1800* (New Haven: Yale University Press, 2007), 40ff.

79. Martin Kemp, ed., *Leonardo on Painting*, trans. Martin Kemp and Margaret Walker (New Haven: Yale University Press, 1989), 204.

80. Antoine Coypel, "Discours sur la peinture" (1721), cited by Martial Guédron, "Automimésis et autoprojection," *Peaux d'âmes. L'interprétation physiognomonique des œuvres d'art* (Paris: Kimé, 2001), 52: "It is true to say that one usually paints oneself in the productions of one's own mind."

81. Giovanni Morelli, *Italian Painters: Critical Studies of Their Works*, vol. 1, trans. Constance Jocelyn Ffoulkes (London: John Murray, 1892), 75, note 2. Ivan Lermolieff, *Kunstkritische Studien über italienische Malerei. Die Galerien Borghese und Doria Panfili in Rom* (Leipzig: Brockhaus, 1890), 94–95.

82. Algarotti, *Essai sur la Peinture et sur l'Académie de France établie à Rome*, trans. M. Pingeron (Paris: Merlin, 1769), xi (translator's preface).

83. Winckelmann, *Reflections on the Imitation of Greek Works in Painting and Sculpture*, 9.

84. Gotthold Ephraim Lessing, *Laocoön: An Essay on the Limits of Painting and Poetry*, trans. Edward Allen McCormick (Baltimore: Johns Hopkins University Press, 1984), 14.

85. Jules Michelet, *The Bible of Humanity* (1863), trans. Vincenzo Calfa (New York: J. W. Bouton, 1877), 156. Michelet offers here once again the formula "first locate the race [then] the fabrication of its gods" that was the starting point of the *natural circulus* (39, note).

86. Ibid., 64, note 1 (translation slightly modified). See the commentary by Claude Rétat, "Jugement des dieux, triomphe de l'humanité. Charles-François Dupuis, Jules Michelet," in Sarga Moussa, ed., *L'Idée de "race" dans les sciences humaines et la littérature (XVIIIe et XIXe siècles)* (Paris: L'Harmattan, 2003), 91–201. I follow his analysis here.

87. See Claude Rétat, "Jules Michelet, l'idéologie du vivant," *Romantisme*, no. 130 (2005), 9–22.

88. Hippolyte Taine, *Art in the Netherlands* (1874), trans. J. Durand (New York: Henry Holt, 1874), 12.

89. Karl Schnaase had already suggested this idea: "Die Wirklichkeit ist der Stamm, welcher die Blüthe der Kunst trägt, und in ihr erzeugt sich wieder das Samenkorn für eine neue Gestaltung des Wirklichen" (Race is reality; it bears art's blossom, and in this blossoming the sap reproduces itself again, giving form to a new reality). Schnaase, *Niederländische Briefe* (Stuttgart and Tübingen: Cotta, 1834), 474.

90. Élie Faure, *History of Art*, trans. Walter Pach (New York: Harper & Brothers, 1921–1930), xxii.

91. Hippolyte Taine, *Philosophie de l'art*, 7th ed. (Paris: Hachette, 1895), vol. II, 291 (*De l'idéal dans l'art*, 1867).

92. Hippolyte Taine, *History of English Literature*, vol. IV (1864), trans. H. Van Laun (London: Chatto & Windus, 1920), 308.

93. Taine, *Philosophie de l'art*, vol. I, 142.

94. Ibid., 232.

95. *H. Taine, sa vie et sa correspondance*, vol. II: *Le Critique et le Philosophe*, 2nd ed. (1853–1870; Paris, Hachette, 1904), 334.

96. Hippolyte Taine, *On Intelligence,* vol. I (1870) (London: L. Reeve & Co., 1871), 224.

97. Taine, *Philosophie de l'art*, vol. I, 259 (emphasis added).

98. Ibid., vol. II, 323–324.

99. Hippolyte Taine, "Études de psychologie. I: Th. Ribot, l'Hérédité" (1873), in *Derniers Essais de critique et d'histoire*, 7th ed. (Paris: Hachette, 1923), 190.

100. Taine, *Philosophie de l'art*, vol. II, 288–289.

101. Taine, "Études de psychologie. I," 191.

102. Ernst Curtius, *The History of Greece* (1857), trans. Adolphus William Ward (New York: C. Scribner, 1871–1874), 37.

103. Paul Milliet, *Études sur les premières périodes de la céramique grecque* (Paris: Giraudon, 1891), 2–3.

104. Édouard Piette, "Races humaines de la période glyptique," session of 5 April 1894, *Bulletins de la Société d'Anthropologie de Paris*, 4th ser., 5 (1894), 382.

105. Édouard Piette and J. de Laporterie, "Les fouilles de Brassempouy en 1894," *Bulletins de la Société d'Anthropologie de Paris*, 4th ser., 5 (1894), 633–648. These delusions are roundly denounced by Deonna, *L'Archéologie*, vol. II, 238–239.

106. Cited by Henri Delporte, "Piette, pionnier de la préhistoire," in his introduction to E. Piette, *Histoire de l'art primitif* (Paris: Picard, 1987), 128.

107. Piette, "Races humaines de la période glyptique," 393

108. Such are, for example, the theories of Louis Courajod, Alois Riegl, Georg Dehio, and Wilhelm Worringer concerning the Gothic–Renaissance–baroque sequence. We shall examine this sequence further in chapter 5.

109. Jean Capart, *Primitive Art in Egypt*, trans. A. S. Griffith (Philadelphia: J. B. Lippincott, 1905), 162.

110. Joseph Déchelette, *Manuel d'archéologie préhistorique celtique et gallo-romaine* (Paris, Picard, 1908), vol. I, 217ff; Deonna, *L'Archéologie*, vol. II, 240.

111. André Michel, "Art—I. Considérations générales," in *La Grande Encyclopédie. Inventaire raisonné des sciences, des lettres et des arts* (Paris: Lamirault, vol. III), 1143. Cited by Jean Laude, *La Peinture française (1905–1814) et "l'art nègre"* (Paris: Klincksieck, 1968), 52.

112. John Lubbock, *The Origin of Civilisation and the Primitive Condition of Man* (New York: Appleton, 1882), 46. "Their idols ... give some of the African characteristics with grotesque fidelity."

113. Winckelmann, *History of the Art of Antiquity*, 118 (*Geschichte der Kunst des Alterthums*, 19–20). *Bildung* is the German equivalent of "physiognomy" in Winckelmann.

114. For a discussion of the physiognomical interpretation of works of art, see Meyer Schapiro, "Style," in Schapiro, *Theory and Philosophy of Art: Style, Artist, and Society* (New York: George Braziller, 1994), 51–102; Ernst Gombrich, "On Physiognomic Perception," *Meditations on a Hobby Horse* (London: Phaidon, 1955), 45–55; David Summers, "'Form', Ninenteenth-Century Metaphysics, and the Problem of Art Historical Description," *Critical Inquiry* 15, no. 2 (1989), 382–383; Claire Farago, "'Vision Itself Has Its History': 'Race', Nation, and Renaissance Art History," in Claire Farago, ed., *Reframing the Renaissance: Visual Culture in Europe and Latin America, 1450–1650* (New Haven: Yale University Press, 1995), 67–88; Martial Guédron, *Peaux d'âmes. L'interprétation physiognomonique des*

œuvres d'art (Paris: Kimé, 2001); Daniela Bohde, *Kunstgeschichte als physiognomische Wissenschaft. Kritik einer Denkfigur der 1920er bis 1940er Jahre* (Berlin: Akademie Verlag, 2012). See also Richard T. Gray's important study *About Face: German Physionomic Thought from Lavater to Auschwitz* (Detroit: Wayne State University Press, 2004).

115. Jean-Joseph Sue, in *Lavater's Looking Glass; Essays on the Face of Animated Nature* (London: Millar Ritchie, 1800), i.

116. John Caspar Lavater, *Essays on Physiognomy*, trans. Thomas Holcroft, 16th ed. (London: William Tegg & Co., 1880), 99; *Physiognomische Fragmente* (Winthertur: Steiners, 1783), vol. I, 183: "Je moralisch besser; Desto schöner. Je moralisch schlimmer; Desto häßlicher."

117. Lavater, *L'Art de connaître les hommes par la physionomie*, ed. Moreau de la Sarthe (Paris: Depelafol, 1835), vol. VII, 119.

118. Ibid., vol. VII, 114.

119. Ibid., vol. I, 268.

120. Lavater, *Essays on Physiognomy*, 40.

121. Buffon, *Buffon's Natural History*, trans. J. S. Barr, vol. IV (London: H. D. Symonds, 1797), 94.

122. Immanuel Kant, "Anthropology from a Pragmatic Point of View (1798)," trans. Robert B. Louden, in Kant, *Anthropology, History, and Education*, ed. Günter Zöller and Robert B. Loudon (Cambridge: Cambridge University Press, 2007), 393–394. On Kant and physiognomy, see Brigitte Geonget, "Kant dans son rapport à Lavater. L'évaluation de la caractéristique physionomique dans l'*Anthropologie du point de vue pragmatique*," in Robert Theis and Lukas K. Sosoe, eds., *Les Sources de la philosophie kantienne aux XVIIe et XVIIIe siècles* (Paris: Vrin, 2005), 313–324; Stephan Pabst, "Physionomik zwischen Anthropologie und Ästhetik. Kants Auseinandersetzung mit der Physiognomik in der *Antropologie in pragmatischer Hinsicht* und in der *Kritik der Urteilskraft*," in Valerio Rohden et al., eds., *Recht und Frieden in der Philosophie Kants. Akten des X. internationalen Kant-Kongresses* (Berlin: Walter de Gruyter, 2008), vol. 5, 53–64.

123. Immanuel Kant, *Observations on the Feeling of the Beautiful and Sublime*, trans. John T. Goldthwait (Berkeley: University of California Press, 1960), 113.

124. Wilhelm von Humboldt, *Le dix-huitième siècle* (ca. 1797). *Plan d'une anthropologie comparée*, intro. J. Quillien, trans. C. Losfeld (Lille: Presses universitaires de Lille, 1995), 118.

125. G. W. F. Hegel, *Encyclopedia of the Philosophical Sciences in Outline*, ed. Ernst Behler, trans. Steven A. Taubeneck (New York: Continuum, 1990), 213. For a discussion of Hegel's criticism of physiognomony, see Michael Emerson, "Hegel on the Inner and the

Outer," *Idealistic Studies*, no. 17 (1987), 133–147; Catherine Malabou, *L'Avenir de Hegel. Plasticité, temporalité, dialectique* (Paris: Vrin, 1996), 96–103.

126. Karl Schnaase, *Geschichte der bildenden Künste* (Leipzig, 1843, vol. I), 86–87: "The most fine and characteristic features of the soul of a people can only be known by its artistic creations." In its art, each nation revealed its "secret essence" as if by "hieroglyphics," intelligible to those who knew how to read the signs.

127. Georges Cuvier, "Note instructive sur les recherches à faire relativement aux différences anatomiques des diverses races d'hommes" (1800), *Revue anthropologique* 20 (September 1910), 303–306, introduction by Georges Hervé, 289–302.

128. Georges Cuvier, *Le Règne animal distribué d'après son organisation* (Paris: Deterville, 1817), vol. I, 94–96.

129. Michel Foucault, *The Order of Things*, trans. Alan Sheridan (New York: Vintage, 1970), 229.

130. Julien-Joseph Virey, *Histoire naturelle du genre humain* (Paris: Dufart, an IX [1801]), vol. I, 146.

131. Victor Courtet de l'Isle, *Tableau ethnographique du genre humain* (Paris: Arthus Bertrand, 1849), 2–3 and 45. For a discussion of Victor Courtet's racial concepts, see Loïc Rignol and Philippe Régnier, "Races et politique dans l'Histoire de France chez Victor Courtet de l'Isle (1813–1867). Enjeux de savoir et luttes de pouvoir au XIXe siècle," in Philippe Régnier, ed., *Études saint-simoniennes* (Lyon: Presses universitaires de Lyon, 2002), 127–152.

132. Charles Dunoyer, *L'Industrie et la morale considérées dans leurs rapports avec la liberté* (Paris: Sautelet et Cie, 1825), 70, 87.

133. Bory de Saint-Vincent, *L'Homme (homo). Essai zoologique sur le genre humain*, 2nd ed. (1825; Paris: Rey et Gravier, 1827), vol. II, 177–178.

CHAPTER 3

The first English translation of this chapter, by Hélène Amal, was published in *October* 139 (Winter 2012), 59–76.

1. See Käthe Panick, *La Race Latine: Politischer Romanismus im Frankreich des 19. Jahrhunderts* (Bonn: Ludwig Rörscheid Verlag, 1978); and Pierre Michel, *Un mythe romantique: Les barbares, 1789–1848* (Lyon: Presses universitaires de Lyon, 1981).

2. See James F. Hamilton, "Structural Polarity in Mme de Staël's *De la littérature*," *French Review* 50, no. 5 (April 1977), 706–712.

3. Montesquieu, *De l'esprit des lois*, bk. 17, chap 5 (Geneva: Barillot, 1748).

4. Johann Gottfried Herder, *Another Philosophy of History and Selected Political Writings*, trans. Ioannis D. Evrigenis and Daniel Pellerin (Indianapolis: Hackett, 2004), 33.

5. Novalis, cited by Jean-Édouard Spenlé in *Novalis: Essai sur l'idéalisme romantique en Allemagne* (Paris: Hachette, 1904), 244–245. The letter from 7 May 1799 can be found in *Friedrich Schlegels Briefe an seinen Bruder August Wilhelm*, ed. Oskar Walzel (Berlin: Speyer and Peters, 1890), 421.

6. Friedrich von Schlegel, "Briefe auf einer Reise durch die Niederlande, Rheingegenden, die Schweiz, und einen Thiel von Frankreich," in *Poetisches Taschenbuch für das Jahr 1806* (Berlin: Unger, 1806), 267–278.

7. Friedrich von Schlegel, *Über die neuere Geschichte: Vorlesungen gehalten zu Wien im Jahre 1810* (Vienna: Karl Schaumburg, 1811), 10. For the English translation, see Schlegel, *A Course of Lectures on Modern History*, trans. Lyndsey Purcell and R. H. Whitelock (London: H. G. Bohn, 1849), 4.

8. Schlegel, *A Course of Lectures*, 4.

9. Ibid., 5.

10. Ibid., 6.

11. See especially the first and thirteenth lessons of August Schlegel's *Vorlesungen über dramatische Kunst und Litteratur* (Heidelberg: Mohr and Zimmer, 1809–1811).

12. See Suzanne L. Marchand, *Down from Olympus: Archaeology and Philhellenism in Germany, 1750–1970* (Princeton, NJ: Princeton University Press, 1996), 158. As early as 1800, Madame de Staël had constructed a literary geography separated into "two hemispheres": "It seems to me that there exist two completely distinct literatures, one which comes from the south and the other from the north, one whose primary source is Homer while the other originates in Ossian." At that time, however, she did not introduce race as a consideration. See De Staël, *De la littérature considérée dans ses rapports avec les institutions sociales* (1800), ed. Paul van Thieghem (Geneva: Droz, 1959).

13. Madame de Staël, *Germany*, translator unknown (London: John Murray, 1813), 1, 4 (translation slightly modified). The first edition of 1810 had been destroyed by Napoleon's censors; the second was published in London in 1813, and the third in Paris in 1814, this last being the first to become accessible in France. On the crucial influence of de Staël's *Germany* on racial ideas in Europe and America, see Nell Irvin Painter, *The History of White People* (New York and London: W. W. Norton and Company, 2010), chapter 7, "Germaine de Staël's German Lessons."

14. Ibid., 2–3. These character traits are exactly those attributed to Germans by Tacitus, so as to oppose them to the general depravity he attributed to the Romans.

15. Ibid., 305.

16. See John Claiborne Isbell, *The Birth of European Romanticism: Truth and Propaganda in Staël's De l'Allemagne* (Cambridge: Cambridge University Press, 1994).

17. On the essential role the Roman Tacitus's *Germania*, written at the end of the first century CE, played in the construction of German identity, see Michael Werner, "Die 'Germania,'" in Étienne François and Hagen Schulze, eds., *Deutsche Erinnerungsorte* (Munich: Beck, 2001), vol. 3, 569–586.

18. Comte de Boulainvilliers, *Histoire de l'ancien gouvernement de la France*, vol. 1 (The Hague and Amsterdam: Aux dépends de la Compagnie, 1727), 29–33. See Hannah Arendt, *The Origins of Totalitarianism* (1951; New York: Harcourt Brace Jovanovich, 1979), 164–165; Marc Bloch, "Sur les grandes invasions," *Revue de synthèse* 19 (1940), 55–82; André Devyver, *Le sang épuré: Les préjugés de race chez les gentilshommes français de l'Ancien régime (1560–1720)* (Brussels: Éditions de l'Université libre de Bruxelles, 1973); Michel Foucault, *"Il faut défendre la société": Cours au Collège de France, 1976* (Paris: Gallimard et Seuil, 1997); Claude Nicolet, *La fabrique d'une nation: La France entre Rome et les Germains* (Paris: Perrin, 2003); Ian Wood, "Barbarians, Historians, and the Construction of National Identities," *Journal of Late Antiquity* 1 (2008), 61–81.

19. Joseph Emmanuel Sieyès, *Qu'est-ce que le Tiers-État?* (1789) (Paris: Société d'histoire de la Révolution française, 1888), 32–33.

20. Boisserée, cited by Pierre Moisy in *Les Séjours en France de Sulpice Boisserée (1820–1825)* (Paris: IAC, 1956), 129.

21. Philarète Chasles, *Études sur l'Allemagne ancienne et moderne* (Paris: Librairie d'Amyot, 1854), 6.

22. Sulpiz Boisserée, *Histoire et description de la cathédrale de Cologne* (1823) (Munich: Institut de Littérature et des Arts, 1843), vii.

23. Arendt, *The Origins of Totalitarianism*, 164–165.

24. François Guizot, *Du gouvernement de la France depuis la restauration, et du ministère actuel* (Paris: Ladvocat, 1820), 1–2.

25. Augustin Thierry, *The historical essays, published under the title "Dix ans d'études historiques,"* translator unknown (Philadelphia: Carey & Hart, 1845), 90 (translation slightly modified). See "Sur l'antipathie de race qui divise la nation française" (1820), in *Oeuvres completes: Dix ans d'études historiques*, vol. 6 (Paris: Furne et Cie, 1851), 236–243.

26. Augustin Thierry, *History of the Conquest of England by the Normans*, trans. William Hazlitt (London: Bell & Daldy, 1869), xix. *Histoire de la conquête de l'Angleterre par les Normands* (1825), in *Oeuvres complètes*, vol. 1 (Paris: Furne et Cie, 1846), 8. We know that it

was not just in the work of Thierry, but also in that of Guizot, that Marx was to discover the first formulations of the idea of class war.

27. Mike Rowlands has argued that the image of the barbarian changed radically during the years 1870–1895. Our hypothesis, however, is rather that it was the reaction to the French Revolution and to Napoleonic imperialism that very quickly brought about a radical change in this image. See "European Barbarism and the Search for Authenticity," in Michael Harbsmeier and Mogens Trolle Larsen, eds., *The Humanities between Art and Science. Intellectual Developments, 1880–1914* (Copenhagen: Akedemisk Forlag, 1989), 225–239.

28. F.-R. de Chateaubriand, *Essais sur les révolutions* (1797), in *Oeuvres complètes*, vol. 2, 1 (Paris: Pourrat Frères, 1836), 11, note 1. See François Hartog, *Anciens, Modernes, Sauvages* (Paris: Galaade, 2005).

29. Aimé Césaire, *Discours sur le colonialisme* (1955), Éditions de L'AAARGH, Internet, 2006, 6–7. I am particularly grateful to Mary Nyquist for referring me to this essential text.

30. Ernest Renan, *La Réforme intellectuelle et morale* (Paris: Michel Lévy Frères, 1871), 92–93.

31. Jules Michelet, *History of the Roman Republic* (1831), trans. William Hazlitt (London: D. Bogue, 1847), 6.

32. Ibid., 7.

33. Giorgio Vasari, *Vasari on Technique*, ed. G. Baldwin Brown, trans. Louisa S. Maclehose (London: J. M. Dent, 1907), 83. "De l'architecture," chapter. 3 in *Les Vies des meilleurs peintres, sculpteurs et architectes*, vol. 1, trans. and ed. André Chastel (Paris: Berger-Levrault, 1981), 101: "Questa maniera fu trovata dai Goti, che per avere ruinate le fabbriche antiche, e morti gli architetti per le guerre, fecero dopo coloro che rimasero le fabbriche di questa maniera."

34. Toussaint-Bernard Émeric-David, *Recherches sur l'art statuaire, considéré chez les Anciens et chez les Modernes* (Paris: Nyon Aîné, 1805), 399–402.

35. Toussaint-Bernard Émeric-David, *Histoire de la peinture au moyen âge* (1812), ed. Paul Lacroix Jacob (Paris: Gosselin, 1842), 43.

36. J. B. L. G. Séroux d'Agincourt (1730–1814), *Histoire de l'art par les monuments, depuis sa décadence au IVe siècle jusqu'à son renouvellement au XVIe* (Paris: Treuttel & Würtz, 1823) vol. 1, 16. Séroux began this work in the 1780s, and it was published in monthly installments after 1810.

37. Philippe Auguste Jeanron, commenting on the life of Don Giulio Clovio, in Giorgio Vasari, *Vies des plus célèbres peintres, sculpteurs et architectes*, vol 5, trans. Léopold Leclanché (Paris: Tessier, 1839), 180, 200–202.

38. Paillot de Montabert, *Traité complet de la peinture*, vol. 3 (Paris: J.-F. Delion, 1829), 1–2.

39. Victor Hugo, *Notre-Dame of Paris* (1831), trans. John Sturrock (London: Penguin, 1978), 197.

40. Comte de Caylus, *Recueil d'antiquités égyptiennes, étrusques, grecques et romaines*, vol. 2 (Paris: Duchesnes, 1756), 23–24.

41. Dagobert Frey, "Die Entwicklung nationaler Stile in der mittelalterlische Kunst des Abendlandes," *Deutsche Vierteljahrsschrift für Literaturwissenschaft und Geistesgeschichte* 16 (1938), 3.

42. On the role of politics in nineteenth-century philology, see Patrick Geary, "A Poisoned Landscape: Ethnicity and Nationalism in the Nineteenth Century," in his *The Myth of Nations: The Medieval Origins of Europe* (Princeton, NJ: Princeton University Press, 2002), 15–40.

43. We should not forget that historically the categories of nation and race were highly permeable. In all European languages, constantly and over a long period of time, they intersected, absorbed and were absorbed by those of people, tribe, ethnic group. Even as late as 1920, Marcel Mauss, believing that he was writing a salutary text, could state that race was not the origin of nations, but on the contrary, nations created new races. Nonetheless, in both cases, it was blood—biology—that was the determining factor. See Marcel Mauss, "La nation," in *Oeuvres*, vol. 3 (Paris: Minuit, 1983), 571–639.

44. See Léon Poliakov, *The Aryan Myth: A History of Racist and Nationalistic Ideas in Europe*, trans. Edmund Howard (New York: Basic Books, 1974). On Viollet-le-Duc's conviction concerning the relations between art and the Aryan migrations, see the article "Sculpture" in *Dictionnaire raisonné de l'architecture française du XIe au XVIe siècle*, vol. 8 (Paris: Morel, 1866), 274, 189–190.

45. Emmanuel Viollet-le-Duc, *Lectures on Architecture*, vol. 1 (1863), trans. Benjamin Bucknall (1877; New York: Dover, 1987), 203. Viollet-le-Duc, who expressly referred to Gobineau in the eighth lecture (vol. 1, 340, note 1), also took from Gobineau the idea of the culturally nullity of Rome as a consequence of the absence of a Roman race. For example: "Rome had nothing that properly belonged to it, neither religion nor laws, nor a language nor a literature ...". See Arthur de Gobineau, *Essai sur l'inégalité des races humaines*, vol. 2 (Paris: Firmin-Didot, 1884), 273.

46. Georg Dehio, *Geschichte der deutschen Kunst*, vol. 1 (1919; Berlin and Leipzig: De Gruyter, 1923), 212–213. Recognizing the "French" origins of the Gothic, Dehio saw it as the product of an epoch and not of a race: how was one to know to which racial component of France—Gallic, Roman, or Germanic—it could be attributed?

47. Viollet-le-Duc, *Lectures on Architecture*, vol. I, 339, 340 (translation slightly modified), 342–344, 237–238, 272.

48. Courajod's teaching at the École du Louvre was to inspire in particular André Michel's great and influential *Histoire de l'art*, and Courajod's student Paul Vitry was to spread his teacher's ideas through to the end of the 1930s. Courajod's racial theories, identifying Christianity with the Northern-Oriental spirit, were also to be taken up and disseminated in the German-speaking countries by Josef Strzygowski. See Pierre Francastel, *L'Histoire de l'art, instrument de la propagande germanique* (Paris: Médicis, 1945), 130–131.

49. Auguste Geoffroy, *Rome et les Barbares. Étude sur la Germanie de Tacite* (Paris: Didier, 1874).

50. Louis Courajod, *Leçons professées à l'École du Louvre (1887–1896)* (Paris: Picard, 1899–1903), vol. III, 195, 159.

51. Ibid., vol. I, 28.

52. Pierre Leroux, "De l'influence philosophique des études orientales," *Revue encyclopédique* (1832), 69–82; see especially 75.

53. Courajod, *Leçons professées à l'École du Louvre*, vol. I, 10, 169, 34, 53 (1890–1891).

54. Ibid., vol. I, 213, 185, 186.

55. Alois Riegl, *Die Entstehung der Barockkunst in Rom*, ed. Arthur Burda and Max Dvoràk (Vienna: Anton Schroll, 1908), 6. See Margaret Olin, "Alois Riegl: The Late Roman Empire in the Late Habsburg Empire," in Ritchie Robertson and Edward Timms, eds., *The Habsburg Legacy: National Identity in Historical Perspective* (Edinburgh: Edinburgh University Press, 1994), 107–120.

56. Alois Riegl, *Historical Grammar of the Visual Arts*, trans. Jacqueline E. Jung (New York: Zone Books, 2004), 259.

57. Alois Riegl, *Die spätrömische Kunst-Industrie nach den Funden in Österreich-Ungarn im Zusammenhange mit der Gesammtenwicklung der bildenen Künste bei den Mittelmeervölkern* (Vienna: Österreiches Archäologisches Institut, 1901), 1.

58. This canonical reading is by Otto Pächt, "Alois Riegl," *Burlington Magazine* 105, no. 722 (May 1963), 188–193.

59. Among the rare works that mention this second part, I want to single out Christopher Wood's important text, "Riegl's *Mache*," *Res* 46 (Autumn 2004), 155–172. His interpretation differs significantly from mine: for Wood, who also cites this last phrase, Riegl assures us that no external ethnic contribution was needed for Rome to become the source of modernity. Riegl nevertheless writes that it was the Germans who had provoked the "decisive turn" toward an art founded on principles other than those of antiquity.

60. Alois Riegl, *Die spätrömische Kunst-Industrie*, vol. 2: *Kunstgewerbe des frühen Mittelalters auf Grundlage des Nachgelassenen Materials Alois Riegls*, ed. E. Heinrich Zimmermann (Vienna: Österreichisches Archäologisches Institut, 1923), 6–7.

61. Pächt, "Alois Riegl," 191.

62. Adolf von Hildebrand, *The Problem of Form in Painting and Sculpture* (1893), trans. Max Meyer and Robert Morris Ogden (New York: G. E. Stechert, 1932); facsimile edition (New York & London: Garland Publishing, 1978), 34, 23–24.

63. See Margaret Olin, *Forms of Representation in Alois Riegl's Theory of Art* (Philadelphia: Pennsylvania State University Press, 1992), 134–137; and Margaret Iversen, *Alois Riegl: Art History and Theory* (Cambridge, MA: MIT Press, 1993), 73–76.

64. Julius von Schlosser, *Die Wiener Schule der Kunstgeschichte*, vol. 13 (Innsbruck: Universitäts-Verlag Wagner, 1934), 186. See also Julius von Schlosser, "Alois Riegl," in *Framing Formalism: Riegl's Work* (Amsterdam: G+B Arts International, 2001), 38. This kind of opposition still connected Riegl to romanticism. From Schiller to A. W. Schlegel and De Staël, sculpture was seen as a pagan art while painting belonged to Christian modernity—a *topos* that, after Hegel, was to be widely accepted. See also Christopher Wood, ed., *The Vienna School Reader: Politics and Art Historical Method in the 1930s* (New York: Zone Books, 2000), 26–27.

65. Alois Riegl, *Late Roman Art Industry*, trans. Rolf Winckes (Rome: Bretschneider Editore, 1985), 21 (translation modified).

66. Meyer Schapiro, "Style," in Alfred Louis Kroeber, ed., *Anthropology Today: An Encyclopedic Inventory* (Chicago: University of Chicago Press, 1953), 302.

67. Riegl, *Historical Grammar of the Visual Arts*, 104.

68. Henri Focillon, *The Life of Forms in Art* (1934), trans. Charles Beecher Hogan and George Kubler (New York: George Wittenborn, 1948), 55.

69. Henri Focillon, *L'Art des sculpteurs romans: Recherches sur l'histoire des formes* (Paris: E. Leroux, 1931), 15.

70. Henri Focillon, "L'art allemand depuis 1870" (1915), in *Technique et sentiment* (1919; Paris: Société de Propagation des Livres d'Art, 1932), 15.

71. Henri Focillon, "Fonction universelle de la France," lecture given at Carnegie Hall, New York, 20 December 1940, in *Témoignage pour la France* (New York: Brentano's, 1945), 51.

72. *Entretiens sur Goethe à l'occasion du centenaire de sa mort* (Paris: Société des Nations, Institut international de coopération intellectuelle, 1932); *Correspondance 4: Civilisations. Orient-Occident, Génie du Nord-Latinité. Lettres de Henri Focillon, Gilbert Murray, Josef Strzygowski, Rabindranath Tagore* (Paris: Société des Nations, Institut international de coopération intellectuelle, 1935).

73. Focillon, *The Life of Forms in Art*, 57 (emphasis added in the last sentence).

74. Antoine C. Quatremère de Quincy, *Lettres à Miranda sur le déplacement des monuments de l'art de l'Italie* (1796), ed. E. Pommier (Paris: Macula, 1989), 103.

Chapter 4

1. These questions are dealt with, from different perspectives to the one offered here, in two essential works: Kalman P. Bland, *The Artless Jew. Medieval and Modern Affirmations and Denials of the Visual* (Princeton, NJ: Princeton University Press, 2000); and Margaret Olin, *The Nation without Art: Examining Modern Discourses on Jewish Art* (Lincoln: University of Nebraska Press, 2001).

2. I am indebted to Maurice Kriegel for helping me to clarify these issues.

3. Karl Schnaase, *Niederländische Briefe* (Stuttgart and Tübingen: Cotta, 1834), 148–149.

4. Karl Schnaase, *Geschichte der bildenden Künste*, vol. I (Düsseldorf: Julius Buddeus, 1843), 86, 87.

5. Ibid., preface, x, xii.

6. See Maurice Olender, *The Languages of Paradise: Race, Religion, and Philology in the Nineteenth Century*, trans. Arthur Goldhammer (Cambridge, MA: Harvard University Press, 1992).

7. Jules Michelet, "David—Géricault. Souvenirs du Collège de France (1846)," *Revue des Deux Mondes*, 15 November 1896, 241–262 (see 241–242).

8. See, for example, the *Mémoire* addressed by Lazare Carnot to the king in July 1814: "Since therefore it has been proven by experience that the national spirit is not an absurd and metaphysical being, the government must now apply itself to bringing about its birth; it must bring together all of the necessary parts and make them real." Cited in Pierre Joseph Benjamin Buchez and Pierre Célestin Roux-Lavergne, *Histoire parlementaire de la Révolution française depuis 1789 jusqu'en 1814*, vol. 40 (Paris: Paulin, 1838), 415.

9. Richard Wagner, *Prose Works*, trans. William Ashton Ellis (1892; New York: Broude Brothers, 1966), vol. III, 80–84 (translation modified).

10. Ibid., 80 (translation modified).

11. Ibid., 86 (translation slightly modified).

12. Ludwig Feuerbach, *The Essence of Christianity*, trans. Marian Evans (London: Kegan Paul, Trench, Trübner, & Co., 1893), 114, 196.

13. Wagner, *Prose Works*, vol. I, 77.

14. Ibid., vol. III, 92.

15. Ibid., vol. IV, 158–159.

16. Ibid., vol. I, 100.

17. A sophism, since it is *de facto* impossible to make any difference between the religious worship of God (*latreia*) and the service (*doulia*) which was supposed to be addressed to angels, saints, and men.

18. Feuerbach, *The Essence of Christianity*, 74, 76 (translation slightly modified).

19. Immanuel Kant, *Critique of the Power of Judgment*, ed. Paul Guyer, trans. Paul Guyer and Eric Matthews (Cambridge: Cambridge University Press, 2000), 156.

20. G. W. F. Hegel, *Lectures on the Philosophy of Art: The Hotho Transcript of the 1823 Berlin Lectures*, ed. and trans. Robert F. Brown (Oxford: Clarendon Press, 2014), 210.

21. G. W. F. Hegel, *Early Theological Writings*, trans. T. M. Knox (Philadelphia: University of Pennsylvania Press, 1975), 191–192.

22. Ibid., 193 and 265. See also *The Phenomenology of Mind*, trans. J. B. Baillie (London: S. Sonnenschein, 1910), 731 (VII B—Religion in the form of art): "They revere their god as the empty profound, not as spirit." For a discussion of the theme of the "void" and the "infinite subject," see Werner Hamacher, "Pleroma—zu Genesis und Struktur einer dialektischen Hermeneutik bei Hegel," introduction to G. W. F. Hegel, *Der Geist des Christentums. Schriften 1796–1800* (Frankfurt: Ullstein, 1978), particularly 67–69.

23. G. W. F. Hegel, *Philosophy of History*, trans. J. Sibree (New York: P. F. Collier & Son, 1900), 494.

24. Wagner, *Prose Works*, vol. I, 59, 62.

25. Hegel, *Early Theological Writings*, 200.

26. Wagner, *Prose Works*, vol. III, 100.

27. François Miel, "Du rapport des arts avec les institutions des peuples," *La Minerve française*, November 1819, 505.

28. Johann Joachim Winckelmann, *History of the Art of Antiquity*, trans. Harry Francis Mallgrave (Los Angeles: Getty, 2006), 147.

29. Daniel Ramée, *Manuel de l'histoire générale de l'architecture chez tous les peuples ...* , vol. I, *Antiquité* (Paris: Paulin, 1843), 19, 32.

30. Daniel Ramée, *Théologie cosmogonique, ou Reconstitution de l'ancienne et primitive loi* (Paris: Amyot et Garnier, 1853), iii–iv

31. Daniel Ramée (1806–1887), *Histoire générale de l'architecture*, vol. I (Paris: Amyot, 1860), 74.

32. Ibid., 45. For a discussion of this *topos*, see Léon Poliakov, *The Aryan Myth: A History of Racist and Nationalist Ideas in Europe*, trans. Edmund Howard (New York: Basic Books, 1974); Olender, *The Languages of Paradise, passim*; and Stefan Arvidsson, *Aryan Idols: Indo-European Mythology as Ideology and Science*, trans. S. Wichman (Chicago: University of Chicago Press, 2006). Ernest Renan, "Mission de Phénicie. Troisième rapport à l'Empereur (Suite et fin)," *Revue archéologique*, n.s., 3rd year vol. 5 (1862), 394–403 (see 397).

33. Félicien de Saulcy, *Histoire de l'art judaïque tirée des textes sacrés et profanes* (Paris: Didier et Cie, 1858), i.

34. Renan, "Mission de Phénicie," 397.

35. Arthur Schopenhauer, *Parerga and Paralipomena: Short Philosophical Essays,* vol. II, trans. E. F. J. Payne (Oxford: Clarendon Press, 2000), 263–264.

36. On the reconstruction of this politico-religious framework, see Jean-Louis Schefer, *L'Hostie profanée. Histoire d'une fiction théologique* (Paris: P.O.L., 2007) Schefer refers to the main anti-Jewish measures (35, note 7 and in the chapter, "Latran IV", 185–201).

37. Olender, *The Languages of Paradise*. See in particular the chapter on Renan, 51–81.

38. Émile Burnouf, *The Science of Religions*, trans. Julie Liebe (London: Swan Sonnenschein, Lowrey & Co., 1888), 76, 138, 153, 193.

39. Ernest Renan, *Life of Jesus*, trans. William G. Hutchison (London: Walter Scott, [1897]), 42.

40. Burnouf, *The Science of Religions*, 193 (translation slightly modified).

41. Ibid., 119, 188, 190, 194.

42. Ernest Renan, *Histoire générale et système comparé des langues sémitiques*, 2nd ed. (1855; Paris: Imprimerie impériale, 1858), vol. I, 16.

43. Ernest Renan, "Nouvelles considérations sur le caractère général des peuples sémitiques et en particulier sur leur tendance au monothéisme," *Journal asiatique*, 5th ser., 13 (1859), 425–426.

44. Renan will repeat the same phrase, "ugly little Jew," in the *Prière sur l'Acropole*, 1899.

45. Ernest Renan, *Saint Paul* (1869), trans. Ingersoll Lockwood (New York: G. W. Carleton, 1885), 126.

46. See Helmut Berding, *Moderner Antisemitismus in Deutschland* (Frankfurt am Main: Suhrkamp, 1988). On p. 60 Berding includes this quotation from Ernst Moritz Arndt: "Ein durchaus fremdes Volk ... mit Frankreich verbündet und Frankreich um Hilfe anschreit, der meint Tückisches und Verräterisches gegen Deutschland, der is wie das Schaf, das dem Wolf die Hürde offnet; er werde friedlos erklärt über das ganze deutsche Reich, und nimmer möge seine Acht versohnt werden." (An entirely foreign people ... ally themselves

gratefully with France, and they call for France's help. Like the sheep who opens the gate to the wolf, they are malicious traitors to Germany. Let us give them no peace throughout the whole German Reich, and never may their outlaw status be reversed.)

47. In France, it is true, the Goncourt brothers had anticipated the great wave of cultural anti-Semitism with *Manette Salomon* (Paris: A. Lacroix, Verboeckhoven & Cie, 1867). Manette, a Jewish model, succeeds in possessing a painter, body and soul, emptying him of his artistic power and thus bringing about his ruin.

48. Ernest Renan, *Histoire générale des langues sémitiques*, cited by Édouard Drumont, *La France juive*, vol. I (Paris: Marpon & Flammarion, 1886), 12.

49. Drumont, *La France juive*, vol. I, 29–30.

50. See Romy Golan, *Modernity and Nostalgia: Art and Politics in France between the Wars* (New Haven: Yale University Press, 1995), 137–154; Éric Michaud, "'Un certain anti-sémitisme mondain,'" *L'École de Paris. 1904–1929, la part de l'Autre* (Musée d'Art moderne de la Ville de Paris, Paris Musées, 2000), 85–102.

51. Vanderpyl, "Existe-t-il une peinture juive ?," *Mercure de France*, 15 July 1925, 390.

52. Pierre Jaccard, "L'art grec et le spiritualisme hébreu," *Mercure de France*, 15 August 1925, 81, 83.

53. Camille Mauclair, *La Farce de l'Art Vivant. Une campagne picturale* (Paris: Nouvelle Revue Critique, 1929), 199.

54. I take up here an argument developed in my book *Un art de l'éternité. L'image et le temps du national-socialisme* (Paris: Gallimard, 1996). English translation by Janet Lloyd, *The Cult of Art in Nazi Germany* (Stanford: Stanford University Press, 2005).

55. Hermann Rauschning, *Hitler Speaks* (London: Butterworth, 1939), 220.

56. See the public order of 27 November 1936, reproduced by Joseph Wulf, *Die bildenden Künste im Dritten Reich. Eine Dokumentation* (Frankfurt: Ullstein, 1983), 127–129.

57. Norman H. Baynes, *The Speeches of Adolf Hitler*, vol. I (New York: Howard Fertig, 1969), 21, 30 (translation slightly modified).

58. Ibid., 59–60.

59. On Hitler as the "German Christ," see Dietrich Bonhoeffer's speech of 1 February 1933, cited by Fritz Stern, *Dreams and Delusions* (New York: Knopf, 1987), 163. "Where the Volksgeist is regarded as a divine-metaphysical sublimity, there the Führer who embodies this Geist has in the true sense a religious function, there he is the Messiah and hence with his appearance the fulfillment of the final hope has begun, then the Reich which he must bring forth with himself, already comes close to the eternal Reich."

60. Adolf Hitler, *Mein Kampf*, trans. Ralph Manheim (Boston: Riverside Press, 1943), 178. (Cf. *Mein Kampf* [1925–1927; Munich: Eher, 1940], 196: "Ihr ganzes Dasein ist der fleischgewordene Protest gegen die Aesthetik des Ebenbildes des Herrn.") And again: "Anyone who dares to lays hands on the highest image of the Lord commits sacrilege against the benevolent creator of this miracle and contributes to the expulsion from paradise" (ibid., 383, 421).

61. Werner Hamacher, "Working through Working," *Modernism/Modernity* 3, no. 1 (1996), 23–56.

62. Oscar Schmitz cited by Alfred Rosenberg, *The Myth of the Twentieth Century* (1930; Wentzville: Invictus, 2011), 302.

63. Oscar Schmitz, "Wünschenswerte und nicht wünschenswerte Juden," *Der Jude*, Sonderheft "Antisemitismus und jüdisches Volkstum" (Berlin, 1926), 17–33 (see 31). Notable contributors to this collection include Arnold Zweig, Alfons Paquet, Léon Blum, Bernard Shaw, Heinrich Mann, and Martin Buber, who founded the journal in 1916.

64. Margaret Olin, "'Jewish Christians' and 'Early Christian' Synagogues: The Discovery at Dura-Europos and Its Aftermath," in Olin, *The Nation without Art*, 127–154.

65. Georges Perrot and Charles Chipiez, *Histoire de l'art dans l'Antiquité*, vol. V (Paris: Hachette, 1887), 475.

66. Clark Hopkins and Robert du Mesnil du Buisson, "La synagogue de Doura-Europos" (session of 2 June 1933), in Académie des Inscriptions et Belles-Lettres, *Comptes rendus des séances de l'année 1933* (Paris: Picard, 1933), 243–255 (see 246, 254; emphasis added). The Frenchman makes clear in a footnote that he has essentially translated the words of his American colleague, adding only a few notes and observations of his own.

67. Joseph Strzygowski, *L'Ancien Art chrétien de Syrie*, preceded by a preliminary study by Gabriel Millet (i–lii) (Paris: de Boccard, 1936).

68. Gabriel Millet, "Note complémentaire," read during the same session of 2 June 1933, in Académie des Inscriptions et Belles-Lettres, *Comptes rendus des séances de l'année 1933*, 237–242 (see 242). In the *Comptes rendus*, Gabriel Millet's notice actually precedes the presentation of the discovery.

69. The debate continues over the influence of Jewish art on the beginnings of Christian art; see Jas Elsner, "Archaeologies and Agendas: Reflections on Late Ancient Jewish Art and Early Christian Art," *Journal of Roman Studies* 93 (2003), 114–128.

70. Olin, *The Nation without Art*, 133 (and 243–244, notes 20–21), referring to the surveys of the History of Art by Horst Waldemar Janson, Frederick Hartt, Hugh Honour, and John Flemming.

71. "L'art grec et le spiritualisme hébreu," *Mercure de France*, 15 July 1925, 85, 87 (emphasis added). For a discussion of other important aspects of cultural anti-Semitism in the France

of the 1920s, see Mark Antliff, "The Jew as Anti-artist: Georges Sorel and the Aesthetics of the Anti-Enlightenment," in Antliff, *Avant-Garde Fascism: The Mobilization of Myth, Art, and Culture in France, 1909–1939* (Durham: Duke University Press, 2007).

72. Herbert Read, *The Meaning of Art* (London: Faber & Faber, 1968), 219.

73. We must remember that the theme of the artless Jew was defended as much by Jews (assimilationists or otherwise, and possibly out of self-hatred) as it was by Gentiles (philo-Semites or anti-Semites). See, for example, Bernard Lazare, *L'Antisémitisme. Son histoire et ses causes* (1894; Paris: Éditions 1900, 1990), 259: "It is true that the Israelite nation has never shown any great aptitude for the visual arts, but ... if it has had no divine painters and sculptors, it has had wonderful poets."

74. Bernard Berenson, *Aesthetics and History* (Garden City, NY: Doubleday, 1954), 178–186. Cf. Olin, *The Nation without Art*, 166–169.

75. Read, *The Meaning of Art*, 221.

76. Werner Haftmann, *Mark Rothko,* Musée national d'Art moderne, 1972 (Paris: Réunion des Musées Nationaux, 1972), ix. We should note here that Werner Haftmann appears to be equally unaware of the history of Jewish art and of Mark Rothko's American nationality, as he reduces Rothko's art to a questionable "Judaism."

77. Johann Gottfried Herder, *Ideen zur Philosophie der Geschichte der Menschheit*, vol. I (Stuttgart: Cotta, n.d.), 52: "Each race of men is organized in their own region according to the fashion that is most natural to them." In the same way, each soil and each region "produce and nourish their own plants."

78. J.-B.-R. Robinet, *Dictionnaire universel ...* , vol. VI (London, 1778), art. "Beaux-Arts," 278; translation from Johann Georg Sulzer, *Allgemeine Theorie der Schönen Künste* (1771). The *Supplément à l'Encyclopédie*, published in 1776, also translated J. G. Sulzer's article "Art," in which he takes up the same theme.

79. Herder, *Reflections on the Philosophy of the History of Mankind*, abr. and trans. Frank E. Manuel (Chicago: University of Chicago Press, 1968), 144.

CHAPTER 5

1. Georg Wilhelm Friedrich Hegel, *The Philosophy of History*, trans. John Sibree (New York: Colonial Press, *c*. 1899), 107, 341.

2. Ibid., 349.

3. Michael Werner, "*La Germanie* de Tacite et l'originalité allemande," *Le Débat*, no. 78 (1994), 39–57; Werner, "Die 'Germania,'" in Étienne François and Hagen Schulze, eds., *Deutsche Erinnerungsorte* (Munich: Beck, 2001), 571–572.

———

4. August Wilhelm Schlegel, *Lectures on Dramatic Art and Literature* (1809), trans. A. J. W. Morrison and John Black (London: H. G. Bohn, 1846), 21–22: "Die, welche dieß annahmen, haben für den eigenthümlichen Geist der modernen Kunst, im Gegensatz mit der antike oder classischen, den Nahmen *romantisch* erfunden. Allerdings nicht unpassend: das Wort kommt her von romance, der Benennung der Volkssprachen, welche sich durch die Vermischung des Lateinischen mit den Mundarten des Altdeutschen gebildet hatten, gerade wie die neuere Bildung aus den fremdartigen Bestandtheilen der nordischen Stammesart und der Bruchstücke des Alterthumes zusammen geschmolzen ist, da hingegen die Bildung der Alten weit mehr aus einem Stücke war."

5. See Jean Bastin, *Les Nouvelles Recherches sur la langue française et leurs résultats* (Brussels: Hayez, 1872), 25–29.

6. Jean Charles Léonard Simonde de Sismondi, *Historical View of the Literature of the South of Europe*, trans. Thomas Roscoe (London: H. G. Bohn, 1853), 33.

7. Hegel, *The Philosophy of History*, 414, 440.

8. "Wichtig war zunächst nur der Unterschied Deutschlands von den romanischen Völkern. Während in Deutschland eine durch Abstammung und Schicksale einige Nation bestand, wohnten in den romanischen Ländern mehrere Stämme, Ureinwohner und Germanen verschiedenen Ursprungs, in Sprache, Recht und Sitten von einander abweichend, in bunter Mischung nebeneinander." Karl Schnaase, *Geschichte der bildenden Künste im Mittelalter*, vol. 2, 2, *Das eigentliche Mittelalter* (Düsseldorf, 1854), 15; see also 10, 244.

9. Schlegel, *Lectures on Dramatic Art and Literature*, 25.

10. A. W. Schlegel, *Leçons sur l'histoire et la théorie des beaux-arts* (1827), trans. Couturier de Vienne (Paris: Pichon et Didier, 1830), 171. For a discussion of the idea that the Germans engendered all of Europe, see Léon Poliakov, *The Aryan Myth: A History of Racist and Nationalistic Ideas in Europe*, trans. Edmund Howard (New York: Basic Books, 1974). On the Scottish version of this idea in the eighteenth century, see Silvia Sebastiani, *The Scottish Enlightenment: Race, Gender and the Limits of Progress* (New York: Palgrave Macmillan, 2013).

11. Johann Gottfried von Herder, *Sculpture* (1778), ed. and trans. Jason Gaiger (Chicago: University of Chicago Press, 2002), 82.

12. Ibid., 81.

13. Friedrich von Schiller, *On Naïve and Sentimental Poetry and On the Sublime: Two Essays* (1795), ed. Julius A. Elias (New York: Frederick Ungar, 1966), 114–115.

14. Meyer Schapiro, *Theory and Philosophy of Art: Style, Artist, and Society* (New York: George Braziller, 1994), 78.

15. Alois Riegl, *Late Roman Art Industry* (1901), trans. Rolf Winkes (Rome: Giorgio Bretchneider, 1985), 26, note 4.

16. Heinrich Wölfflin, *Principles of Art History: The Problem of the Development of Style in Early Modern Art*, trans. Jonathan Blower, ed. Evonne Levy and Tristan Weddigen (Los Angeles: Getty Research Institute, 2015), 73.

17. Ibid., 103.

18. Ibid., 316, 149. As we shall see below, after writing his thesis *Prologomena to a Psychology of Architecture*, Wölfflin was to be constantly preoccupied with the racial or "national" question.

19. See Andrew Causey, "Herbert Read and Contemporary Art," in David Goodway, ed., *Herbert Read Reassessed* (Liverpool: Liverpool University Press, 1998), 123–144; and Catherine Fraixe, "L'artiste comme fabricateur de mythes ou 'la valeur sociale de l'art abstrait' selon Herbert Read," in Neil McWilliam, Constance Moréteau, and Johanne Lamoureux, eds., *Histoires sociales de l'art. Une anthologie critique*, I (Dijon: Les Presses du réel, 2016), 329–343.

20. Herbert Read, *The Meaning of Art* (London: Faber & Faber, 1968), 219.

21. Ibid., 213–215.

22. Born in a region of Prussia that is now part of Poland, Wilhelm Uhde (1874–1947) grew up in the enlightened milieu of the European avant-garde. After studying the history of art at Munich and then in Florence where he met, in 1900 or thereabouts, Henry Thode and Aby Warburg, Uhde moved to Paris in 1904. He soon became a collector and gallery owner, purchasing his first Picasso in 1905. He was among the first to take an interest in Braque and Picasso's Cubist paintings, showing them in his gallery as early as 1908. In 1911, he published the first work on the Douanier Rousseau. As a German, he was forced to leave France in August 1914. He returned to France in 1924. His truly remarkable collection, seized by the State during the war, was put up for sale in 1921.

23. W. Uhde, *Picasso and the French Tradition: Notes on Contemporary Painting*, trans. F. M. Loving (New York: E. Weyhe, 1929), 26–27 (translation slightly modified).

24. Ibid., 30.

25. Ibid., 33.

26. Ibid., 40 (translation slightly modified).

27. Ibid., 47.

28. Émile Mâle, Louis Bréhier, Élie Faure, and Henri Focillon on one side, and, on the other, the medievalists Hans Karlinger and Konrad Escher, and Albert Erich Brinckmann, the author of *Geist der Nationen. Italiener—Franzosen—Deutsche* (1938), and Josef Strzygowski, a valued contributor at the time to French avant-garde journals. See Rémi

Labrusse, "Délires anthropologiques: Josef Strzygowski face à Alois Riegl," in Thierry Dufrêne and Anne-Christine Taylor, eds., *Cannibalismes disciplinaires. Quand l'histoire de l'art et l'anthropologie se rencontrent* (Paris: INHA / Musée du quai Branly, 2009), 149–162.

29. *Formes*, no. 1 (January 1930), 19–20.

30. Henri Focillon, *Les Pierres de France* (Paris: H. Laurens, 1919), 59.

31. Élie Faure, "Gobineau et le problème des races," *Europe*, no. 9 (October 1923) (issue devoted to Gobineau), 41.

32. Élie Faure, *The Spirit of the Forms*, trans. Walter Pach (Garden City, NY: Garden City Publishing, 1937), 96, 154.

33. Ibid., 102.

34. *Formes*, no. 9 (January 1930), 22. Wilhelm Uhde, of course, was delighted. He immediately wrote an "open letter" to Waldemar-George praising Brinckmann's foresight. See *Formes*, no. 4 (April 1930), 18.

35. Henri Focillon, *The Life Forms in Art*, revised trans. Charles Beecher Hogan and George Kubler (New York: George Wittenborn, 1948), 56

36. Gustav Klemm, *Allgemeine Cultur-Geschichte der Menschheit*, vol. I (Leipzig: Teubner, 1843), 196, 204. Cited by Poliakov, *The Aryan Myth*, 252–253. Poliakov notes that, according to Klemm, even if it were true that the Latins belonged to the "active races," the Germans were nonetheless superior to them.

37. Gustave d'Eichthal and Ismayl Urbain, *Lettre sur la race noire et la race blanche* (Paris: Paulin, 1839), 22. It is worth quoting what follows: "Like women, black people are deprived of political and scientific faculties; they have never created a great State, and among them there are no astronomers, mathematicians, or naturalists; they have achieved nothing in the way of industrial mechanics. But, on the other hand, they possess in the highest degree qualities of the heart, domestic feelings and affections; they are *indoor* people. Like women, they love ardently all adornment, dance, and singing; and the few examples that I have seen of their poetry are charming idylls. While the white person is *pantheistic* and caught up in the contemplation of the infinitely great, the black person is *fetishistic*, and loves the infinite power in its tiny and minuscule manifestations."

38. Poliakov, *The Aryan Myth*, 253. See also Tom Lloyd, "The Feminine in Thomas Carlyle's Aesthetics," *European Romantic Review* 2, no. 2 (1992), 173–194.

39. Gobineau, *The Inequality of Human Races* (1853–1855), trans. Adrian Collins (London: William Heinemann, 1915), 87.

40. As late, for example, as with Ernst Niekisch. See Stefan Breuer, *Anatomie der konservativen Revolution* (Darmstadt: Wissenschaftliche Buchgesellschaft, 1993), 92.

41. Wilhelm Worringer, *Form in Gothic*, trans. Sir Herbert Read (London: Alec Tiranti, 1957), 39–40; *Formprobleme der Gotik* (Munich: Piper, 1911), 28–29.

42. Sulpiz Boisserée, *Histoire et description de la cathédrale de Cologne* (1823), rev. ed. (Munich: Institut de littérature et des arts, 1843), 75; *Geschichte und Beschreibung des Doms von Köln* (1823), 2nd ed. (Munich: Literarisch-artistische Anstalt, 1842), 70–71: "Und da waren es dann wirklich die Deutschen und die mit ihnen durch frühere Stammesvermischung verwandten Nachbarn, die Nordfranzosen und Engländer, bei denen diese Baukunst zuerst am meisten und vortrefflichsten geübt wurde."

43. Franz Kugler, *Handbuch der Kunstegeschichte* (Stuttgart: Ebner & Seubert, 1842), 529–537.

44. Franz Mertens, "Paris baugeschichtlich im Mittelalter," *Allgemeine Bauzeitung* (Vienna, 1843), 257–259.

45. August Reichensperger, *L'Art gothique au xixe siècle*, trans. C. Nothomb, Pref. P. de Haulleville (Brussels: Devaux & Cie, 1867), 18. On the subject of A. Reichensperger, see Michael J. Lewis, *The Politics of the German Gothic Revival: August Reichensperger* (Cambridge, MA: MIT Press, 1993).

46. Louis Pfau, *Études sur l'art* (Paris: Hetzel, 1862), 122–123.

47. Paul Frankl, *The Gothic. Literary Sources and Interpretations through Eight Centuries* (Princeton, NJ: Princeton University Press, 1960), 540. For a discussion of Franz Mertens, see 531–537.

48. Eugène Viollet-le-Duc, "De l'architecture dans ses rapports avec l'histoire," *Revue des Cours littéraires de la France et de l'étranger*, 4, no. 16 (16 March 1867), 241–247.

49. Louis Courajod, *Leçons professées à l'École du Louvre (1887–1896)* (Paris: Picard, 1899–1903), vol. I, 157–158, 184, 227.

50. Ibid., vol. III, 45–46, 190, 127.

51. Ibid., vol. I, 186.

52. Pierre Francastel, *L'Histoire de l'art, instrument de la propagande germanique* (Paris: Librairie de Médicis, 1945), 130–131.

53. Georg Dehio, "Deutsche Kunstgeschichte und Deutsche Geschichte" (1907), *Kunsthistorische Aufsätze* (Munich–Berlin, 1914), 69.

54. Georg Dehio, "Über die Grenze der Renaissance gegen de Gotik (1900), *Kunsthistorische Aufsätze* (Munich–Berlin, 1914), 59–60. See also Éric Michaud, "Nord–Sud (Du nationalisme et du racisme en histoire de l'art. Une anthologie)," *Critique* 586 (March 1996), 163–187.

55. Georg Dehio, "Der Meister der Gemmingendenkmals im Mainzer Dom" (1909), *Kunsthistorische Aufsätze* (Munich–Berlin, 1914), 131–144 (see 141). Heinrich Wölfflin will refer to these lines in 1914, arguing that while Dehio was concerned to "remove the concept of the Renaissance from the history of German art," he (Wölfflin) was trying to reconcile a "German Renaissance" with the Baroque through the concept of the *painterly*, thus unifying them in a single "northern character." Wölfflin, *Gedanken zur Kunstgeschichte*, 4th ed. (Basel: Benno Schwabe, 1947), 117.

56. In *The Origins of Baroque Art in Rome*, a posthumously published collection of his lectures from 1901 to 1902, Alois Riegl employed the same strategy that he had used in his major work, *Late Roman Art Industry*: in the same way that late-Roman culture had emerged from ancient classicism thanks to the driving force of the Germanic peoples, this "later Italian art" that was the Roman Baroque took on the form that it did only because it "incorporated elements from northern developments, such as its conception of heightened sensation or its increased subjective-optical perception in its formal depiction." This explained the "intrinsic relation between the Gothic and Baroque styles." Riegl, *The Origins of Baroque Art in Rome*, ed. and trans. Andrew Hopkins and Arnold Witte (Los Angeles: Getty Research Institute, 2010), 94, 156.

57. Worringer, *Form in Gothic*, 180.

58. Ibid., 38–39.

59. Albert E. Brinckmann, *Geist der Nationen* (Hamburg: Hoffmann und Campe Verlag, 1938), 46.

60. "What Is Race: Evidence from Scientists" (Paris: UNESCO, 1952), 40.

61. For a discussion of the parallel between Riegl and Wölfflin, see Michael Ann Holly, *Panofsky and the Foundations of Art History* (Ithaca: Cornell University Press, 1985), 46ff.

62. Heinrich Wölfflin, "Italien und das deutsche Formgefühl" (1921), in Wölfflin, *Gedanken zur Kunstgeschichte*, 119. The semantic field of the term *Art* is very broad, including essence, but also nature, character, fashion, way of being, and species (in the biological sense).

63. Heinrich Wölfflin, "Prolegomena to a Psychology of Architecture," in Harry Francis Mallgrave, ed., *Empathy, Form, and Space: Problems in German Aesthetics, 1873–1893*, trans. Harry Francis Mallgrave and Eleftherios Ikonomou (Santa Monica: Getty Center for the History of Art and the Humanities, 1994), 170, 149.

64. See Meinhold Lurz, *Heinrich Wölfflin. Biographie einer Kunsttheorie* (Worms: Wernersche Verlagsgesellschaft, 1981); Joan Goldhammer Hart, "Heinrich Wölfflin: An Intellectual Biography," PhD thesis, University of California at Berkeley, 1981; Hubert Locher, *Kunstgeschichte als historische Theorie der Kunst, 1750–1950* (Munich: Fink, 2001), 380–387.

65. See Robert Vischer, "On the Optical Sense of Form: A Contribution to Aesthetics," in Mallgrave, *Empathy, Form, and Space*, 92.

66. Wölfflin, "Prolegomena to a Psychology of Architecture," 157–158, 155.

67. Ibid., 170, 184–185.

68. Heinrich Wölfflin, *Classic Art: An Introduction to the Italian Renaissance*, trans. Peter and Linda Murray (Ithaca: Cornell University Press, 1980), xvi.

69. Heinrich Wölfflin, *The Sense of Form*, trans. Alice Muehsam and Norma A. Shatan (New York: Chelsea, 1958), 18.

70. Wölfflin, *Gedanken zur Kunstgeschichte*, 109.

71. Wölfflin, *Principles of Art History*, 315, 149, 187 (emphasis added); "Italien hat den Instinkt für Fläche immer stärken besessen als der germanischen Norden, dem das Auf-wühlen der Tiefe im Blute steckt" (*Kunstgeschichtliche Grundbegriffe*, 111). The art historian Roger Fry noted with some humor in 1921 that, despite Wölfflin's praiseworthy attempts at objectivity, Wölfflin never questioned the idea that the baroque way of seeing—the one he clearly preferred—was the special contribution of the northern and, in particular, the Germanic races to history; although it had to be said that the only great baroque sculptor was Bernini, followed perhaps by Puget, neither of whom was at all Germanic. Roger Fry, "The Baroque," *Burlington Magazine* 39, no. 222 (September 1921), 145–148.

72. Wölfflin, *Principles of Art History*, 93 ("Das Sehen an sich hat seine Geschichte"). See the excellent essay by Claire Farago, "Vision Itself Has Its History: 'Race,' Nation, and Renaissance Art History," in Claire Farago, ed., *Reframing the Renaissance: Visual Culture in Europe and Latin America, 1450–1650* (New Haven: Yale University Press, 1995), 67–88.

73. Martin Warnke, "On Heinrich Wölfflin," *Representations* 27 (1989), 172–187 (see his note 14).

74. Wölfflin, *The Sense of Form in Art*, 36, 151.

75. Meyer Schapiro, "Race, Nationality and Art," *Art Front* 2 (1936), 10.

76. Johann Joachim Winckelmann, *History of the Art of Antiquity*, trans. Harry Francis Mallgrave (Los Angeles: Getty, 2006), 118–119.

77. Winckelmann, *History of the Art of Antiquity*, 173; see also Sabina Loriga, "In Search of Origins: Making Etruscans into Italics and Italics into Italians," *Res: Anthropology and Aesthetics*, 2019, 71–72.

78. Vivant Denon, *Voyage dans la Basse et la Haute Égypte, pendant les campagnes du général Bonaparte* (Paris: Didot, 1802), 46.

79. François Pouqueville, *Voyage en Morée, en Constantinople, en Albanie et dans plusieurs autres parties de l'Empire Othoman (... avec des rapprochemens entre l'état actuel de la Grèce et ce qu'elle fut dans l'antiquité)*, vol. I (Paris: Gabon et Cie, 1805), 249–250.

———

80. Théodule Ribot, *L'Hérédité. Étude psychologique sur ses phénomènes, ses lois, ses causes, ses conséquences* (Paris: Ladrange, 1873), 123–124.

81. Johann Joachim Winckelmann, *Description des pierres gravées du feu Baron de Stosch* (Florence: Bonducci, 1760), ix. See, however, David Bindman, who asserts (in *Ape to Apollo: Aesthetics and the Idea of Race in the 18th Century* [Ithaca: Cornell University Press, 2002], 91) that Winckelmann did not equate the Egyptians with black Africans.

82. Edme-François Jomard, *Études géographiques et historiques sur l'Arabie* ... (Paris: Didot, 1839), 168–172.

83. "Observations on Some Egyptian Mummies Opened in London. By Johann Friederich Blumenbach, M. D. F. R. S. Addressed to Sir Joseph Banks, Bart. P. R. S.," *Philosophical Transactions of the Royal Society of London*, vol. 84, 1 January 1794, 190–191.

84. Antoine Desmoulins, *Histoire naturelle des races du Nord-Est de l'Europe, de l'Asie boréale et orientale, et de l'Afrique australe* (Paris: Méquignon-Marvis, 1826), 231–232.

85. Paul Topinard, *Éléments d'anthropologie générale* (Paris: Delahaye et Lecrosnier, 1885), p. 121. See Claude Blanckaert, "Un fil d'Ariane dans le labyrinthe des origines ... Langues, races et classification ethnologique au XIXe siècle," *Revue d'Histoire des Sciences Humaines*, no. 17 (2007), 137–171.

86. This theory of the two Gaulish races was so widely distributed that it became a very commonly held belief, extending well beyond the discourse of scholars. Stendhal, who was a friend of Dr. Edwards, noted in his *Mémoires d'un touriste* that he had met two distinct races of men in the streets of Dijon: those from the Franche-Comté, who were big and tall, and were obviously Kymrys, making "a perfect contrast with the Galls, with their round heads and smiling, happy faces." On 24 May 1837, he noted that, during an evening spent in Lyon, all of the dinner guests had "abandoned small talk, and, with an admirable seriousness of purpose, had begun to point to physical signs of their descent from the Galls, Kymry or Iberians." Stendhal, *Mémoires d'un touriste*, vol. I (Paris: Michel Lévy, 1854), 91, 131 (12 and 24 May 1837).

87. William Frédéric Edwards, *Des caractères physiologiques des races humaines considérées dans leur rapport avec l'histoire. Lettre à M. Amédée Thierry* (Paris: Compère Jeune, 1829), 6, 13–15, 42–62. See Marie-France Piguet, "Observation et histoire. *Race* chez Amédée Thierry et William F. Edwards," *L'Homme*, no. 153 (2000), 93–106.

88. Giuseppe Dell'Isola (G. Pensabene), "La razza aquiline," *La Difesa della Razza* (1939), II, 10, p. 8–9, cited by Loriga, "In Search of Origins: Making Etruscans into Italics and Italics into Italians."

89. Paul Broca, "Mémoire sur l'hybridité en général, sur la distinction des espèces animales et sur les métis obtenus par le croisement du lièvre et du lapin" (1858), *Recherches sur l'hybridité animale en général et sur l'hybridité humaine et particulier, considérées dans leurs rapports*

avec la question de la pluralité des espèces humaines (Paris: J. de Claye, 1860), 452–453; Samuel George Morton, *Crania Aegyptiaca; or, Observations on Egyptian Ethnography, derived from Anatomy, History and the Monuments* (Philadelphia: J. Penington; London: Madden & Co., 1844), 61–62.

90. Ernest T. Hamy, "La figure humaine dans les Monuments chaldéens, babyloniens et assyriens," *Bulletins et Mémoires de la Société d'anthropologie de Paris* 8, no. 8 (1907), 116–132.

91. Courajod, *Leçons professées à l'École du Louvre*, vol. III, 336.

92. See Ernst Kris and Otto Kurz, *Legend, Myth and Magic in the Image of the Artist: A Historical Experiment* (New Haven: Yale University Press, 1979).

93. Marcel Proust, *In Search of Lost Time*, vol. III, *The Guermantes Way*, trans. C. K. Scott Moncrieff and Terence Kilmartin, rev. D. J. Enright (New York: Modern Library, 1993), 254.

94. S. M. Eisenstein, *Que Viva Mexico!* intro. Ernest Lindgren, trans. unknown (London: Vision Press, 1952), 27–28. I would like to thank Jean-Claude Lebensztejn for drawing my attention to this prologue.

Epilogue

1. Raymond Lantier and Jean Hubert, *Les Origines de l'art français* (Paris: Le Prat, 1947), 46, 81.

2. *Pérennité de l'art gaulois* (Paris: Musée pédagogique, 1955), 13. The catalogue was divided into two major sections: "Art gaulois: art pré-français" and "De l'art gaulois à l'art moderne."

3. Charles Estienne, "La ligne de l'hérésie," in *Pérennité de l'art gaulois*, 85; André Breton, "Présent des Gaules," in ibid., 69–72; Jean Babelon, "Originalité de l'art gaulois," in ibid., 21.

4. René Huyghe, *L'Amour de l'art* (January 1933), 14; (May 1934), 369; (September 1934), 417. These articles were to be included in his *Histoire de l'art contemporain* (Paris: Alcan, 1935). See Catherine Fraixe, "L'Amour de l'art. Une revue 'ni droite ni gauche' au début des années 30," in Rossella Froissart Pezone and Yves Chevrefils Desbiolles, eds., *Les Revues d'art. Formes, stratégies et réseaux au XXe siècle* (Rennes: Presses universitaires de Rennes, 2011), 255–280.

5. Fernando Chueca Goitia, *Invariantes castizos de la arquitectura española* (Madrid, 1947).

6. Nikolaus Pevsner, *The Englishness of English Art* (New York: Penguin, 1978), 197.

7. Robert Rosenblum, *Modern Painting and the Northern Romantic Tradition: Friedrich to Rothko* (New York: Harper and Row, 1975).

8. Svetlana Alpers, *The Art of Describing* (Chicago: University of Chicago Press, 1983), 243, 33–49 and *passim*. Svetlana Alpers did admit (albeit in a footnote) that she was alone in claiming that Kepler's optics were in conflict with Brunelleschi's; however, she persisted in maintaining her position against all historians of science.

9. Jean Dubuffet, "In Honor of Savage Values," trans. Kent Minturn and Gini Alhadeff, *RES* 46 (Autumn 2004), 259–268. I would like to thank Didier Semin for drawing my attention both to this text and to the writings of André Breton that I refer to here.

10. See Daniel J. Sherman, *French Primitivism and the Ends of Empire, 1945–1975* (Chicago and London: University of Chicago Press, 2011), 136–138.

11. Jean Dubuffet, letter to Jacques Berne, 17 March 1947, in Dubuffet, *Lettres à J. B., 1946–1985* (Paris: Hermann, 1991), 8.

12. Letter to Henri and Marie-Louise Michaux, 23 January 1948, cited by Marianne Jakobi, "Jean Dubuffet et le désert dans l'immédiat après-guerre: le mythe du bon sauvage," in M. Vanci-Perahim and C. Wermester, eds., *Atlas et les territoires du regard. Le géographique de l'histoire de l'art (XIXe et XXe siècles)* (Paris: Publications de la Sorbonne, 2006), 172.

13. Dubuffet, letter to Jacques Berne, 29 April 1949, in Dubuffet, *Lettres à J. B.*, 47.

14. Paul Guillaume responding to the survey "Opinions sur l'art nègre," *Action. Cahiers de philosophie et d'art*, no. 3 (April 1920), 24; cited in Jack Flam and Miriam Deutch, eds., *Primitivism and Twentieth-Century Art: A Documentary History* (Berkeley: University of California Press, 2003), 130. See also Jean Laude, *La Peinture française (1905–1914) et l'"Art nègre". Contribution à l'étude des sources du fauvisme et du cubisme* (Paris: Klincksieck, 1968), 19; Dominique Jarrassé, "Trois gouttes d'art nègre. Gobinisme et métissage en histoire de l'art," in T. Dufrêne and A. C. Taylor, eds., *Cannibalismes disciplinaires. Quand l'histoire de l'art et l'anthropologie se rencontrent* (Paris: Inha et Musée du quai Branly, 2010), 142.

15. Bernard Berenson, *Aesthetics and History* (Garden City, NY: Doubleday, 1954). I would like to thank Paul Bernard-Nouraud for drawing my attention to this point.

16. Johannes Fabian, *Time and the Other: How Anthropology Makes Its Object* (New York: Columbia University Press, 1983), 31.

17. Ashis Nandy, *The Intimate Enemy: Loss and Recovery of the Self under Colonialism* (Oxford: Oxford University Press, 1983), xi.

18. Nelson H. H. Graburn, "L'art et les processus d'acculturation," *Revue internationale des sciences sociales* 21, no. 3 (1969), 491–504; Nelson H. H. Graburn, ed., *Ethnic and Tourist Arts: Cultural Expressions from the Fourth World* (Berkeley: University of California Press, 1977).

19. Nelson H. H. Graburn, "Authentic Inuit Art: Creation and Exclusion in the Canadian North," *Journal of Material Culture* 9, no. 2 (2004), 141–159.

20. Ignacio Ramonet, "Sculpter l'identité inuit," *Vie des Arts* 34, no. 137 (1989), 28–31.

21. Victor Segalen, "Gauguin dans son dernier décor," *Mercure de France* 50, no. 174 (June 1904), 685.

22. For an analysis of the very real ambiguities surrounding the concept of the indigenous, see Jean-Loup Amselle, "Qu'est-ce qu'un peuple autochtone?," *Rétrovolutions* (Paris: Stock, 2010), 141–159. See also Pauline Turner Strong and Barrik Van Winkle, "'Indian Blood': Reflections on the Reckoning and Refiguring of Native North American Identity," *Cultural Anthropology* 11 (1996), 547–576.

23. Meaghan Wilson-Anastasios, "Le marché de l'art aborigène d'Australie," *Diogène*, no. 231 (July 2010), 28–46.

24. See especially John L. Comaroff and Jean Comaroff, *Ethnicity, Inc.* (Chicago: University of Chicago Press), 2009.

25. Wilson-Anastasios, "Le marché de l'art aborigène d'Australie," 28, 30.

26. Jean-Luc Chalumeau, *Basquiat, 1960–1988* (Paris: Cercle d'art, 2003), 5.

27. One of the works by Chris Ofili (born 1968) involving elephant feces, *Afrodizzia* (1996), was sold at Sotheby's in New York for more than 1.5 million dollars in May 2014 (http://www.sothebys.com/en/auctions/ecatalogue/2014/contemporary-art-evening-sale-n09141/lot.18.html).

28. For some approaches that are critical of this phenomenon, see Darby English, *How to See a Work of Art in Total Darkness* (Cambridge, MA: MIT Press, 2007); Jennifer A. Gonzalez, *Subject to Display: Reframing Race in Contemporary Installation Art* (Cambridge, MA: MIT Press, 2008).

29. See Jean-Loup Amselle, *L'Art de la friche. Essai sur l'art africain contemporain* (Paris: Flammarion, 2005); Monia Abdallah, *Construire le progrès continu du passé. Enquête sur la notion d'"art islamique contemporain" (1970–2009)*, PhD EHESS, Paris, 2009.

Figure 1.1 Caylus, *Recueil d'Antiquités*, vol. II (Paris: Duchesne, 1756), p. 71, pl. V. Public domain. Courtesy of Columbia University Libraries.

Figure 2.1 Camper, *Dissertation physique de Mr. Pierre Camper sur les différences réelles que présentent les traits du visage chez les hommes de différents pays ...* (Utrecht: B. Wild & J. Altheer, 1791), tab. I. Public domain. Courtesy of BPU Neuchâtel, geussc LIRA 128, http://doi.org/10.3931/e-rara-8091/.

Figure 2.2 *Magasin pittoresque* 12, no. 34 (August 1844), p. 272. Public domain. Courtesy of Columbia University Libraries.

Figure 2.3 Camper, *Dissertation physique de Mr. Pierre Camper sur les différences réelles que présentent les traits du visage chez les hommes de différents pays ...* (Utrecht: B. Wild & J. Altheer, 1791), tab. VIII, fig. 1. Public domain. Courtesy of BPU Neuchâtel, geussc LIRA 128, http://doi.org/10.3931/e-rara-8091.

Figure 2.4 Virey, *Histoire naturelle du genre humain* (Paris: Dufart, 1801 [an IX]), vol. 2, pl. IV. Public domain. Courtesy of Columbia University Libraries.

Figure 2.5 *Types of Mankind, or Ethnological Researches ...* (Philadelphia: Lippincott, Grambo & Co.; London: Trübner & Co., 1854), p. 458. Public domain. Courtesy of Columbia University Libraries.

Figure 2.6 Virey, *Histoire naturelle du genre humain*, 2nd ed. (Paris: Crochard, 1824), vol. 2, pl. 8. Public domain. Courtesy of BIU Santé (Paris), http://www.biusante.parisdescartes.fr/histmed/image ?med34003x02x0050

Figure 2.7 *L'Anthropologie* 18 (1907), p. 10. Public domain. Courtesy of Columbia University Libraries.

Figure 2.8 *A New, Authentic and Complete Account of Voyages Round the World* (London: Alexander Hogg, 1784–1786). © Lowe Art Museum, Miami, Florida, USA / Gift of Dr. and Mrs. Robert Walzer / Bridgeman Images.

Figure 5.1 Albert E. Brinckmann, *Geist der Nationen* (Hamburg: Hoffmann und Campe Verlag, 1938). Public domain. Courtesy of Columbia University Libraries.

Figure 5.2 *What Is Race?: Evidence from Scientists* (Paris: UNESCO, 1952). © UNESCO, http://unesdoc.unesco.org/images/0006/000678/ 067867EB.pdf.

Figure 5.3 J. F. Blumenbach, "Observations on Some Egyptian Mummies Opened in London," *Transactions of the Royal Society of London* 84 (1794), p. 194, tab. XVI. Public domain. Courtesy of Columbia University Libraries.

Figure 5.4 *Bulletins et Mémoires de la Société d'anthropologie de Paris* 8, no. 8 (1907). Left: Plaque perforée d'Ur-Nanshe, roi de Lagash, ca. 2550–2500 BC. N° AO2344, Paris, Musée du Louvre. Photo © RMN-Grand Palais (musée du Louvre) / Philipp Bernard. Right: Kurde Bourouki, cote 80009, fonds Ernest Chantre. Photo Ernest Chantre. Public domain. Courtesy of Musée des Confluences (Lyon, France).

Figure 5.5 Sergei Eisenstein, two movie stills from *¡Que Viva México!*, 1931.

Index